DESIGN MEDIA

DESIGN MEDIA
Techniques for Watercolor, Pen & Ink, Pastel and Colored Marker

RON KASPRISIN

JOHN WILEY & SONS, INC.
New York · Chichester · Weinheim · Brisbane · Singapore · Toronto

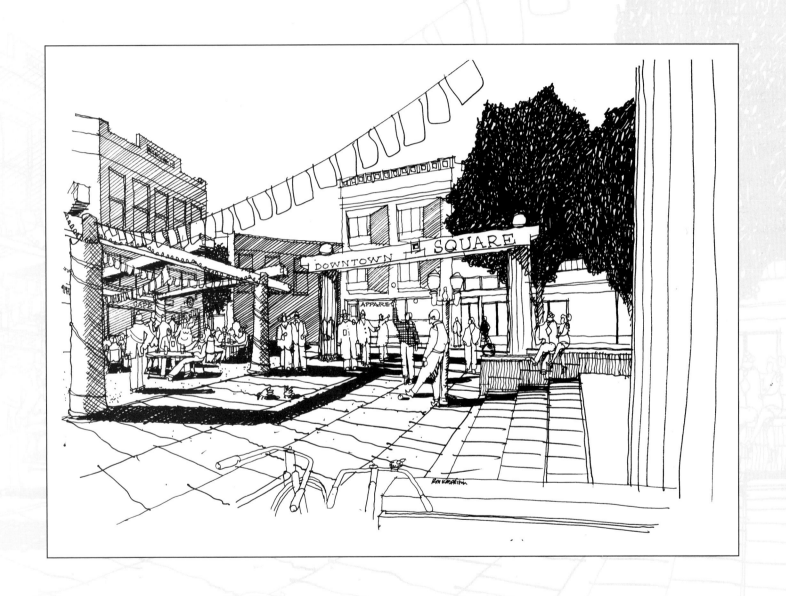

Copyright © 1999 by John Wiley & Sons, Inc. All rights reserved.

Published simultaneously in Canada.

Library of Congress Cataloging-in-Publication Data:

Kasprisin, Ronald J.
 Design media : techniques for watercolor, pen & ink, pastel and
colored marker / Ronald J. Kasprisin.
 p. cm.
 Includes bibliographical references and index.
 ISBN 0-471-29301-6 (paper : alk. paper)
 1. Color drawing—Technique. 2. Watercolor painting—Technique.
3. Architectural rendering—Technique. I. Title.
NC758 .K37 1999
751.4'2—ddc21 98-37589

Printed in the United States of America.

10 9 8 7 6 5 4 3 2 1

In memory of my brother, Dennis,
for his unwavering love and support.

CONTENTS

CHAPTER 2
PEN & INK: Line, Pattern, and Value 78

CHAPTER 3
Pastel and Colored Marker 152

PREFACE

I have a unique or at least uncommon relationship to design graphics. I am a teacher and a practitioner in urban design and planning, and I teach watercolor and drawing to architecture and landscape architecture students and professionals. I consider it unique because it enables me to bring additional townscape perspectives to design graphics. Two others stand out. The first is my interest as an urban designer/planner in the multiple scales and complexities of *context*. The second is a strong commitment, born out of countless hours of public involvement work, to provide *contextual communication* to the public participation process at all levels of design. Other designers do consider these issues, but too often in design we become overly focused regarding use of drawing skills and lose sight of the larger graphical portrayal of context. Which brings me to a key point of this book: it is about drawing and painting but not about rendering or final presentation illustrations. The book's focus for drawing and painting is a trialectic: *context, public communication, and design morphology.*

The book is about the methods and techniques of watercolor painting, pen and ink drawing, colored marker illustration, and pastel painting. In *Visual Thinking for Architects and Designers* (1995), Professor James Pettinari and I focused on what type of graphics were appropriate where and in what form in the design process; and how that enabled the designer to greatly expand the notion of "context." This book deals more with the "how to" of drawing and painting in design, but the drawing styles and techniques are strongly influenced by the trialectic.

It is not my intention to emphasize one medium over another. A medium such as watercolor may stand out more because it can be a more complex application process with more layers and requires more explanation. I find that each of the four media have their own special

application characteristics and I have ordered them accordingly, beginning with watercolor, then pen and ink, followed by pastel and colored marker.

Watercolor painting is a tool that I use to identify, describe, and understand the larger context and its many "places"; or, as Professor Pettinari and I enjoy pointing out, "places within places." If teaching watercolor was limited to washes and techniques for illustrating building materials and landscape features, I think a great opportunity would be lost. Asking students and professionals to capture what they "see" in the landscape, townscape, and characteristics of buildings and streetscape requires them to change how they observe. I have former students who come back and tell me how they look at things very differently after taking watercolor—how they look at the light's effects on shapes and surfaces; how they notice the value patterns in the landscape; and how they are able to see compositional patterns differently in the real world. Undertaking difficult organic shapes and complex townscapes as *painting* rather than illustration, in my opinion, advances the capability of the designer more than teaching only the mechanics of design illustration. It is an easier transition to architectural illustration from a more artful painting approach than the reverse. Many students initially gravitate for the small brush and the fine detail, tightening up both their results and their approach. My message is the opposite. I hope the lessons and examples in the watercolor chapter can lead others to a more expressive and exploratory use of this wonderful medium as a way of seeing and understanding the complexities of the rural landscape, cities and towns.

Pen and ink has been my workhorse medium for 30 years. Like many others of my '60s generation, I was greatly impressed and influenced by Gordon Cullen's work, *Townscape* (1961). I was and still am fascinated by the speed and strength of pen and ink. As my practice gravitated more into community design and away from architecture, there was an increased public demand for three-dimensional communication graphics for planning projects. Of course, the budgets were not equal to the community expectations of product, so increased drawing speed was necessary. The drawings then evolved from more meticulous technical pen drawings to faster and looser fiber pen drawings. I often refer to the many perspective sketches that I churned out for public meetings as three-dimensional *diagrams*. As you will see in the lessons, they are in many ways semi-abstract depictions of design implications and impacts. They all seek to depict design changes within a local and identifiable context with sufficient clarity to help residents and elected officials understand better the ramifications and potentials of their actions (and non-actions).

Pen and ink drawings also are valuable because they reproduce well and inexpensively compared to color media. A black and white drawing with strong value patterns can have the appeal of an Ansel Adams type black and white photograph—it stands on its own *value structure* without color assistance. The lessons on pen and ink address both the technical pen and the fiber pen. Each has its strengths and shortcomings for design. Neither is limited to only one type of application. For example, the technical pen can be a great sketching tool, not merely limited to straight line drawings. A major difference is in the point sizes that are available and their durability. Whether you prefer to work in straight line or freehand styles, pen and ink can be adapted to both your style of working and your personality.

In Chapter 3, I discuss pastel painting as a wonderful and fast way to "paint" washes and color studies. With computer color scanning and printing, color media like watercolor and pastel have made a comeback. It is easier and more cost-effective to color print today than even ten years ago. Pastel has been for me a newly discovered fun and fast way to add color emphasis to pen and ink drawings. If I have only a few hours prior to a deadline and someone wants color added for a meeting, I use the pastels rather than colored markers. They are less garish yet strong in color. They have great texture characteristics and work well on both bond paper and watercolor paper (or other textured papers). I have replaced color pencils with pastels for both their speed and workability.

Colored marker is also discussed in Chapter 3, with pastel painting. I have decreased the amount of examples for colored marker in comparison to other media because of the excellent and numerous books already on the market that specialize in them. I am a strong proponent

of *diagramming* as a part of the design/planning process, much to the chagrin of some students and professionals who want to engage the design geometry immediately. Colored marker is the most appropriate medium for diagramming that I have used due to its speed, color attraction, and versatility, particularly in preparing for workshops, charrettes, and other public meeting events. So if you want to know more of the detail of colored marker rendering, I refer you to such texts as Doyle (1993) and Lin (1985).

As you use the book, remember its trialectic and how that influences the visualization techniques: "seeing" and understanding context; communicating design and its ramifications to the substantive users of design outcomes; and bridging the levels of design development (organization, structure, and form characteristics), when "data" is translated into geometry and other *forms-in-relationship*. And remember that if you look closely, your drawing will tell you much about yourself, your moods, motivation, focus, and attention.

I hope the work and instruction in this book are helpful to you in your own personal exploration of design and environment. I trust you will find the enjoyment and challenge in drawing and painting that I have. Keep connected to the crafted drawing process with the pen, pencil, pastel, and brush.

BIBLIOGRAPHY

Cullen, Gordon. 1961. *Townscape.* New York: John Wiley & Sons, Inc.

Doyle, Michael E. 1993. *Color Drawing.* New York: John Wiley & Sons, Inc.

Kasprisin, Ronald J. and James Pettinari. 1995. *Visual Thinking for Architects and Designers.* New York: John Wiley & Sons, Inc.

Lin, Mike W. 1985. *Architectural Rendering Techniques/A Color Reference.* New York: John Wiley & Sons, Inc.

INTRODUCTION: CRAFTING, FEAR, AND CREATIVITY

When many students and not a few professionals are asked to actually express ideas in hand-crafted graphic form, without a computer, the sweat glands and the reticence begin to flow. Expressing ideas, of course, means playing with shapes, principles, and elements through sketches and diagrams in a search for an integrated composition. This process generates many versions of fear, some for everyone. It makes the most experienced of us pause with doubt. A British Columbian colleague turned to me just as we were about to begin an intensive one-day charrette process outside of Vancouver and told me how nervous he was at the impending event. He had been away from the hand-drawn process for quite some time and felt that he had to perform, that he was on the spot, and that he might not be able to do it. He not only did a great job, especially when he realized that people were interested in his translation of their ideas and not how he was as a performer, but he came away invigorat-ed by the entire process. These natural fears can also prevent those who are new to design from accessing a powerful and rewarding process. Therefore, recognizing that fear or uncertainty, crafting, and creativity all go hand in hand is an excellent first step toward developing your design skills.

CRAFTING

To craft means to have a special skill or art; to have an occupation requiring special manual skills. Historically it has set individuals aside for their knowledge, experience, and craftsmanship—elevating them in status and stature, or acknowledging their eccentricities. Design, with all of its technological changes, is still a crafting process when it involves skill

development that is *reflected in the art or design itself.* Architecture, landscape architecture, and urban design soon exact their demands for detail, rigidity, and finality. The art of design, the crafting process, establishes the vision that by its strength and communication lasts through to the final product.

FEAR

I have used watercolorist Frank Webb's statement before and it is important to repeat again: *Fear is an inherent ingredient in creativity.* Students and professionals in design are constantly confronted with fear in some form. Fear of failure, of success, of not being perfect, of being too loose, of not being good enough, and of not being like the person next to us. We all have fear, and recognizing it and working through it helps create passion and resolve. "Each creative action risks failure" (Webb 1990). Accept its presence. Listen to what it is telling you. Identify the object of the fear and work toward it. In many cases, simply identifying the fear can cause it to dissolve. In other cases, use it as a challenge.

CREATIVITY

Creativity has many interpretations, the least of which is "problem-solving." Creativity goes beyond that to innovation and exploration, pushing the question as far as it can go to change reality. It pushes the accepted limits and boundaries out a bit more, redefining the shape. It is not merely competence, or thoroughness, or pizzazz, or even brilliance. It is a capacity to learn and change and to learn by that change. Problem-solving is a by-product of creativity.

Drawing and painting are crafting languages that are potential vehicles of creativity. They directly connect the designer to the form-making exploration. They demand a commitment of pen to paper, of mental concept interpreted in a geometry that can only begin to emerge from

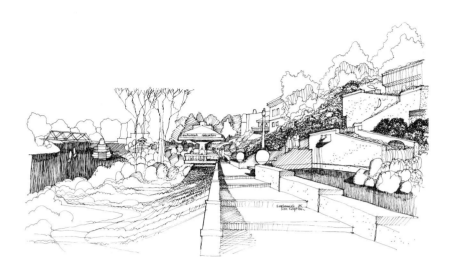

the abstract when the pen or brush touches the paper. They enable experimentation, and can generate variety with each repeated effort, as no two hand-drawn lines are the same. They encourage and promote uncertainty, the other side of the known boundary where exciting things can happen. The sketch, concept diagram, and doodle are each unique and each connected in a creative process achieved through drawing. Drawing and painting also require the designer to take their "product" and expose and share it with the client, public, neighbors, peers, etc. It is a form of communication, and with communication comes feedback, the start of dialogue. People identify with and have great respect for hand-drawn communication, in part because it personalizes the communication process. When mixed with other appropriate media, it can contribute to the public's confidence in that process, thereby making consensus possible.

Whether you are a beginner or an expert, personal growth is the measure of success in your drawing and painting, not comparisons to the work of others. Compete with yourself if you have to compete. The

drawings and paintings of others are so different based on the complexity of environment, dexterity, personality, and motivation that competition is not productive nor is it an accurate comparison. No teacher can teach you how to draw or paint, but can only guide you. You teach yourself by doing it, learning from the "failure" and success of pen or brush to paper. And forget "talent." I have found through my experience with students that it is merely a term that represents a level of self-confidence based on a combination of motivation, freedom through fear reduction (or challenge in response to it), lots of work, and self-perpetuating increases in confidence because of the success of the previous factors. I believe that talent is created.

BIBLIOGRAPHY

Webb, Frank. 1983. *Watercolor Energies* (out of print).

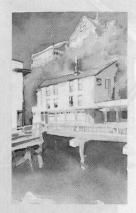

WATERCOLOR: FLUID AND TRANSPARENT

INTRODUCTION: TRANSPARENCY, FLUIDITY, SHAPE, AND VALUE

Transparent watercolor is different from oil, acrylic, color pencil, and pastel work because it is transparent and fluid: *transparent* because light is reflected back from the paper through the layers of pigment, and *fluid* because the pigments are suspended in water made mobile by gravity, adding another dimension to the application process. Transparency and fluidity determine both the methods of application and their sequencing.

Because watercolor is transparent, a lighter color cannot cover a darker color as is possible in oil painting. Transparency adds "luminosity" to watercolor painting. This is described as the ". . . glow from within resulting from the reflection of white paper through the transparent layer of paint . . . Other media are more dependent on color selection and

arrangement to suggest luminosity" (*Materials and Information for Artists* 1988/1989). Fluidity affects the settlement of pigment during the drying process as well as edge conditions as one fluid shape meets another.

Like other color media, watercolor has additional characteristics including temperature, value differences, and complementary color relationships. It has a reputation of being the most difficult of the media used in the design fields. Regardless of whether this is so, watercolor certainly is among the more complex in its methods. This complexity presents challenges for the painter, not problems, and makes watercolor exciting and magical.

Watercolor process is pattern making with shapes, value, and color, as opposed to outlines and black and white patterns in pen and ink. I have found that this difference affects the visual thinking processes in design and art for each of these media. In watercolor, shapes define their edges. In pen and ink drawing, the line and/or outline (edge) define the shape.

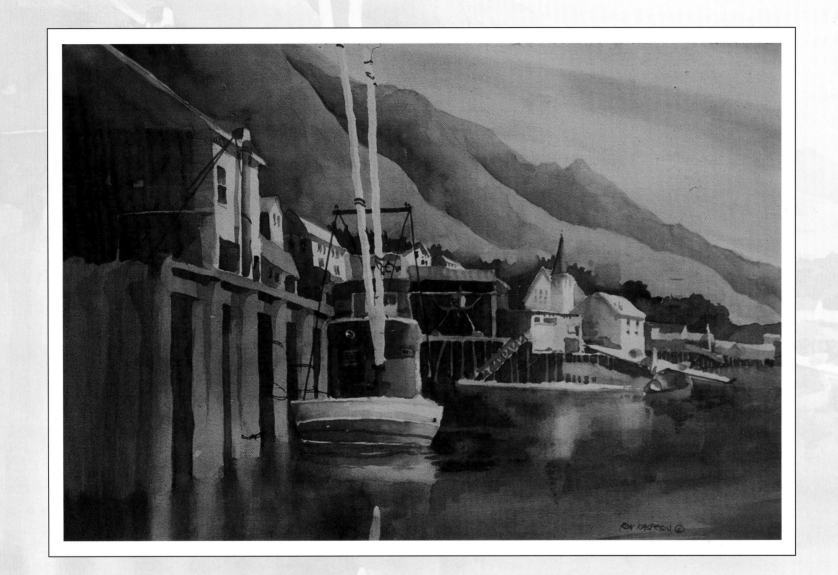

The overall *field* or surface of the shape and the manner in which it meets the next shape, creating an edge, often determine the success or failure of the resulting pattern. Adding to the dynamics of the edge transitions is the role of *value*—the light to dark relationships that give each shape characteristics of depth and structure. All of these factors combine to make watercolor a design process as well as visual communication.

THE TEACHING VALUES OF WATERCOLOR

Watercolor is accessible to everyone, regardless of level of experience and competence. After some basic practice in method and approach, many painters achieve a level of satisfaction and progress that sustains them as they pursue even higher levels. One does not have to become a *master* to find enjoyment, confidence, and effectiveness in watercolor painting. Remember that most people are intimidated and somewhat fearful for varying reasons when confronted with the crafting and creative process. This is natural and inherent to the process. Be aware of your fears and/or reticence and confront them with work, brush to paper. When you find yourself spinning your metaphorical wheels, just paint doodles or playful sketches to move beyond the impasse. Years ago during an outdoor workshop, James Godwin Scott, watercolor artist and teacher, told me that it was important to complete each watercolor study and painting regardless of whether or not I felt that it had failed. The reason: Working through perceived failure was actually a testing and problem-solving process that advanced my capabilities. If I had stopped at the halfway point in a painting, I would not have benefited from the lessons learned when I applied the final dark values, adding structure (and success) to an otherwise weak painting; or when I learned how to lift out less desirable applications after they were dry, if they were transparent and nonstaining colors; or when I learned how to pull a painting together by overpainting with a final wash. So remember, whether or not you "save" a painting is not important—but the fact that you work

through problems and make them challenges and learning experiences is.

The watercolors in this chapter are a combination of professional field sketches, studies, and personal explorations. It is my opinion that watercolor painting has a significant teaching role in design well beyond the finished or final rendering process. Being able to paint landscapes, nonarchitectural subjects, still lifes, and semi-abstract subjects greatly advances the designer's ability to paint subjects related to professional design and become more observant of environmental and site conditions.

MATERIALS AND EQUIPMENT: ESSENTIALS AND OPTIONS

Quality, Economy, Suitability

For students and professionals who are serious about using watercolor in their work, I recommend buying quality with economy, not economy over quality. Painting equipment can be expensive. Be selective and choose quality where it is critical to the learning process.

Choosing Brushes. Brushes are the equipment types for which I recommend quality over basic economy for beginners. Buying brushes that bend over or go limp when they are wet unnecessarily hinders the quality of the work. Brushes must be capable of carrying water and maintaining their shape. Learning a new medium is difficult enough without adding extra burdens caused by inferior-quality tools. Brushes with a combination of synthetic and real sable hairs and some synthetics, moderately priced, are recommended (see the section on Brushes, below).

A helpful test to use before buying a brush is to wet it in the store, removing the glue that protects the hairs during shipping. Ask the store personnel for clear water to wash the glue off so that it can be tested. Once the brush is good and wet, push and pull it around a piece of paper. Look at its shape. If it does not return to a straight position after being bent over, do not buy it.

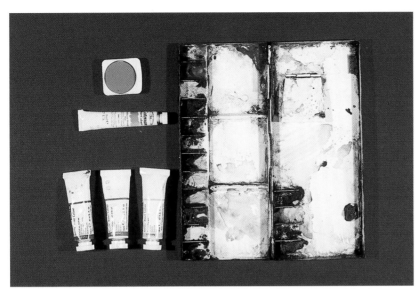

PIGMENTS. Professional quality paints usually come in larger tubes. Student grade are available in smaller tubes. Cakes are solid pieces of pigment individually wrapped or set in pigment wells in smaller palettes. For practice and beginning work, use the student-grade pigments. When permanence is important for the work, use professional grades.

Choosing Paint. Paint quality is also somewhat flexible, depending on its use. Student-grade paints are suitable for studies and sketches for beginning painters. Where permanence matters on final works or for presentations, and work is expected to last, use professional-grade or artists' quality paints. And do not hesitate to compare professional-grade paints, as all manufacturers are not of equal quality, no matter what the labeling. I use professional-grade paints from various manufacturers for all work, experimenting and comparing the results over time. Students and professionals are better off avoiding all pigments, regardless of price, that do not carry common names for pigments, for example, Yellow Ochre, Rose Madder, Cobalt Blue and so on. Paints with names like Bright Green, Green, etc. may be suitable for young children but not for any design application.

PIGMENTS. Pigments come in larger tubes of professional-quality or artists' quality paints; larger and smaller tubes of student-gradepaints; and hard cakes or pans of both professional and student grade. Watercolor inks are also available.

Most pigments are synthetic and vary in quality. If permanence or lightfastness is critical to your work, you should review technical manuals that rate manufacturers. *The Wilcox Guide to the Finest Watercolour Paints by* Michael Wilcox (1991) reviews most manufacturers pigment by pigment, classifying lightfastness, health cautions, and pigment reliability and suitability.

Choosing Paper. You will find there is greater flexibility with paper quality for beginners and practice painting. Studies and practice work can be done on student-grade watercolor papers, discussed in this section. Permanent or final work is best done on quality and durable paper. Quality paper allows you to rough up the paper, through scraping, scratching, or lifting out, because it has better sizing and surface strength. Economy papers tear and show abrasions easily, affecting the way colors move and dry. But for painting wash and other technique exercises, economy watercolor papers are sufficient.

PERMANENCE OR LIGHTFASTNESS. Permanent pigments do not fade in normal light. Manufacturers have developed a rating system for permanence or lightfastness (Wilcox's ratings in parentheses; see Wilcox 1991): AA for extremely permanent pigments (ASTM I excellent lightfastness); A for durable pigments (ASTM II very good lightfastness); B for moderately durable (ASTM III colors can fade badly, particularly the tints); and C for fugitive colors (ASTM IV colors can fade rapidly; ASTM V colors will bleach very quickly). Fugitive pigments include Carmine, Chrome Lemon, Chrome Yellow, Mauve, Rose Carthame, and Vandyke Brown.

Less durable pigments that should be used with caution include: Hooker's Green Light, Sap Green, Prussian Green, Gamboge, Crimson Lake, and Violet Carmine.

The discussion on color palettes in this chapter can help you determine what colors to buy for primaries and mixing colors.

Brushes

Brushes are made up of brush hair (or synthetic fibers that are machine roughed to hold water droplets), a ferrule to connect the hairs to the handle, and the handle.

Brush hairs are made from a variety of animal hairs, including Kolinsky red sable, goat, squirrel, ox, pony, camel, and hog (bristle). Synthetic fibers include nylon and other chemically produced fibers, sometimes mixed with natural hairs.

The ferrule is the metal tube that fastens the brush unit to the handle. It is either seamless or seamed (soldered), and its size both determines the brush size and shapes it (round, oval, flat). The best ferrules are nickel-plated brass tubes (tapered, cylindrical, or seamless). The lesser-quality seamed ferrules can split if water and/or paint in the ferrule cause swelling.

Brush handles are most often made of seasoned hardwoods that will not stretch or shrink, which causes the ferrule to loosen. Handles are usually finished with enamel or varnish as a sealer.

Once the brush is made, it is inserted tip first into the ferrule, measured for the correct exposed length (and proportion of hidden to exposed hairs), and cemented in place. Usually the exposed part of the brush is less than half the total brush length, giving it more spring. The ferrule is crimped at the brush end and the handle end to fasten it to the handle. If the ferrule ever loosens, use a nail and a small hammer to tap (not pound) indentations into the ferrule (without piercing it) to tighten it.

To make transport easier, the brush is coated with a water-soluble gum arabic (a gum obtained from African acacias, used as a stabilizing emulsion). As noted earlier, this gum can be washed off in clear water in the store so that brushes can be tested before purchase.

Brushes can vary in width from one-eighth to two inches and are generally classified according to the following types:

Brush Classifications

Rounds—circular in cross section and come to a point at the tip.

Flats—rectangular in cross section, ½″ to 1″ in width.

Script—for sign painting, with long, narrow, round shape.

Lettering—long, narrow, round shape similar to script.

Fan—shaped like a fan and useful for feathering dry or semi-dry washes.

One Stroke—wide and flat for broad, fast washes. Some available up to 6″.

Travel—usually round, small, compact, and collapsible.

Brush Care and Maintenance

- Always clean brush after use to avoid pigment build-up at base of brush near handle, which can destroy brush.

- Clean and charge brushes in clear water but do not leave them soaking in it.

- To clean brushes, rinse first in clear water. Lather up the brush by rubbing it on a cake of household soap, and continue to work up a lather by rubbing the brush in the palm of your hand. Avoid strong detergents.

- After cleaning the brush, wipe and shape it with your hand or a soft cloth.

- Rest the brush on its side or standing on its handle. Avoid at all costs having the tip take any pressure, as it can bend out of shape. Never leave the brush standing on its tip in the water jar or anywhere else.

- Dry all brushes thoroughly before storing in closed containers. Mold or mildew may develop from moisture left in brush with no air movement.

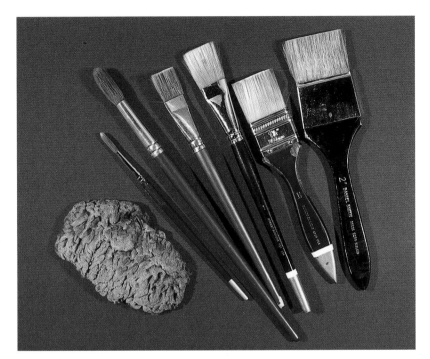

BRUSHES. **Wash brushes, flat (rectangular in section) and round (round in section) make up the basic inventory. If a brush tip does not return to a vertical position after being wet and bent, I suggest you do not buy it.**

Wash or Sky—rectangular in cross section, ¼″ to 2″ in width.

Mop or Duster—brushes with large thick heads extending 2″ from the ferrule. Oval shapes are also available, which form pointed tips when wet.

Aquarelle—flat and rectangular in cross section, ½″ to 1″ in width, chiseled at an angle at the end of the handle, for scraping, burnishing, highlighting, and removing color.

Liner—for calligraphy and line work with long fine point protruding from a round head.

Paper

Watercolor paper is available in sizes ranging from 4×6 inch postcards to 43½″ wide rolls.

Paper Classifications

- *Watercolor paper* is available in hot pressed, cold pressed, and rough surfaces in 22″ × 30″ and 25½″ × 40″; and from 90 to 555 lb. weight.

- *Watercolor blocks* are bound on four sides by glue, pre-stretched. They usually come in 90, 130, and 140 lb. blocks ranging in size from 7″ × 10″ to 18″ × 24″.

- *Watercolor pads* are heavyweight paper, usually spiral bound, ranging in size from 6″ × 8″ to 19″ × 24″.

- *Watercolor sketch pads or books* vary from craftsperson specialties to standard manufacturer sizes, 9″ × 12″ to 14″ × 17″.

- *Watercolor boards,* usually 90 lb. Cold pressed, 22″ × 30″.

- *Watercolor rolls,* 140 lb. and 156 lb., approximately 43½″ to 52½″ wide.

Paper Characteristics*

Acid Free: Refers to paper that has a neutral pH below 7, usually between 6.5 and 7.0.

Buffering: The neutralizing of acid in the paper by adding an alkaline substance such as calcium carbonate or magnesium carbonate. A paper does not have to be buffered in order to have a neutral pH.

Cold Pressed: Refers to mildly textured paper surfaces produced by pressing the paper through unheated rollers. Generally, it is the intermediate surface between rough and hot pressed.

Deckle Edge: The natural fuzzy edges of hand-made and mold-made sheets of paper, simulated in machine-made papers by "cutting" them with a stream of water when still wet. Hand-made papers have four deckle edges and mold-made and machine-made have two. The term *deckle* comes from the frame or board of the paper mold.

Fibers: Refers to the thread-like cellulose structures that form the paper.

Gampi: A vegetable fiber used in oriental papermaking that results in a strong, translucent sheet.

Gm/m2: The European measure of weight for artists' paper. It compares the weights of different papers, each occupying one square meter of space, irrespective of the individual sheet dimensions.

Grain: Refers to the direction in which the sheet was made on the paper machine. This may be important because the fibers of the sheet tend to run in one direction, occasionally causing problems in printing and binding. Hand-made and mold-made papers have no grain direction.

*From *Materials and Information for Artists,* 1988/1989 (see Bibliography).

Hand-made: Refers to hand-making each sheet of paper by using a mold and deckle. It is a costly, time-consuming method that produces sheets without any grain direction.

Hot pressed: Smooth, glazed surfaces produced by pressing the paper through hot rollers after each sheet is formed.

Laid: Refers to paper with a "chain" pattern running throughout the paper. The pattern is determined by the mold used. Its counterpart is a wove sheet that has no chain pattern.

Machine-made: Refers to the method used to manufacture virtually all commercial papers. The machine is called a Fourdrinier. It makes a sheet very quickly, and the fibers point in a linear direction. Because it makes large quantities of paper quickly, this method does not offer much flexibility of variation.

Mold-made: Refers to an in-between process of papermaking, originally invented to simulate hand-made paper by means of a rotating cylinder that slowly forms each sheet.

pH: Refers to the amount of the hydrogen ion concentration of a water solution and substance, indicating acid or alkaline. A value of 7.0 is considered neutral.

Ply: the number of layers of paper, often laminated together to make heavier sheets, such as Bristol boards and museum boards.

Rag: The nonwood products used in the manufacture of paper. Rag can be true rags, cotton linters, or other vegetable matter (hemp, linen, and so on). Rag papers can contain from twenty-five to one hundred percent of cotton fiber pulp. New cotton remnants from the garment industry are used in high-quality papers.

Rough: Heavily textured surfaces produced by minimal pressing after sheet formation.

Sizing: Glue-like materials in the sheet to control the amount of absorption of ink or paint. Sizing is a gelatin or cornstarch substance. Gelatin sizing can be applied with a brush and flows better when warm. Cornstarch is nontoxic and dissolves in cold water.

Watermark: A design in the surface of the sheet created by sewing a thin wire to the mold during manufacturing, which makes the sheet thinner in that part so it is transparent.

Weight: The European weight, grams per square meter, or the English weight, pounds per ream (lb/ream). The European method bases the weight of a paper on the weight of each sheet, measured in a square meter. The English method measures only the weight of the paper in a ream (five hundred sheets), regardless of its size.

Wove Paper: Paper that shows no fine lines running through the sheet when held up to light. This is a relatively modern invention. Until the eighteenth century, most paper was laid and showed "chain" patterns when held up to light. Most papers produced today are wove.

Equipment and Supplies

The list that follows contains suggestions for cost-effective equipment purchases suitable for students and beginning to intermediate professionals. It is not all-inclusive. Additional equipment and supplies can be added, based on personal preferences.

Paper

One watercolor block, 9″ × 12″ minimum, 140 lb. professional grade for studies, student grade for practice

One watercolor sketch pad, 9″ × 12″ minimum, 140 lb.

One watercolor sketchbook, 6″ × 8″ to 9″ × 12″

Brushes

One round, no. 12 or 14

One round, no. 6 or 8

One flat, 1″

One wash, 1.5″ or 2″

(Preferences: sable/synthetic combination or quality synthetic)

Other brushes are optional, based on personal preference and need. Larger brushes are recommended to avoid a student/beginner tendency to become immersed in premature detail.

Pigments

Primaries from transparent, intense, and opaque palettes

plus

Yellow Ochre, Viridian, French Ultramarine Blue, Alizarin Crimson, Burnt Sienna.

Avoid pre-mixed tube colors.

Other Equipment

Water containers: reservoir (water bottle), working wash container (plastic type that margarine usually comes in), and small wash dish

Paper towels

Soft pencil (graphite)

Pencil sharpener

Drafting tape

Soap and/or kneaded erasure

Stapler

Pen knife

Masking fluid

Brush holder

Sponge, synthetic or real

Old toothbrush

View finder

Palette: in-studio palette should have at least three preferably larger wash mixing areas in addition to pigment wells; field palette can be smaller.

Plywood board cut to 18″ × 24″ or 24″ × 36″ for mounting watercolor sheets

Backpack

Tripod or easel—your choice

PAINTING METHODS AND STRATEGIES

Types of Methods

Five methods of painting commonly used by artists and useful in design work are:

- Dry on Dry
- Wet on Wet
- Wet on Dry (Direct Method)
- Merging or Mingling (variation)
- Glazing (variation)

Dry on Dry. Dry on dry consists of pure pigment (or pigment with a hint of water) in a nearly dry brush (damp dry) applied to dry paper. There is little or no transparency to the paint and its application is slow with a lot of friction between brush and paper. The brush can be damp or completely dry. Dry on dry is useful for detailed and controlled photo-realism. It usually accompanies other methods as a last step, adding detail. For example, dry on dry is effective for adding rough texture over previous washes applied as wet on wet or wet on dry. Variations of dry on dry for detailed work consist of adding limited amounts of water with the pigment and applying that to dry paper, or rubbing clear wax (candle) onto the paper and painting a damp brush over the wax. Remove wax with rubber cement remover or a hot iron over a towel. Control is a key objective. Characteristics of dry on dry include hard edges, photo-realism, and grainy or textured effects.

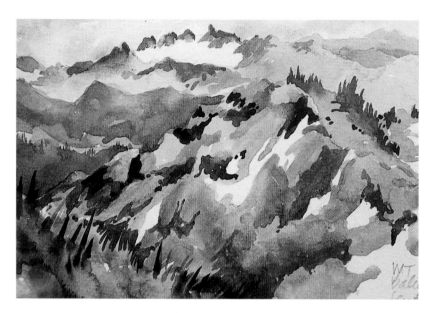

DRY ON DRY. There is very little water in the "dry" brush, mostly pure pigment. Some dampness is needed to pick up pigment. Drag the brush over most papers and you will feel friction, leaving a dry dispersed affect of pigment and white paper. This is effective as a final wash over previously applied and dry washes (for rough surfaces like wood planking, rusting metal parts, etc.). This is not unlike scumbling in pastels. Another dry method is one using wax: rub wax over the paper and paint over it. Remove the wax with rubber cement remover or an iron over a towel.

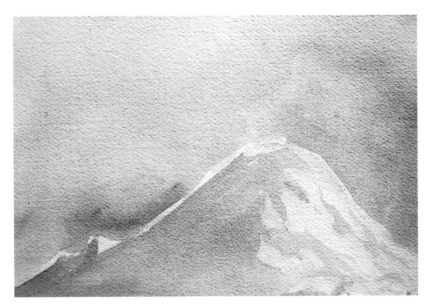

WET ON WET. This produces soft edges by letting the paint be pulled across the paper by the water in the paper. Wait until the shininess disappears before adding paint, then experiment on how fast or slow the paint moves with the wet to damp paper.

Wet on Wet. Wet on wet is defined as pigment mixed in a brush with a lot of water, referred to as a "charged brush," and placed on paper that is wet. This method is useful when painting in hot and dry atmospheres and/or in situations where paints dry very fast, causing unwanted hard edges; when more control is desired over larger washes, avoiding streaks and lines due to fast drying; and when soft and fuzzy edges and effects are desired. Experienced watercolorists can judge when to place paint into a wet wash as it is drying for a variety of effects. Like all methods, it takes practice and experimentation.

Basic principles of application for wet on wet include:

- *Wet the paper with clear water over the area to be painted.* The paint will stop at the wet-dry edge because the water in the paper acts as a dispersal vehicle (like a sponge) for the charged pigment. Wet only what is being painted unless you want the application to bleed into other areas.

- *Wait for the sheen or shininess to disappear before applying paint.* When the wet paper is shiny, it means that water is sitting on top of the paper. If paint is applied at this point, it will move around on top of the paper uncontrolled and not in the fibers of the paper. As soon as the shininess or sheen disappears and the surface is again nonreflective or matte, paint may be applied. The water has settled into the fibers and the paper is still very wet, so the applied paint spreads throughout the wet area. Practice and experience are important in determining how fast or slowly paint will move in the wet paper. The less wet the paper is, the slower the flow of paint will be. The wetter the paper, the faster the flow. Practice applying paints in 4-inch by 5-inch rectangles, waiting a bit longer on each one after the sheen disappears to apply the paint. Also vary the amount of water pigment in the brush.

- *Do not go back into the wet (and drying) application.* The water in the paper is constantly evaporating, making the paper drier with each second that passes. Paint from a charged brush is absorbed by the drier (yet wet) paper/paint application because the less wet area pulls to itself the more wet application. If there is paint (color) already in the previous and drying wash, it will not mix evenly with the new charged brush because their dampness rates are different. A blossom or backwash will occur, marring the wash. Let the previous wash dry completely before painting over or into it. Remind yourself: Leave *it alone!* If you want another layer, do the same wet on wet procedure over the first dry wash.

Wet on Dry. Wet on dry is also labeled the "direct method" in that pigment in a wet or charged brush is applied directly to dry paper. This process has more control. Paint is applied to dry paper while retaining the fluid wetness of watercolor through the amount of water in the brush. It helps to apply the wash faster than wet on wet in order to prevent the wash edge from drying prematurely. The edge is constantly worked and recharged with the brush, moving down the shape and paper. This method requires a decision on what edge condition the shape will have before the wash is attempted (hard edge, soft and blurred edge, interlocking edge, or lost and found edge). This is discussed in the section on edges.

Some principles for wet on dry:

- *Work from top down.* A common way to work wet on dry is from the top of the sheet down, moving from shape to shape, edge to edge, applying a first layer of paint (color, temperature, value). The first layer is allowed to dry before adding second and third layers.

- *Planning the edges.* Before a wash is completed, it is a good idea to think about the edge condition. If a hard edge is not desired, the edge can be softened or blurred with clear water, or lifted out with a semi-damp brush to break any hardness.

- *Keep "working" or leading edge wet.* The working edge, the downward portion of the new wash, needs to be wet in order to move it down the paper with the brush. Strive to keep and maintain a bead or small edge-pool of watercolor along the edge. With gravity (tilted paper) and your brush, the wash via the bead is easier to move downward.

- *Leave it alone!* Previous washes that are still wet need to dry before working again.

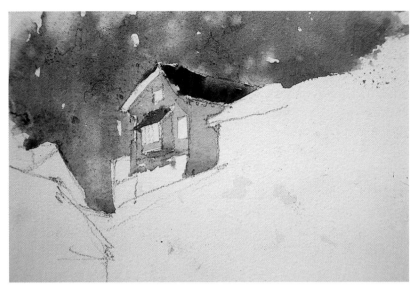

WET ON DRY. This method essentially carries the water in the brush and in the bead edge created by gravity at the bottom of a wash-in-progress, rather than loading the paper with water first. It is also called the *direct method* because it applies wet paint directly to the dry paper with a good amount of control over the wash. The concrete effect in this example was quickly applied with a number of light colors added as the wash moved down the paper. I added a dry on dry touch of detail after the first wash was applied to represent ridges in the concrete.

Gravity and the bead or wet edge at the bottom of the applied wash helps keep the wash moving smoothly down the shape. The bead also enables the painter to go quickly to the palette and recharge the brush, returning to the wash before the bead has dried. If you do not see a bead or raised are of wet paint along the bottom of your wash, you are painting dry, inviting more streaks at the point of brush recharge (going to and from the palette to recharge the brush). Most of my washes are "direct" method.

Merging or Mingling. Merging is accomplished by placing one color next to and touching another without overpainting. It lends itself to a wet on wet method as each color being merged moves through the wet paper and combines along the edges to make a third color. Wet on dry also works when two wet charges are made to touch on dry paper. The key here is to touch two or more colors together at their edges, not overlay or overpaint them.

- *Let the colors do the work of mixing their edges.* By bringing two colors into contact with one another, you get them to do the work. They will mix along the edge, making a third color, and will keep some parent color away from the edge as well.

- *Merging is not overpainting, glazing, or layering.* Add one color wash; quickly get a new color and place it next to and touching the first with the brush; or push it into the first and then let the two colors interact on their own. The amount of interaction is directly related to the amount of water in each wash.

Characteristics of merging or mingling methods include a color variation that contains the two parent colors and a third new color, soft edges within the wash or along the merge.

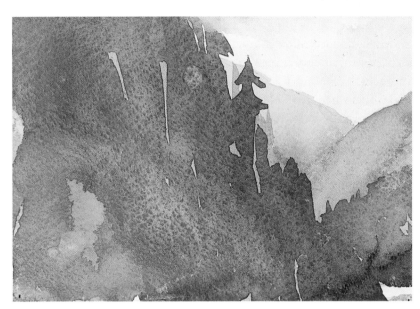

ROSS LAKE MERGING. This field sketch was quickly done using a wet on dry approach and quickly changing colors within the wash, placing the new colors into but not over the preceding color. This is a merging or mingling technique that touches paints together but does not overpaint.

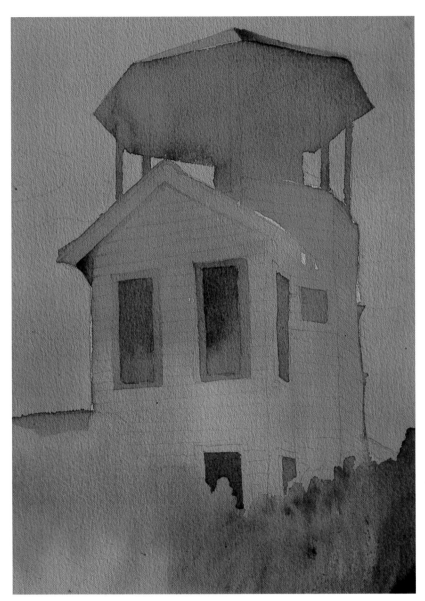

SEASIDE. In this multi-color wash, the sky wash was laid first and allowed to dry. The house shape was washed from top to bottom in one continuous wash. As the wash progressed downward, colors were changed but the basic wash motion and application remained the same.

Glazing. Glazing is a process of painting images with layers of washes. Each transparent layer is added to a dry paper or dry previous wash. As a layering process, remember that colors layered over others create new colors. Placing a blue layer over a yellow produces a green; add a red and you get a colored gray; add a green to a red and a colored gray occurs, and so on. Layering three different primaries (red, yellow, and blue) produces a colored gray. Glazing layers are usually delicate, light, half-tone paints. Each layer is allowed to dry before applying the next layer. A common approach to glazing is to mix each layer so that, when applied, there is just the hint of color. This allows multiple layers to be applied without losing transparency and avoids becoming opaque. The amount of pigment can be adjusted for mood, atmosphere, and darkness.

Negative glazing produces lighter shapes by painting around them. Or, painting over the background makes the primary shape lighter. Positive glazing produces darker shapes by painting over the primary shape, leaving a lighter background.

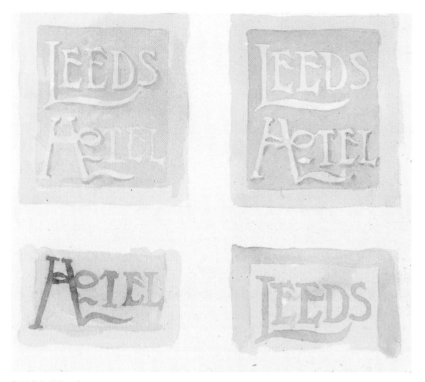

LEEDS HOTEL. Yellow, red, and blue are sequentially overlaid on all or portions of the composition. Play with creating color through the overlay rather than by mixing color on the palette.

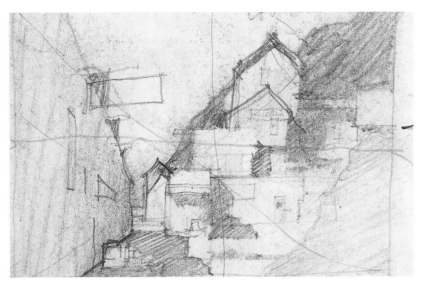

HOPKINS VALUE SKETCH. A number of small value sketches explored the placement of value patterns.

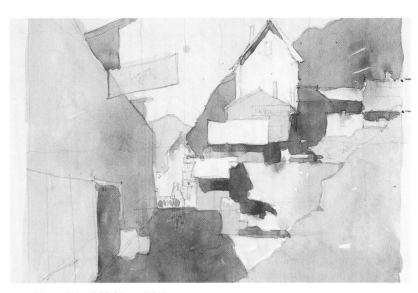

HOPKINS ONE-COLOR STUDY. One color permits a value test using paint, without the confusion of numerous colors. This intermediate step helps the painter explore washes and edge conditions without the burden of temperature, harmony, and dominance.

Strategies of Application

Painting Studies. As in any design process, a progressive evolution of studies is essential to successfully completing a final painting. These studies include:

- Composition sketches (compositional structure, movement, center of interest, maximum of twelve shapes)

- Pencil or pen value sketches (experimenting with value patterns)

- One-color value sketches (identifying dark values as organizing shapes rather than outlines or random blotches)

- Mid-size color sketch for temperature, intensity, and value (warm or cool dominance, intense or muted, colored darks, complementary colors)

- Half-size or larger color study (integrating composition, value, temperature, dominance, movement, color, balance, edges)

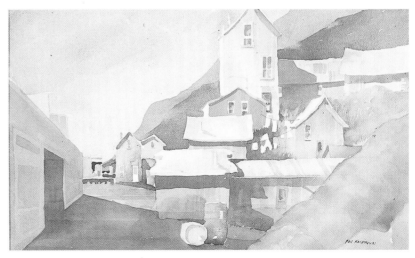

HOPKINS ALLEY. The color study experiments with temperature (cooler colors in the distance, warmer colors in the foreground), local color, and color dominance.

Each study is a learning and testing process, advancing the design of the final painting. A general rule is to finish each study no matter how "bad" you think it is. Finishing it requires you to work through and deal with problems, with success or not. You learn by doing. Remember that in watercolor, the process of painting is usually from light values to dark. The strong shaping darker values do not occur until late in the study. It is important not to give up during the middle and less-defined stage, which some watercolorists refer to as the "ugly" stage. Many paintings do not emerge or mature until the final stages.

Painting from Light to Dark. Watercolors are either transparent or translucent (as in opaque pigments, which are not discussed in this book). A light *transparent* watercolor can not cover a darker color as a result. So a basic strategy of application is to work from light to dark, where dark will cover light but not the reverse. Many painters use two to five layers of application, increasing the value or darkness with each layer. I strongly recommend that opaque white not be used during the learning process as it can become a crutch and may interfere with the intentional use of the white paper as white. To use the white paper as the color white, the painter must plan ahead to determine which white shapes are to be saved from paint. A common sequence is:

1. Light values and temperature in first application

2. Mid values, shadow shapes, and some detail in second and/or third application

3. Dark values as organizing shapes in third or fourth application

4. Detailed highlights, usually as darks, in last application

Dark values can be painted early in the sequence, with experience. Establishing a clear, strong dark pattern in early stages can provide a "maximum not to be exceeded." Once the darkest value is fixed, the painter goes back to the lightest and works through the middle values.

The light to dark process is a proven convention and is recommended for beginning painters.

Painting from Top to Bottom. Painting from the top of the paper to the bottom in successive layers of light to dark, with the top of the board tilted up from 5 to 30 degrees, enlists the aid of gravity. It keeps the paint beaded at the lowest edge of the washes. It also helps in the planning of edge conditions, because it requires the painter to decide how each wash is to end and transition into the next shape or wash.

Painting Piece by Piece. Painters who use predominantly hard edges use the mosaic or piece by piece strategy. Each shape is painted and completed before moving on to the next shape, with little or no edge transition. This produces a mosaic or picture puzzle-like effect and can result in edge overlaps. Key shapes can be masked out and painted around until the very end.

This process has certain pitfalls:

- The predominant and multiple hard edges can be distracting to the painting in the same way the puzzle piece edges are to the image of the puzzle.

- Painting a shape surrounded by hard-edged shapes can result in overlapped edges because it is difficult to align each wash next to a previous dry wash without overlapping.

Painting in Layers or Overpainting. Most painting methods employ overpainting or layers, where one layer is painted over another, usually dry, layer. When a wet wash is painted over, the entire wet shape must be included or a blossom can occur. Muddy effects can also result.

For example, glazing is a layered process. As a guide, limit the layers of paint to three or four. More than four layers can inadvertently mix all primaries plus secondary colors, creating dull or muddy grays. The restrained use of overpainting can produce luminous transparent colors.

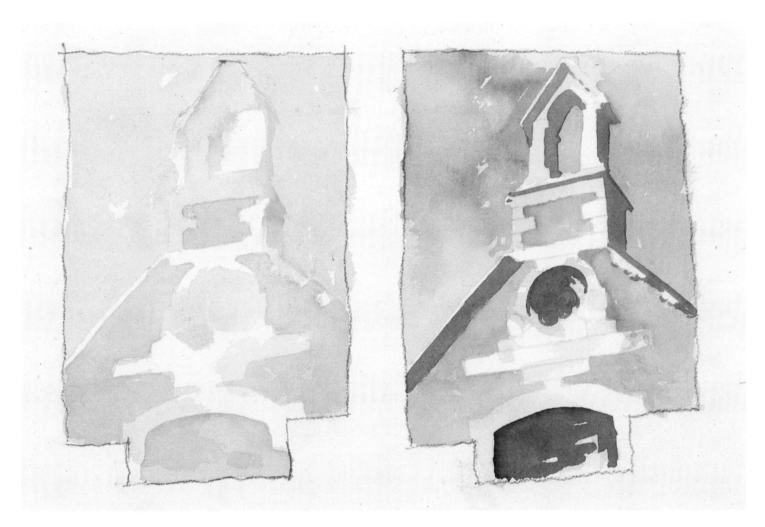

DARK OVER LIGHT. This diagram consists of two applications of washes: the first one with light values to set temperature (left) and the second as an overpainting of darker values to shape the building façade (right). If a light color is to be covered with a dark, the light wash can stray over the boundaries. The second darker blue sky wash seen on the right covers building washes that spilled over into the sky shape in the application on the left. *Dark covers light.*

 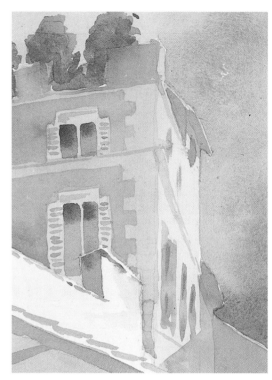

LEAVING THE CAMPO. The pen outline represents the larger aggregate of smaller shapes. This larger shape can be initially drawn in with pencil. At this stage, most details are left out. After this larger shape(s) is painted, using merging and mingling, additional details are added.

Twelve Parts to a Whole. Too many shapes can complicate a composition. They also can fragment the painting with small mosaic-like pieces. A hillside with 200 trees does not mean the painting has 200 tree shapes. A useful guide is to limit the total number of shapes in the composition to twelve. For example, four building shapes can be combined into three plus one (*Leaving the Campo*). Two hundred trees can be combined into three or four shapes based on differences in value patterns and color, still representing lots of trees (*Heading to Bella Bella*); and thousands of tree shapes can be subtly represented in three shapes (*Ross Lake Citadel*). Merging and mingling techniques can add variety within one overall shape that contains many smaller shapes.

This applies to sketching and studies as well as final paintings. Limiting the shapes to twelve requires the painter to filter out unnecessary detail. Near the end of the process, detail can be brought back into the

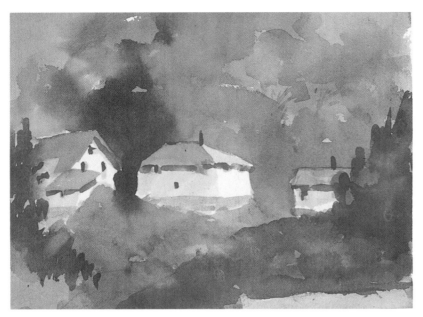

HEADING TO BELLA BELLA. This sketch was initially drawn in pencil as the Alaska ferry moved quickly past an island off the British Columbia coast. I then did a fast watercolor to capture the overall feeling of the place while it was still in view. Merging techniques help represent many tree shapes densely packed together without painting each one. This is the wet on dry method.

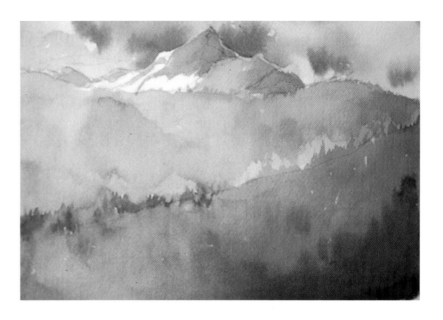

ROSS LAKE CITADEL. Merging techniques coupled with interlocking edge treatment where the forested area meets the sky shape help create a sense of a heavily treed slope without painting individual trees.

composition by adding darker positive or lighter negative shapes within each of the initial applications. These layers can *carve out* or separate additional positive and negative shapes from the previous washes. Remember: adding darker shapes around a shape lightens it in relation to the background. Painting the shape directly with a color darker than the surrounding shapes darkens it. Although this sounds simple, it can initially confuse beginners.

Painting two hundred trees as one wash using merging, color changes, and subtle value differences in one application adds harmony and unity to the entire shape. Subsequent washes can add shapes and value over a harmonious underlayment.

Strokes

Handling the Brush. I often find beginning painters hesitant to ask a basic and important question, for fear it is too simple: How do I hold the brush? Good question. The brush is your connection between the mental image and its physical evolution on the paper. It adds characteristics based on its materials, its quality, and how it is held and manipulated. While you can hold it any way you want, here are some guidelines that may overcome some basic frustrations:

- Hold the brush as lightly as you can, avoiding pressure on the tip. If you are holding it down close to the ferrule, move up the handle to a third or half of the length.

- Let the brush and *charge* do the work for you. If the brush is too dry, it can drag, bending the tip from too much pressure. This doesn't hurt the brush but can generate unnecessary marks in the wash. The wetter it is, and the looser or more gently it is held, the more the brush flows or skims over the paper. If you are squeezing the brush, relax your grip (and your concentration!). Pushing down on the brush tip, bending it over, can produce an exaggerated overlap (and line) in your wash.

- There are many occasions where forceful, pressured handling of the brush is desired. I recommend a gentle "feel" or pressure for all of your initial wash practice because it requires you to experiment with the water pigment charge in the brush.

- Never stand brushes up on their tips in the water containers or elsewhere, as this can bend and damage the tips. Lay them down on the table or stand them up in a container with the tips up.

- Store brushes in a container that breathes, i.e., cloth or a perforated holder, so that mold does not form.

- *What* brush you use and *how* you use it depends on the width of the wash. For shapes ranging from a few inches to a foot in width, a large round (nos. 12 or 14) and a 1-inch flat are suitable. For wider shapes, a 1½- or 2-inch flat wash brush holds more charge. There is no set rule; test how far you can go with a super charged brush. To measure each brush's capacity, keep working the wet edge and work quickly so that the edge does not dry. I urge students to avoid small brushes (under a no. 8). They do not cover large areas and do not carry large charges, resulting in slow, plodding work. Use them for detail at the end of a painting.

Types of Strokes

- *Skiing Downhill.* Regardless of the type of brush being used, this term refers to the basic wash strokes it takes to move the brush horizontally back and forth across the paper, slightly overlapping the previous horizontal stroke. Don't lift the brush until the wash starts to run out. At each end of the horizontal stroke, keep the brush on the paper; turn and head back the other way, just like skiing downhill (for a novice like me). Try to establish enough of a pool or bead of wash at the bottom of each horizontal band so that the next stroke can use the bead and keep it moving downward. This is why the top of the paper is elevated from 5 to 30 degrees (or more), enlisting the aid of gravity. Start with 5 to 10 degrees and increase it as you gain proficiency in washes. Keeping the paper flat can result in pooling and subsequent blossoms or back washes as the newer wash moves in all directions (and back into a damp but drier previous wash) instead of down.

- *Smooshing.* This is my term for pushing the brush around the paper in a more "random" or nonlinear stroke. However, three principles remain: always work the downward edge, keeping it wet; work it *downward,* and, never go back into the wet wash. If I work fast and wet enough, the wash dries with few if any blemishes. If variations appear in the wash, do not go back into it to "fix it." In most cases, the wash will blend and soften the variations as it dries into a nice even wash. This can produce subtle variations in the wash without blossoms or back washes, which can be effective for clouds and other soft, billowy shapes.

- *Play with the brush.* Dragging, pushing, dabbling, and slapping the brush are all acceptable. Experiment. If the brush is a decent quality, it can take a lot of rough handling and may reward you with interesting effects.

Water and Pigment Proportions: The 30% Rule. This refers to the amount of water in the brush. The pigment-to-water ratio directly affects the color intensity, opaqueness, and value for each color. A lot of water with a little pigment produces a blush or halftone, a lighter wash. Little water and a lot of pigment produce a more opaque, darker, more intense, and drier wash. Practicing with various amounts is critical to understanding how much is enough. Wet washes as seen in the mixing tray of the palette normally dry 30% lighter on the paper. The more water in the ratio, the lighter the final affect. It is helpful to test washes on scrap watercolor paper before application. Tape a strip to your board or use an old sketchbook.

To control the amount of water charge in the brush, have accessible an intermediary absorbent material such as a damp sponge, wadded toilet paper, or toweling to absorb excess water from the brush before it goes to the paper, or simply shake or knock excess water from the brush onto the side of the mixing tray. Visualize your palette and water container next to you, then the sponge, followed by the painting. Use a damp-dry sponge, not one that is bone dry. If the sponge is damp dry, a wetter brush will have its water pulled into the less wet sponge. This adjusts the amount of water or water pigment in the brush before it goes to the paper. Caution: do not dry up the brush charge with this method. Some beginners can have *pigment* wells filled with water, thereby diluting and wasting valuable pigment. Keep the water in the *mixing* tray or well. When mixing water and pigment, discharge excess water into the sponge or toilet tissue before using the brush to bring pigment from the pigment well to the mixing tray. The dampness in the brush is enough to dab up pigment without leaving water in the well. An alternate method is to touch the charged brush to a scrap piece of watercolor paper to test for saturation and discharge a tiny bit of moisture.

Washes

Flat Washes. Flat washes are even, and consistent in value, intensity, and dilution. They strive to be unvarying (or *flat*). They are particularly useful for architectural planes that have an even light, or elevation and section studies with straight-on light effects. There are two ways to achieve evenly colored washes: directly and with pre-mixed washes.

The Direct Method

· Work quickly.

· Mix a small pool (not over-diluted!) of wash in the mixing tray or well.

· Apply the charged brush to the paper, working back and forth.

· Return to the palette for an additional charge, adding more water and pigment in the mixing well—at times even changing pigments.

· This permits the addition of other color variations in the on-going wash.

The method requires a faster application and some experience at how much water and pigment are needed to achieve a consistent mixture, and may result in washes with slight variations.

Pre-mixing Method

· Pre-mix the wash in a small saucer or container.

· Test for dilution on a scrap paper to make sure wash is not too weak; this eliminates any variation in wash.

· Avoid large pools of wash because, although they look deep and colorful, they may dry much lighter than intended.

· On large sky washes, building planes, and large shapes in plan, pre-mixing helps attain uniform flat washes.

Washes with Sponges. A damp sponge dipped into a pre-mixed wash can cover a large area with smooth, even results. Whether the wash is applied on dry or wet paper, a back and forth motion with a slight overlap is effective for sky and other background washes and glazes. The sponge needs to be damp before dipping into the wash mix. Soak it in clear water and wring damp dry. Unless the effect is intentional, it is not advisable to mix pigment and water with a sponge, as pieces of pure unmixed pigment can get lodged into the pores and streak the wash. Try the sponge on any large shape such as a sky or ground plane.

Graded Washes. Graded washes are possible with one color, simply by grading the value from light to dark, and with multiple colors by changing both color and value. One color graded from a dark to a light value and light to dark are basic gradations. The following are types of graded washes.

· *One Color with Graded Value.* Begin with a fully charged water pigment mix that is the darkest grade desired (test on scrap paper). Work the wash back and forth down the shape. As it begins to run out or when the next increment of change is desired, go immediately to the palette and add a bit less pigment to the same amount of water and continue the wash. Keep decreasing the pigment amount until there is essentially little if any in the water. The wash will be graded from dark to light. Reverse the procedure for light to dark: incrementally add pigment to the water charge. This needs to be applied faster on dry paper than on wet so that the edge does not set up and so blossoms and backwashes do not occur. Go to the mixing well, quickly add new pigment to the brush, work it into water in the well (do not over-dilute), and go back to the wash.

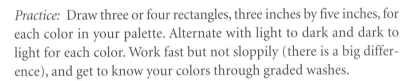

FLAT WASHES. Consistent color and value.

GRADED WASHES. Add more water to lighten or more pigment to darken.

Practice: Draw three or four rectangles, three inches by five inches, for each color in your palette. Alternate with light to dark and dark to light for each color. Work fast but not sloppily (there is a big difference), and get to know your colors through graded washes.

If backwashes or blossoms occur, you are waiting too long between applications, permitting the previous wash to dry too much. If streaks occur, you may be pushing down on the brush with too much pressure, forcing the brush tip to become too wide, and forcing it too far up into the previous wash.

- *Light to Dark and Back to Light.* Using the graded wash, simply reverse the process within the same shape for a light to dark and back to light wash.

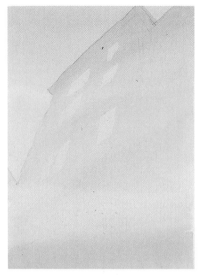 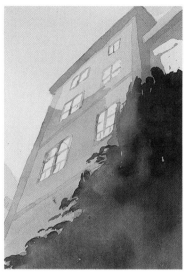

PRAGUE HOTEL. A two-color wash from blue to yellow adds lighting effects to the side of this building façade. It is a graded wash that simply changes pigment.

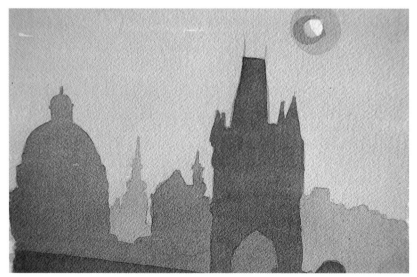

BRIDGETOWER. One color is painted in four layers of the same value. With the white dot, there are actually five values represented. Layer one covers all shapes except the white (paper) dot; shape two covers all shapes in layers two through four; and so on. Diagram, *9″ × 9″*.

- *Two-Color Graded Wash.* Begin as in a one-color graded wash. When the first color gradation becomes the desired lighter value, with very little pigment, begin adding a touch of the second color, setting aside the first. The first and second colors in the light range will blend by themselves, so don't force them. Essentially, the second color can be added at any time in the dark to light sequence. The transition is smoother and less dramatic in the lighter range (*Prague Hotel*).

- *Overlapped One Color.* Overlapping or overpainting with one color increases luminosity (an added brightness caused by the light reflecting back from the paper through layers of transparent washes).

> *Key principle:* Allow the previous application to dry thoroughly before adding the next. Overlapping one color with multiple layers changes the density and value of the wash, making it richer and obviously darker.

- *Overlapped Multi-color.* The same techniques apply for multiple colors: the previous wash must be dry before applying the second; wet on dry or wet on wet application is effective. Color mixing is the difference. Here, color is mixed on the paper through the layers of paint. Add a red on top of a (dry) yellow and orange is produced. Blue on yellow becomes green; green on yellow becomes another green; purple on yellow becomes a colored gray (all three primaries are present). This is particularly important to understand when applying more than two layers on any painting: layered colors produce other colors. If layers include at least three primaries plus secondaries, neutral grays or muddy colors can result. Be aware of the color effects of overlapping.

Merged Washes. Glazing and merging comprise a good deal of technique for many watercolorists. I use merging extensively, especially as a first layer. Merging consists of two or more colors placed next to one another so that their edges meet and mix. It is not overpainting. Place one color next to another; with the brush tip, break the edge of the second color with the first, avoiding any overpainting (completely painting over the first) (*Prague National Theater*).

Merging is effective for adding color and temperature variety in a wash. Use it as the first foundation layer or for building materials with varietal surface blemishes.

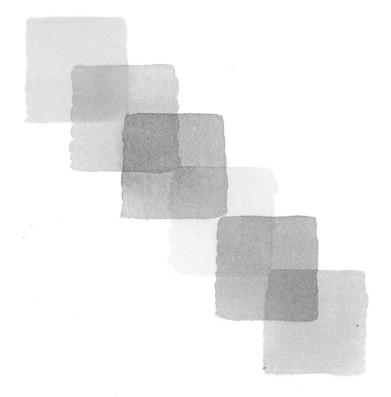

OVERLAPPED MULTI-COLOR.

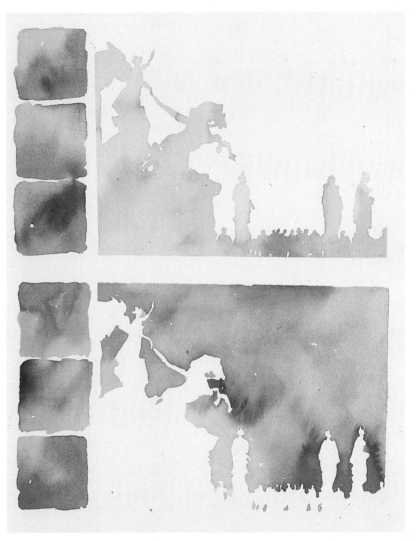

PRAGUE NATIONAL THEATER. Part of this exercise deals with applying paint in and around complex shapes using wet on dry methods. No masking was used in order to force a quicker pace in applying merges and minglings. The diagrams represent one layer of paint, normally followed by one to two more layers. In the application, always return to the *oldest* edges, keeping them wet with new merges. Don't stray too far away from the last *drying* edges. Always continue the same color on the opposite side of a shape.

Blossoms. Blossoms are flower-shaped backwashes. A backwash occurs when one part of a wash is much drier (but still damp) than the more recently applied wetter wash. As an example, wet a dry sponge. Wring out the excess water, making it damp dry. Charge your brush with lots of water, supercharged to the point that it has a bead of water hanging from the tip. Now touch that tip to the damp-dry sponge. The sponge will quickly absorb the moisture on the brush because the sponge is wet but less saturated than the brush. This is what happens on your paper when the previously applied wash is still wet but has had a chance to dry. Any new, wetter wash that touches it will be drawn or sponged into the previous wash. Because the saturation levels are significantly different, the washes do not merge; instead, they create a semi-hard edge that mimics the pull of wet into damp dry. Sound confusing? Try some experiments now and save washes later.

Key principle: Work fast when going from your wash on the paper to mix additional wash on your palette or just to recharge your brush with pre-mixed wash. If the temperature is hot and dry, work even faster (wet on wet provides more time in the drying process and for this reason is used more in hot and dry climates).

Color: Triads, Palettes, and Color Harmony

This section concentrates on triads and palettes that have proven effective in color harmony. It is predicated on the key principle that colors that are mixed from a basic triad have a built-in color harmony. Three primary triads are used by themselves and in combinations, depending on atmosphere and other desired effects. Avoid buying pre-mixed colors that can be mixed from a basic triad. Here are four triads or basic palettes that are useful for design work, along with their most important characteristics.

Transparent Delicate Triad

Rose Madder Genuine or Rose Madder

Aureolin Yellow

Cobalt Blue (slightly opaque)

Viridian Green (a transparent green for mixing)

- Transparent, light passes easily through to the paper and back to the viewer
- Nonstaining, may be removed before and after drying with relative ease
- Mix well with other paints, not dominant
- Lighter in value and not suitable for making dark colors

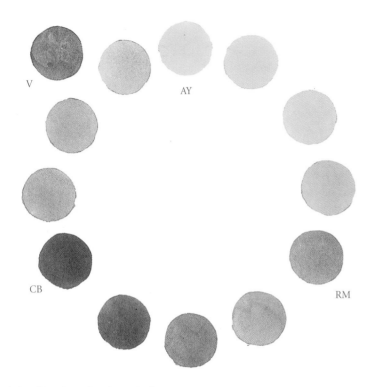

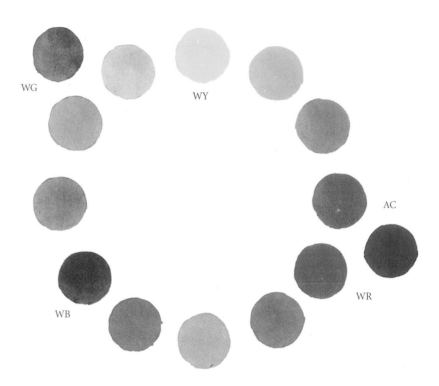

TRANSPARENT DELICATE TRIAD. Nonstaining lighter and delicate transparent colors.

TRANSPARENT INTENSE TRIAD. Staining and intense transparent colors.

Transparent Intense Triad

Alizarin Crimson and/or Winsor Red

Winsor Yellow

Winsor or Pthalo Blue

Winsor or Pthalo Green (an intense mixing green, especially for darks)

- Transparent
- Bright, full of intensity, high key
- Stain the paper fibers and cannot be removed, especially after drying
- Mix well with many paints, can be dominant (especially Alizarin Crimson, Winsor Green)
- Darker in value and the key to making lustrous darks when mixed with other triads

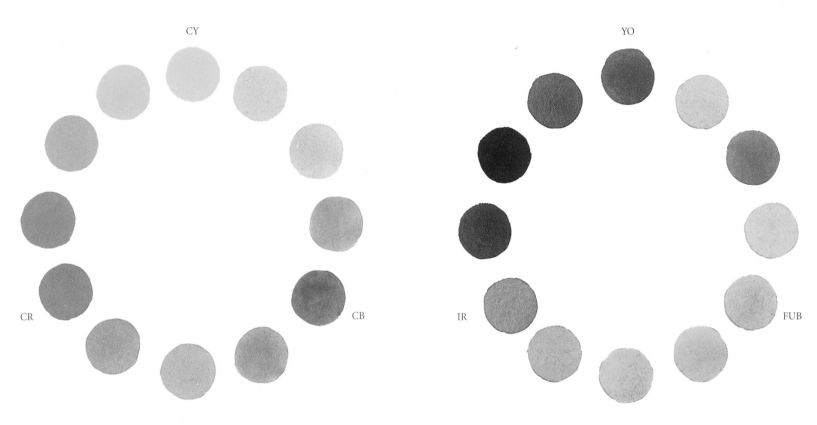

SEMI-OPAQUE TRIAD. Colors are grittier, chalkier, and less transparent.

VERY OPAQUE TRIAD. Dense and gritty colors.

Semi-Opaque Triad

Cadmium Yellow

Cadmium Red

Cerulean Blue

Cadmium Orange (a rich mixing color)

- Less transparent to semi-opaque (due to more particle matter in pigment)
- Lower key, muted
- Some staining properties
- Selective mixing only, can produce neutral or muddy grays
- Murky, grainy, muted

Very Opaque Triad

Light and Indian Reds

French Ultramarine Blue

Yellow Ochre

- Opaque, little light reflection
- Dense
- Very muted, with black

Combinations. Your individual palette may include two or more of the basic triads or one triad supported by colors from other triads. Glaziers and painters who want to achieve bright effects use the transparent and intense triads together. Rich darks are produced from transparent colors mixed with intense greens and blues. Muted atmospheric effects are produced with opaque palettes and some transparent colors. See the discussion on greens, grays, and darks.

TEMPERATURE. Temperature regulates *depth* as well as *mood* in painting. Depicting depth on a two-dimensional plane can be accomplished with value (lighter in the background) and/or with temperature. Objects in the distance have their color affected by particles in the air (moisture, dust, etc.). Consequently, the farther away an object, the more the light is dispersed into the bluer ranges.

Key principle: warmer colors bring shapes closer to the viewer; cooler shapes push them in the distance.

Temperature is relative to the context: in a green-blue painting, with a generally cool temperature and subdued or peaceful mood, the green can be warm relative to the blue. The green can be located in foreground and midground shapes (*Ross Lake Sketch*). A purple in a warm painting with reds, yellows, and oranges is the cooler color. In another painting, it may be the warmer (with blues and cool greens). When dealing with objects with little or no depth of background, temperature can be treated with half-tones and accents.

A temperature wheel suggested by Jeanne Dobie (1986) identifies primaries that have either warm or cool tendencies based on their pigment compositions. A Winsor Blue is cooler than a French Ultramarine Blue, for example, because the FUB contains red and the WB does not—a slight but important variation when mixing other colors such as greens.

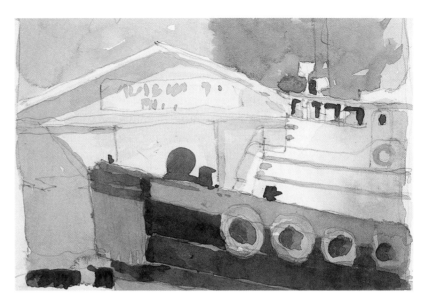

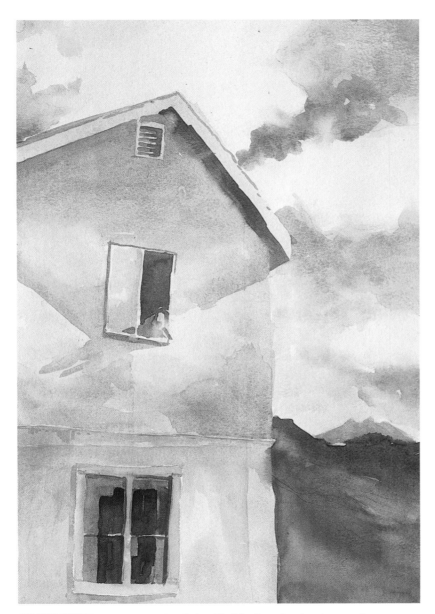

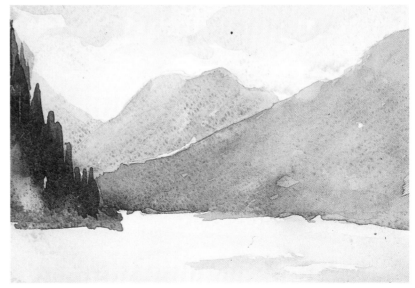

TEMPERATURE. Temperature is relative. The blue is cooler than its complement orange. The Rose Madder is cooler than the Winsor Red. A painting can be dominantly warm but have cool–warm distance relationships. The blue building in the fore-ground has been warmed with a touch of red. The blue to orange complement creates a pleasant contrast between interior and exterior. In the *Ross Lake Sketch* (above, bottom), blues with purples are warm but cooler than the foreground green trees.

MIXING GREENS. Greens can be warm or cool, gray or pure. They dominate most landscapes. Care in mixing is important to avoid overly vibrant or garish greens or dull greens. Dull greens, as opposed to muted or subdued greens, result from using primaries that contain reds, the complement of green and a key component of green-gray (all three primaries). For example, mixing Cadmium Yellow (contains some red) and French Ultramarine Blue (also contains red) will produce a duller or grayer green. Aureolin Yellow and Winsor Blue, both devoid of red, produce a vibrant green.

Greens in the landscape vary according to geographical region based on lighting conditions and type of vegetation. Observe carefully the greens at different times of day, and check with local artists, when preparing to paint a landscape of an area that is unfamiliar to you.

As an exercise, begin with the primaries of each major triad or palette, then decide for yourself the effects and vibrancy or dullness of each combination:

Mixture 1: Aureolin Yellow (AY) and Cobalt Blue (CB)

 Add a touch of Rose Madder (RM) but keep mixture in green-gray range

Mixture 2: Winsor Yellow and Winsor (WB) or Pthalo Blue

 Add a touch of Winsor Red (WR)

Mixture 3: Cadmium Yellow (CY) or Yellow Ochre (YO) and Cerulean Blue (CeB)

 Add a touch of Cadmium Red (CR) (Cadmium Red can muddy some mixtures, so also try Winsor or Intense Red, Rose Madder, or Alizarin Crimson)

Now begin with the tube greens of Viridian and Winsor Green:

Mixture 4: Viridian (VG) with a little Aureolin Yellow

 Same VG with more AY

 Same VG with even more AY

Mixture 5: VG with AY, then add RM

 Repeat with WR

 Repeat with CR

 Repeat with Alizarin Crimson (AZ)

 Repeat the same mixtures with Winsor Green.

These are rich and diverse greens from the transparent and intense palettes for the most part. Experiment with others, including the opaque colors.

COLORED GRAYS. Mixing all three primaries of a triad together produces gray. In near equal amounts, a neutral or battleship gray occurs. The objective is the opposite: *colored* grays that are not neutral. Colored grays form the backdrop of most paintings, adding harmony through their mixture of basic primaries and secondary.

Remember that *primaries* generally are colors that stand alone, cannot be mixed by two other colors—red, yellow, and blue. (In fact, some colors used as primaries such as Cadmium Yellow and others have slight additives of other primaries.)

Secondary colors result from two primaries: red and yellow make orange, yellow and blue make green, and blue and red make purple.

Tertiary colors result from one primary and one secondary, or three primaries: they are *colored grays*. The umbers and siennas are pre-mixed tertiary colors and are best used by themselves because they are already colored grays. Mix a gray with a gray and you get dull mud.

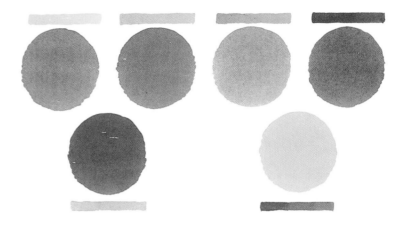

COLORED GRAYS. The colored stripe is the complement.

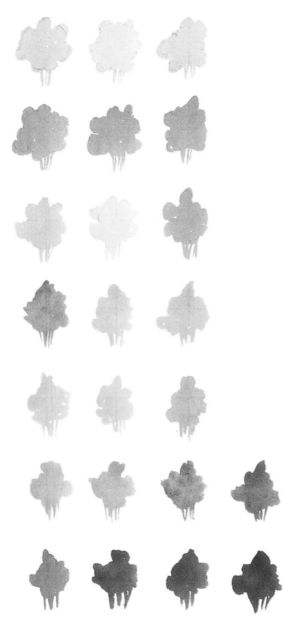

GREEN TREE CHART. Practice mixing greens with various combinations of yellows, blues, reds, and greens.

Complementary or opposite colors are functions of grays or are colors that produce grays. An easy way to remember them is with the triad: choose one color, red for example. What is left? Yellow and blue, which equal green. Green is the complement or opposite of red. Choose purple (red and blue). What is left of the triad? Yellow. The complement or opposite of purple is yellow. Choose blue. What is left? Red and yellow or orange. Orange is the complement of blue. The word complement is used intentionally. Placed next to one another, opposite colors (in a broad range of shades) complement or reinforce one another.

Now make some colored grays highlighted by the complement. For example, the complement of an orange gray (mixed with red, yellow, and blue but heavy on the red and yellow) is blue! Adding more or less water can further vary grays—less for darker grays and more for lighter grays.

Grays are effective when they are clearly warm or cool and colored. Keep the exercises on the wall or in a notebook as guides.

COLORED DARKS. Shadows are not black and neither are darks in watercolor. Like the grays, darks are given a dominant color through mixing. The staining colors (Winsor Green, Winsor or Pthalo Blue, Alizarin Crimson) play a major role in deepening the dark colors. By themselves they are too powerful. Without them, other colors do not have the strength to be dark enough.

Key principles for darks:

- Mix darks from pure pigments and not black. Avoid using black, as it dulls color mixtures.

- Darks need variations within their shapes. Avoid one large, dark pattern. Use merging or drop pure pigment into a dark wash to add that variation.

- Avoid overpainting darks once they are dry. Try to get the dark on the first wash.

- If a dark is too strong, add some additional mid-value to the shapes surrounding the dark to reduce its power.

- Applying a glaze of a staining color can revive darks that are dull.

- Make a light color brighter by placing its dark complement next to it, not over it.

Try these mixtures for colored darks:

Dark blues

Winsor Blue (WB) plus Indian Red (IR)

Winsor Blue plus Alizarin Crimson (AC)

Winsor Blue plus Cadmium Red (CR)

French Ultramarine Blue (FUB) with the same reds

Increasing the reds moves the dark blue into purple

Dark greens

Winsor Green (WG), Viridian Green (VG), with AC, CR, IR

Winsor Green, Winsor Blue, AC, CR, IR

Close to Black

Winsor Green plus Alizarin Crimson

Dark Reds

WR + WB

AC + IR

AC + WB

Dark Complements

When complementary colors are mixed together in equal amounts, they become neutral. If they are placed side by side in a dark to light relationship, they can be dramatic. Want to make a light color stand out, brighter? Place its *dark complement* next to it, not over it.

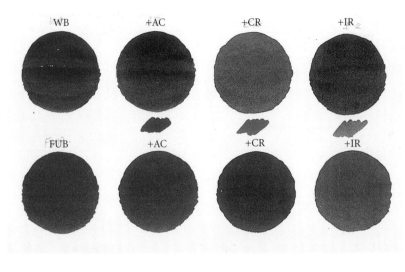

WB +AC +CR +IR

FUB +AC +CR +IR

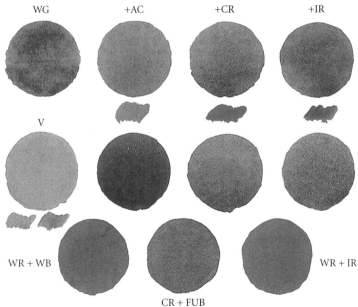

WG +AC +CR +IR

V

WR + WB WR + IR

CR + FUB

COLORED BLUES AND GREENS. Use the staining colors to deepen blues and greens.

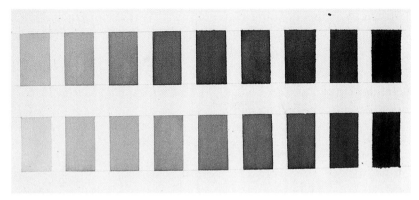

VALUE SCALE. Practice a nine-value scale with different colors. A five-value scale is often used in painting and illustration.

Value

The Structure of Visualization. Value is the relationship between light and dark, white and black. It is a contrast that draws the eye of the viewer to the point of difference between the value of one shape and that of another. Color gives a painting local identity, depth through temperature, and mood. Composition gives a painting its organization and shape structure. Value provides another layer of structure through the pattern of its dark shapes, patterns that are a part of the composition and not incidental to it.

Scales of Value. Scales of nine, five, and three increments are often used in graphic communication. A three scale works for concept and preliminary studies, a five scale for detailed and final work. A nine scale often accompanies a lot of detail and is less frequently used in design graphics.

As a helpful exercise, try a few scale diagrams using only one color. The scales are not unlike a segmented graded wash.

Value as Shapes in Patterns. Values are shapes in patterns, not lines or edges like outlines. Simple but important. Treat the value patterns as inherent parts of the composition.

Key principles to remember:

- Prepare 3 × 5 inch value sketches in pencil or pen before starting any color study. If the value sketch does not work as a part of the composition, do another. If it does not work, the painting will not.

- Select the white (paper) or lightest value shapes first. The eye will seek those out first. In watercolor, light colors do not cover dark. The white and light need planning as compositional elements, just as dark shapes do.

- Use the darks to support the lights, located in close proximity to the lights.

- Give each shape (remember the "twelve parts make a whole") a value; if it helps, use a numbering system similar to those in the examples. This is a "thinking guide," not paint by numbers.

- Make the darks as shapes, not details and accents that are distributed in an unrelated manner throughout the painting.

- Plan mid-tones carefully; use them as supporting instruments. Mid-tones help transition lights and darks.

- Don't be limited to the value pattern that is in the field, or in a photograph. Decide on a value pattern that best composes the view, even if you change the way the value was recorded in the field.

- Objects that recede often appear lighter in value as well as cooler in temperature.

- There is a hierarchy of value, pattern, and color, in that order. One is dominant. Value (light to dark contrast) is stronger than pattern (collection of shapes), and pattern is stronger than color (hue, temperature).

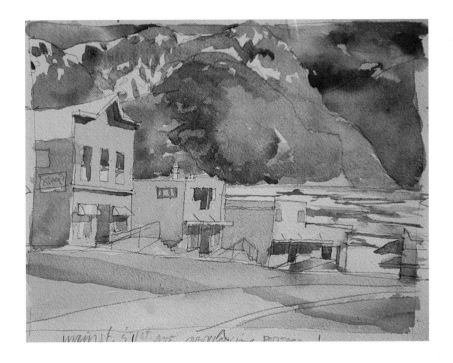

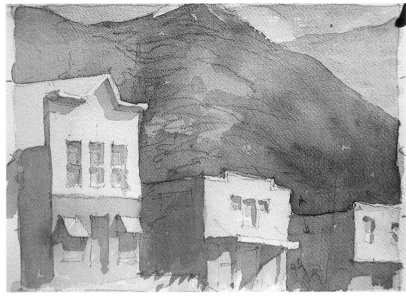

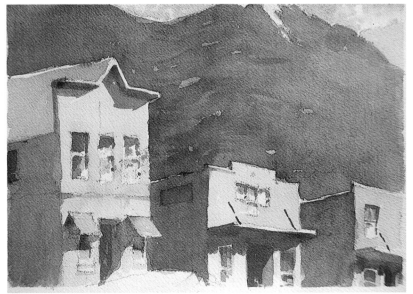

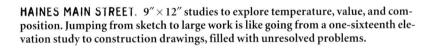

HAINES MAIN STREET. 9″ × 12″ studies to explore temperature, value, and composition. Jumping from sketch to large work is like going from a one-sixteenth elevation study to construction drawings, filled with unresolved problems.

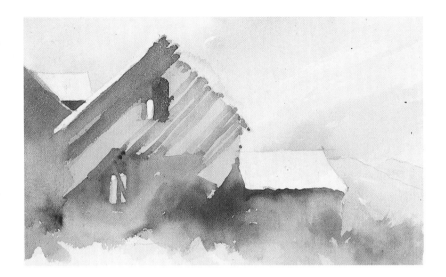

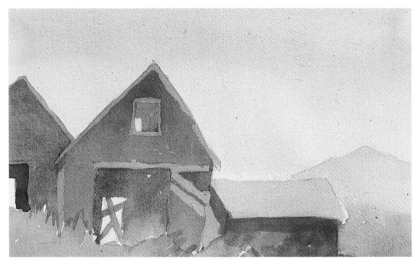

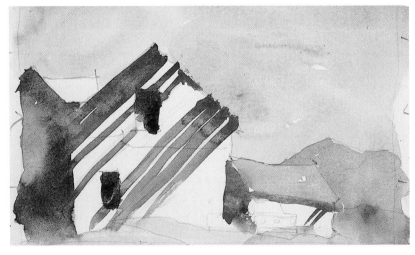

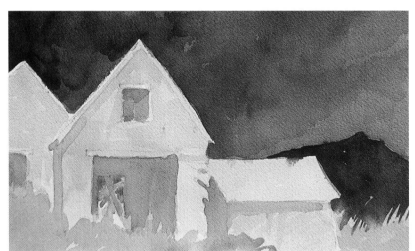

The Two Against One Method. William "Skip" Lawrence (1994) defines an approach using values that I find very helpful in planning value patterns, called "two against one." Essentially, the featured shape (actually a collection of shapes into one major shape) is always given any two of three basic values: light, middle, and dark. The remaining or supporting shapes have the remaining value. For example, out of three major shapes I select a building and its midground supporting shapes as the feature. Assign any two values to that featured shape, light and dark or dark and middle or middle and light, and the rest of the shapes are the remaining value. If you use three major shapes for concept studies,

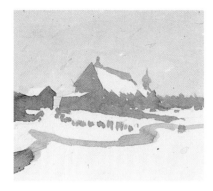
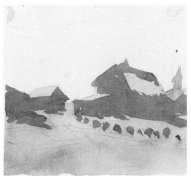
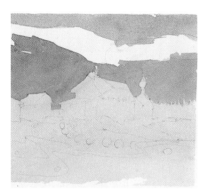
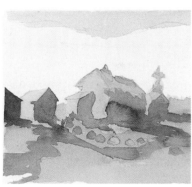
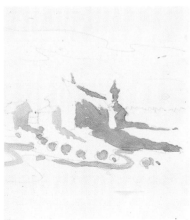

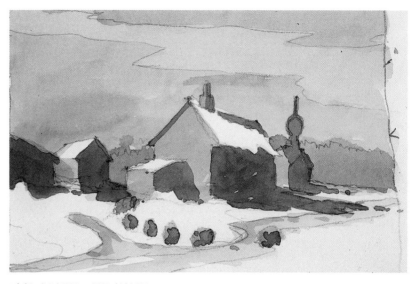

TWO AGAINST ONE VALUE. Experiment with William Lawrence's idea of a two against one value pattern by making a chart of small images. Then do a larger study (9 × 12) or comparison of two contrasting patterns. Limit color selections to avoid unnecessary complexity.

remember that they can be broken down into more shapes in later layers as detail is added. This approach can be expanded to the three against two method using five values, where the featured shapes get the *most variety of value.*

Try this exercise and keep it on your wall or in your workbook:

Do nine variations of the same scene (pencil, pen, or watercolor), working with a sketch divided into foreground, midground, and background. For the first part of the exercise, select the foreground as the focal subject and do three value variations of the subject using two values (light plus dark against middle, light plus middle against dark, and dark and middle against light). Use the remaining one value for the background and midground. Repeat the exercise for the midground and the background as focal areas. The results produce a range of mood and atmosphere.

The following are some examples of the two against one method:

Value Patterns	Mood or Atmosphere
Light and middle against dark	Effective for white shapes
	Traditional landscape sky
Dark and light against middle	Very dramatic (high contrast on featured shape)
	Objects in direct sunlight
Middle and dark against light	Landscape painting with sky as light
	Architectural clusters, urban design

Edges

End and Beginning. An edge is the end of one shape and the beginning of the next. Critically, they are relational devices or transitions that bind shapes into compositions. Methods of defining edges consist of melding or connecting groups of shapes into larger patterns.

Before and during the painting application, have a strategy for ending a wash before it begins. This requires anticipation and understanding of how the next wash begins. There are three kinds of basic edge conditions:

- Hard edges
- Soft edges
- Interlocking edges

Other variations include:

- Merged edges (a form of soft edge)
- Same value-different color edges (a form of soft and merged edge where only the color change marks the edge)
- Lost and found edges (combination of hard and soft edges)
- Contrasting edges

Hard Edges. Hard edges are abrupt, explicit, and specific borders or distinguishable perimeters of shapes. Common uses include backlighted subjects where light contrast is strong and a silhouette occurs. Object materials can determine hard edges (buildings more than landscapes; individual objects more than objects within a group or cluster). All hard edges in a painting can create a mosaic or picture puzzle effect, making the communication fragmented. Hard edges represent adjacency rather than mingling. They are produced by letting one wash dry next to or over (a lighter) wash without breaking or dissolving the edge, or without merging the first wash into a second. Paint any shape and let it dry. Its edge will be crisp and defined. The key is to know when this is preferred or not. If not, the edge needs to be softened or otherwise treated before it dries.

downtown
yakima

HARD EDGES. Hard edges are crisp and continuous "lines" where two shapes meet and become adjacent. They can also be broken and hard, a form of hard interlocking edge. In *Yakima Plan* (left and above), hard edges are used exclusively to represent building footprints.

Soft Edges. Fading out the edge produces soft edges as if it were fog. Soft edges can also be formed by dissolving or dispersing the edge into smaller parts.

In *wet on dry* painting, since the paper at the shape edge is dry, the edge is softened by:

- wetting the edge area with clear water, merging the edge from color to clear, or

- lifting out the edge by quickly rinsing the brush in clear water, removing most of the water, and wiping the brush back into the wet wash. This breaks the hard edge line and causes it to dry softly. This must be done quickly, otherwise a blossom can occur.

In *wet on wet* painting, the paper is wet or damp and the end of a wash will (slowly or quickly, depending on amount of water in paper) spread and soften after the brush is lifted. There is more control with this method but all of the wash edges are soft.

Interlocking Edges. Interlocking edges are made by joining two edges in a manner similar to clasping together two hands by interlocking the fingers. A sawtooth edge is an interlocking edge, where two shapes penetrate one another, equally or not. One may be the positive or dramatic shape (the saw blade) and the other is the background shape. Interlocking edges usually have hard edges but are integrated or made interlocking by the *design of the shape edge* (sawtooth, jagged, undulating, radial bursts, etc.). For additional complexity, they can be hard and soft or lost and found.

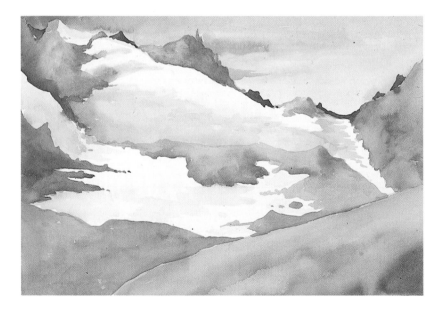

SOFT EDGES. In *Seattle-Scape,* the foreground shapes, trees, and interior building forms are soft with fuzzy edges. This is effective with wet on wet techniques and wet on dry with *lifting out* techniques to break hard edges. Break a hard edge by going into its wet application with a damp brush to pick up or lift out some of the pigment. Work fast.

INTERLOCKING EDGES. The edge of the rocks in the midground consists of jagged or sawtooth-like shapes that interlock with the background mountain shape. These can be a combination of hard and soft or "lost and found."

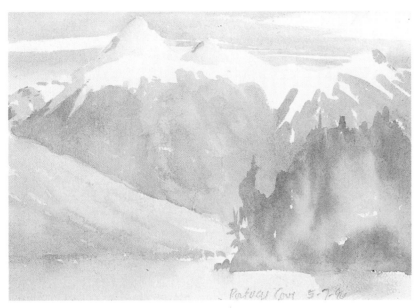

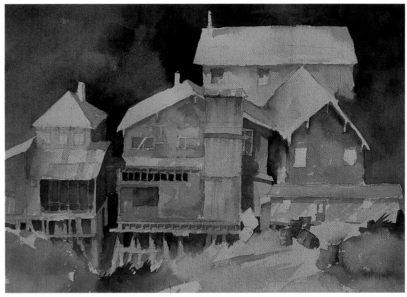

MERGED EDGES. Merged edges are used on many examples in the book. The trees in this sketch are a variety of individual tree value shapes merged together with soft edges, not overpainted.

SAME VALUE EDGE. In *Wrangell Native Village*, the dark background shape is divided into a number of different shapes separated only by a change in color, not value. Look at the right side background where a darker reddish orange (brush) changes to darker greens (trees).

Merged Edges. Merged edges occur when two or more colors or different values of the same color are put in touch with one another so they can mix. They are soft and fuzzy edges. Three problems are common for beginners: one, overpainting the previous color rather than simply touching or joining its edge; two, waiting too long before applying the second wash, which results in the third problem—blossoms form as the first wash draws too much water from the second. Merged edges are effective in painting multiple shapes, such as trees, without painting individual shapes, and they are less distracting because the multitude of hard edges are eliminated.

Same Value-Different Color Edges. When one shape is blended into another where both have the same value, edges can be distinguished by changes in color through the merge. It is a subtle transition device to integrate feature shapes with background shapes.

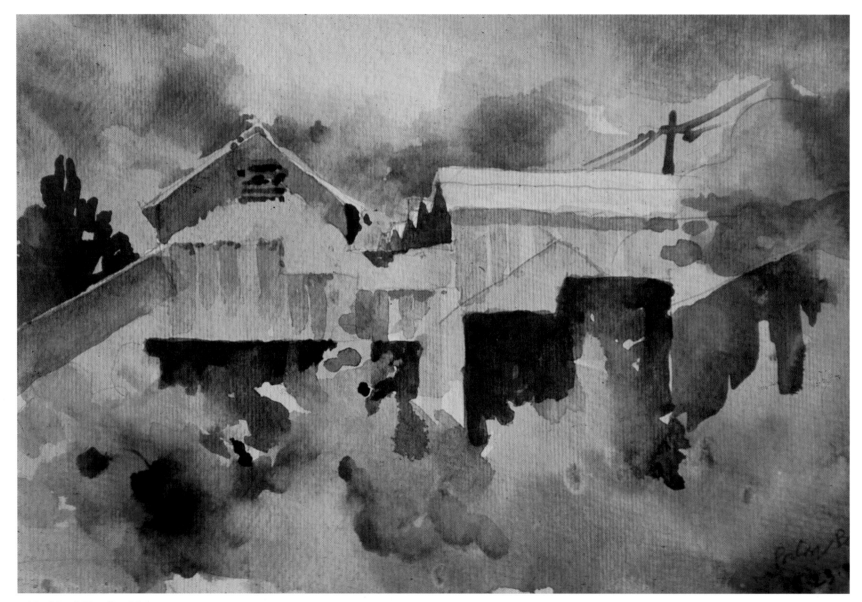

PORTAGE BAY SKETCH. In this waterfront shed sketch, edges in the sky and foreground landscape are both hard and soft, "lost and found," and hard and broken. These varieties in edge conditions help to connect shapes and increase the viewer's interest in the overall composition.

Lost and Found Edges. Lost and found edges consist of hard and soft edge treatment of one edge condition. The purpose is to create variety in the edge and connect or integrate parts of the two shapes while retaining a hard edge appearance. This creates connection with separation. Charles Reid (1991) is very accomplished at losing and finding edges by implying that the entire boundary is there when it is not. He uses the lost parts of the edge to connect adjacent primary, secondary, and background shapes. A variation of lost and found is the broken or dispersed edge, as in *Portage Bay Sketch.*

Contrasting Edges. Beginning painters tend to paint with a majority of hard edges. More experienced painters work hard at losing edges, creating variety. Using contrast, edges can be defined by light against dark, dark against light, temperature differences (cool to warm), and primary color to complement.

USES AND APPLICATIONS

A Design Teaching Method

Watercolor painting deals with shapes and edges in composition. Its complexity requires a certain level of competence at separate techniques that are then combined or integrated into a composition. Working through this process is an excellent way to teach the principles and elements of design.

Design Tool. Watercolor can be a surprisingly fast study method in design. It is often overlooked because of its complexity and array of equipment. As a design tool, it requires an attention and discipline to process that can increase observation methods and information retention. The following are some categories for which watercolor may be suitable as a design tool.

- field surveys
- context descriptions
- design studies
- design diagrams
- design illustrations (client presentations, bank packages, etc.)

Field surveys are performed with sketches and in some cases transferred to storyboards (a presentation or communication tool illustrated later in the chapter). These can capture multiple images of a given site or region and are highly effective in public and client meetings and presentations. Painting in the field, for example, requires the observer to pay attention to the shape and pattern of landforms and buildings—all elements of composition. A critical eye is necessary to view and assess light, color, and value patterns that are normally overlooked or delegated to the camera. The observer records more information over more conventional field note techniques.

Context descriptions can range from regional characteristics (mountains, rivers, watersheds, etc.) to district, project area, and site-scale vignettes that capture the personality, scale, culture, and functions of an area. Examples are discussed later in this chapter.

Design studies include plan, perspective, and paraline images that assist in developing design solutions. They also are beneficial in public and client communications.

Design diagrams range from doodles to space program images. I find that the watercolor doodles help me set aside the sometimes meticulous focus of pen and ink line work, replacing line work with color-shape compositions.

Design illustrations are a traditional and conventional use of watercolor in design. Final illustrations are used for client presentations, financing and marketing exhibits where an enhanced and accurate depiction of a completed project is important. This book focuses on concept and design development rather than final illustrations.

Context: Field Sketching and Site Inventory

The Sketch. The sketch is the basic descriptive image in design. It is a conceptual visualization used to capture key characteristics of a site or a form-idea. Watercolor is an excellent medium for sketching because it is suited to fast, loose applications of conceptual shapes in color with strong value. Thinking through the shape-making compositions of a watercolor sketch also helps the designer understand the intricacies of the subject.

Painting Outdoors. Equipment and Mobility. Keep equipment simple and minimal when painting outdoors, if possible. For field sketching, I suggest the following materials and equipment (choose options, listed below, based on your comfort level):

- Watercolor sketchbook(s) or watercolor block(s), 8″ × 10″ or 10″ × 14″

- (I always have two minimum so I can paint in one while the other is drying)

- Small sketchbook, 5″ × 7″ for quick pencil or pen value and composition studies

- Role of drafting tape, 1″ width

- Soft graphite pencil for sketch outlines (check to see if it erases easily with soap or kneaded erasure—some soft pencil lines are hard to erase)

- Soap and/or kneaded erasure

- Water jar (used as reservoir for clean water, such as a gallon milk container with cap)

- Water wash container (margarine tub, small pail, small bowl, etc.)

- Brushes (the more you take, the greater your chances of losing some): I suggest one large (no. 12 or 14) and one medium (no. 8 or 10) round brush; one wash brush

- Brush container (plastic tube containers are great for protecting brushes in the field, but do not leave brushes in closed containers after use because of mold)

- Palette: I prefer small, metal enameled palettes with lids; small plastic palettes are also suitable. Travel kits with watercolor pans are sufficient for some sketch work, although I prefer tube paints even in the field. This is a matter of personal preference, so experiment.

- Pigments: I choose not more than eight tubes of paint, usually selecting two triads with a couple of additional colors (Viridian Green and an umber or sienna, for example). One of the triads is almost always the intense, which I use for mixing darks and vivid colors.

- Knapsack, backpack, or other pouch with straps to put everything in—if it doesn't fit, don't take it!

 Options

- For larger sketches, I sometimes take larger watercolor blocks, up to 14″ × 20″. When traveling, I take a portfolio for the larger blocks and for finished studies.

- Fold-up chair, light and sturdy.

- Masking fluid.

- Easels (the lighter the better in most cases). I have used plastic, metal, and wood for larger study sketches. Easels that contain a hook on which to hang water containers under the easel track are preferable. The easel is not necessary when using sketchbooks.

As you can imagine, the list of supplies can continue to grow. However, simplicity and ease of mobility should be priorities when working in the field.

Context and Site Inventory. Context is the parent place for a project. It is the larger surrounding area, the site vicinity, and the conditions on the site. Capturing this context and its characteristics as conditions and opportunities is the role of the sketch. Sketching is visual thinking, loading the brain "computer" as well as recording what is observed. It requires the designer to be attentive to terrain and built form involving overall compositional structures, light, shadow, form, and detail.
Types of *context sketches* include:

- Larger spatial systems, or bio-forms, such as watersheds, mountain ranges, forest systems (as opposed to stands of trees and woodlots), prairies, wetlands and drainages, etc. Sketches can be assembled from U.S. (and Canadian) Geological Survey (USGS) maps, aerial photography, environmental atlases, watershed maps, and local history.

- Aerial oblique perspective sketches.

- Sequential or serial sketches traversing a project area and/or site, at eye level or aerial oblique.

- Contextual section sketches through larger scales (district, neighborhood, and locale).

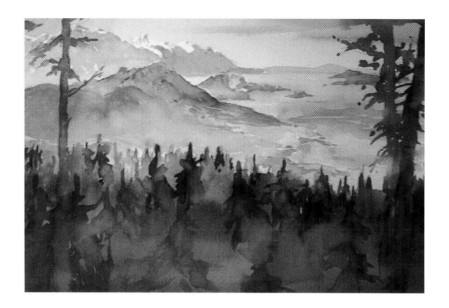

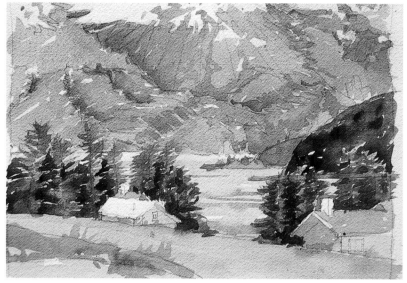

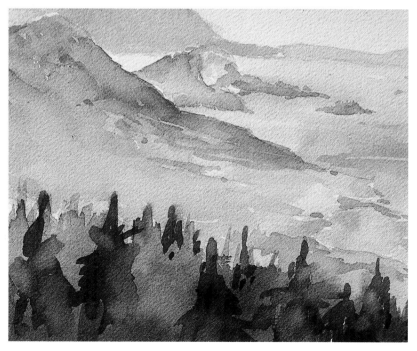

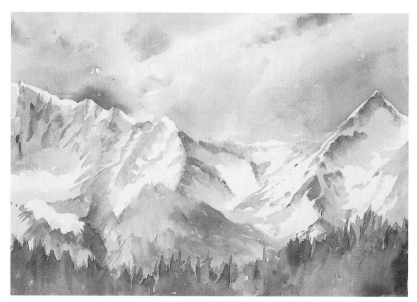

HAINES SEQUENCE. This scale ladder visit to Haines, Alaska in Lynn Canal north of Juneau explores the overall context and setting of this small town of 1,400 people. From Lynn Canal and Cathedral Peaks to Main Street and Fort William H.

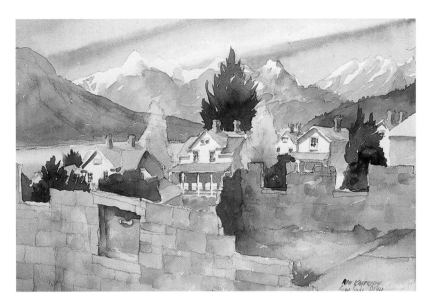

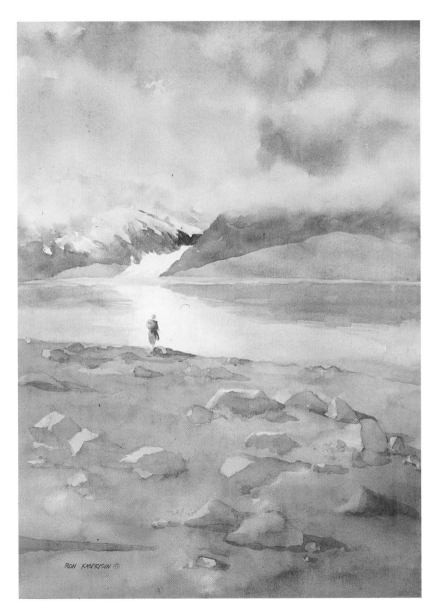

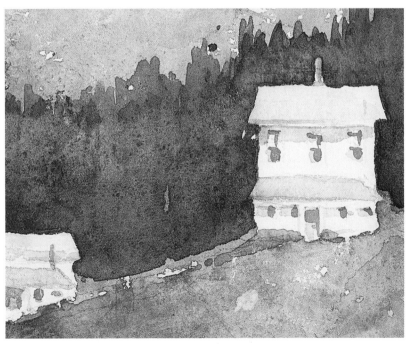

Seward, the act of sketching and painting the forms of this place enabled me to develop a deep appreciation of its unique qualities. The examples are a range of field sketches and studies from field sketches.

Context Sketch Examples

The following examples represent portions of context sketches from various field studies in Alaska, Rome, Italy, and Washington state. They are arranged in a *scale ladder* sequence, from large landscapes to building scales.

Ketchikan Waterfront and Newtown. Watercolor painting challenges me to observe in the field the town-scape and building characteristics of project areas. The very act of deciding upon a composition to paint is a design exercise. In the accompanying examples, a number of different city districts are portrayed as *context*—the definition of "place," or "places within places." What is this place telling me? What is special about it? What are its blemishes and wrinkles? Its life marks? The place has a story to tell as a prelude to design intervention. Listen through painting and drawing.

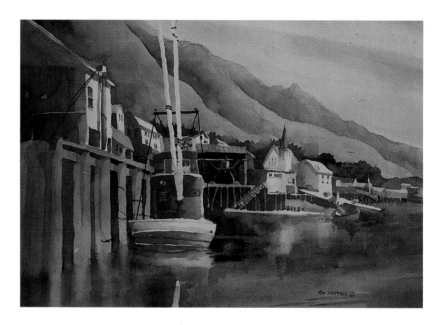

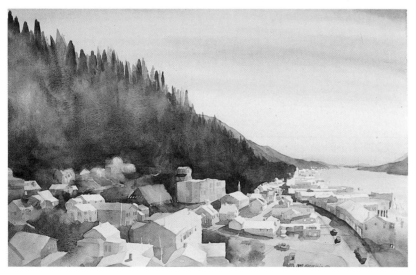

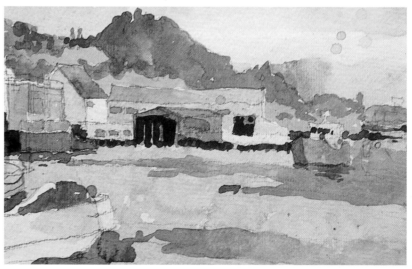

KETCHIKAN SEQUENCE. Another trip through Ketchikan, Alaska, the gateway to the state, offers a view of larger landscape/townscape relationships; working waterfront districts; old pioneer shanties on wooden wharves, fast disappearing; and the native village of Saxman. The sequence includes Dolly's House, the last of the brothels on historic Creek Street. The work is a combination of field sketches and completed studio works. I include some sketches that are only partially complete as examples of the looseness and diversity of the sketch. In the pioneer shanty sketches, actual raindrops can be seen spattering on the then-wet watercolor washes, adding to the mood of the place.

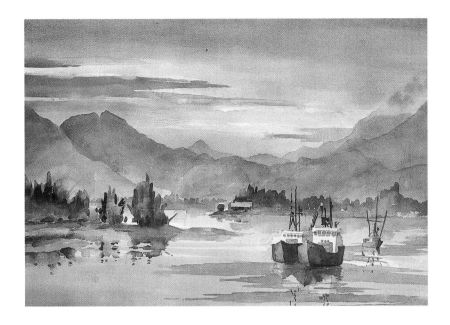

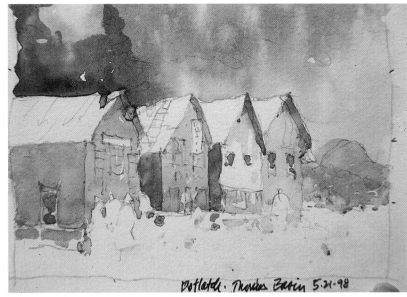

Potlatch. Thomas Basin 5.21.98

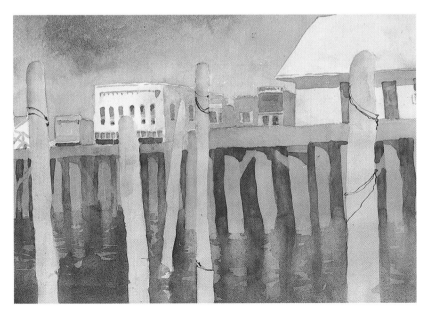

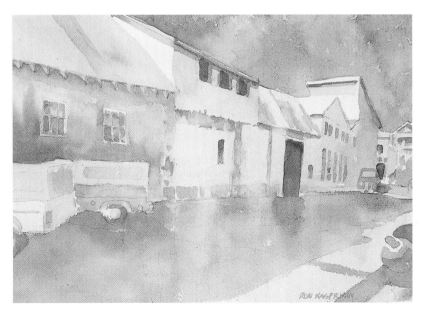

RON RANSOM

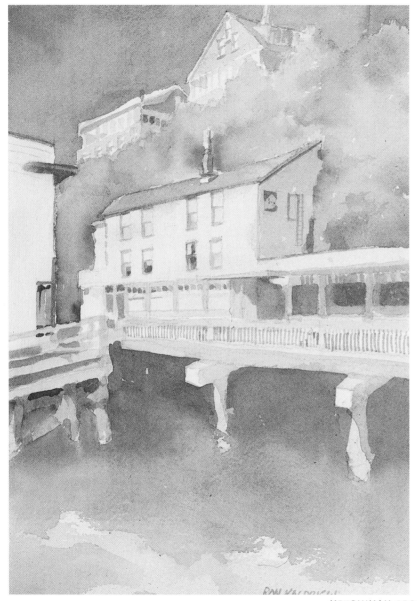
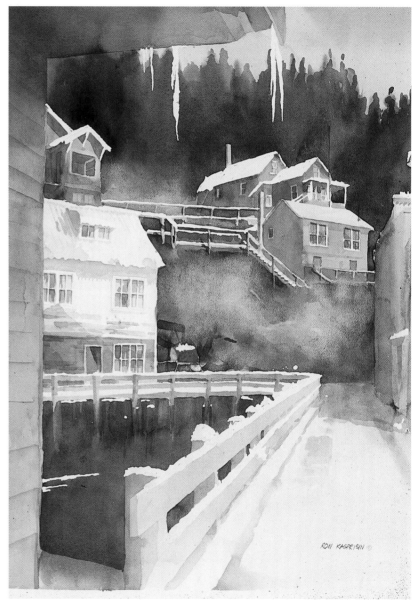

KETCHIKAN SEQUENCE (continued).

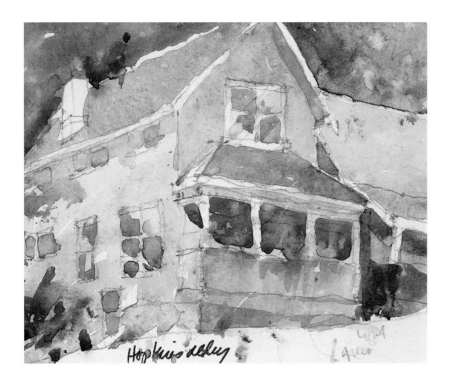

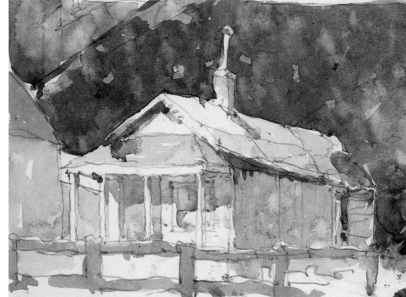

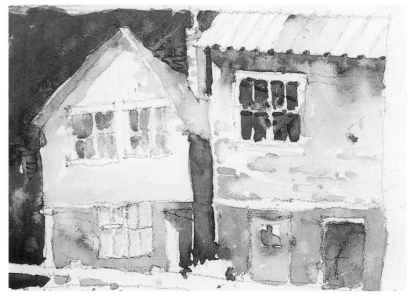

The field sketches and painting studies are arranged by project area and in a scale ladder—from larger townscape image to building image. They are all depictions of Alaska, and include: the Ketchikan working waterfront; Hopkins Alley in Newtown, a potential historic district; signature building sketches; and the Saxman Native village center and waterfront.

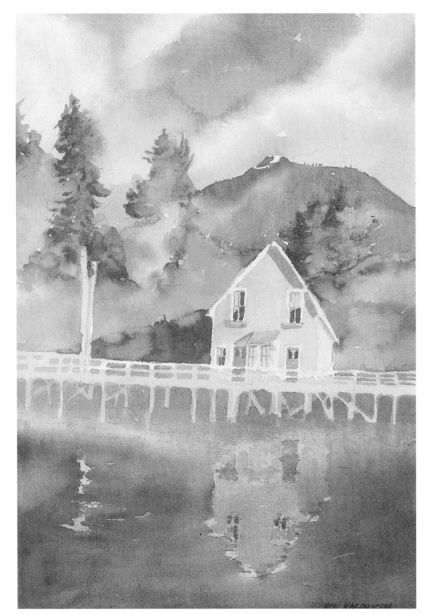

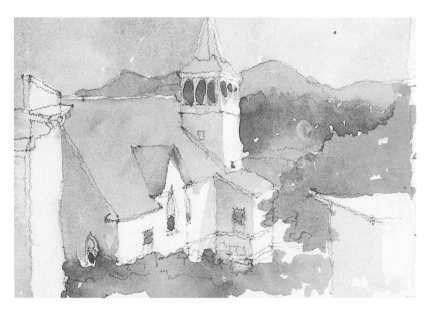

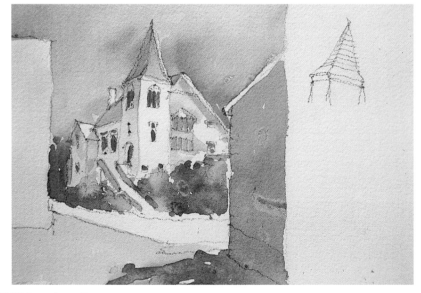

KETCHIKAN SEQUENCE (continued).

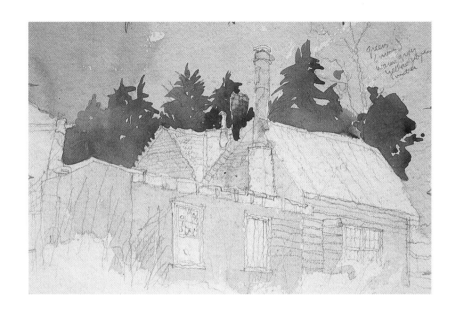

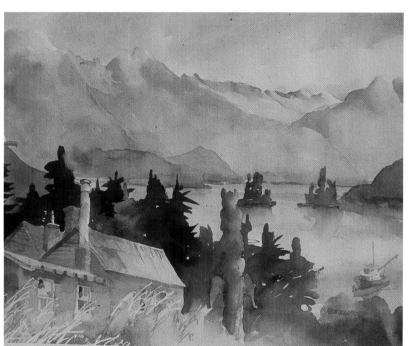

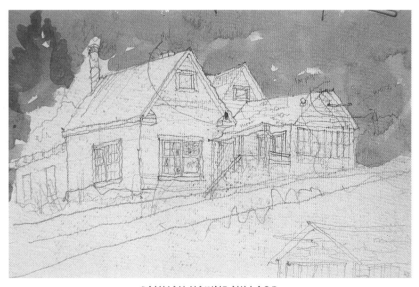

SAXMAN NATIVE VILLAGE.

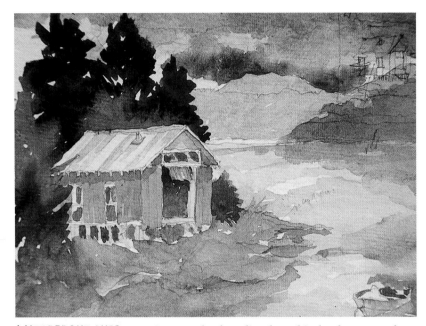

WATERFRONT SHED. Despite a couple of snarling dogs, this sketch was completed as I sat by the edge of the road looking down into the small harbor. I took care to sketch as much detail as possible to record the scene and make the limited color count.

Sitka, Alaska, and Katlian Street. On a hot, sunny day in Sitka, Alaska, I walked along Katlian Street, sketching its changing facade. On the uphill side, the local native Tlingit village, with its clan houses, overlooked the waterfront. On the waterfront, fish processing plants were working and expanding along the water's edge—with native houses, sheds, and artifacts scattered among them. The field sketches of the day's efforts gave me a part of the story of the changing culture and economies—of the power of edge conditions in waterfront towns. I struggled with the watercolors as they dried rapidly in the hot sun, but they still have an on-site energy to them.

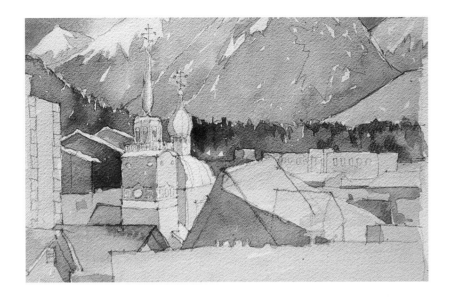

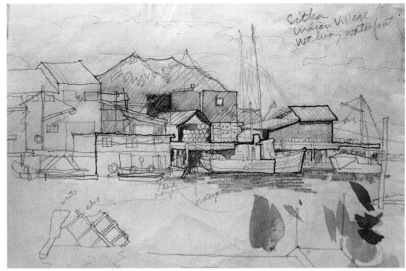

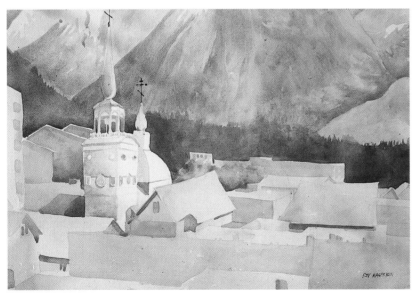

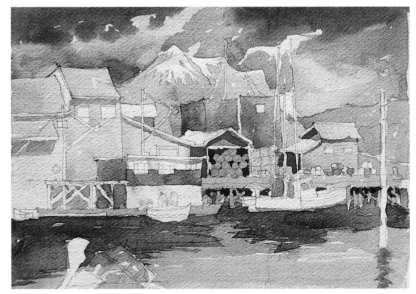

SITKA SEQUENCE. Sitka's Katlian Street is a waterfront edge condition represent-ing a clash of the working industrial fishing waterfront and the native village across the street. Clan houses and older sheds are mixed with active canneries and trucks. It is a thriving street with its own "design" characteristics, one made from the energy and cultures of the place rather than from an urban designer's pen.

Most works in the sequence are field sketches done under various weather condi-tions (hot, fast-drying days to wet and damp) and accompanied by barking dogs! For field sketches, I work at two sizes: around 8 × 10 or 9 × 12 and 18 × 24. The larg-er size challenges me to deal with larger shapes and more complex washes in the field.

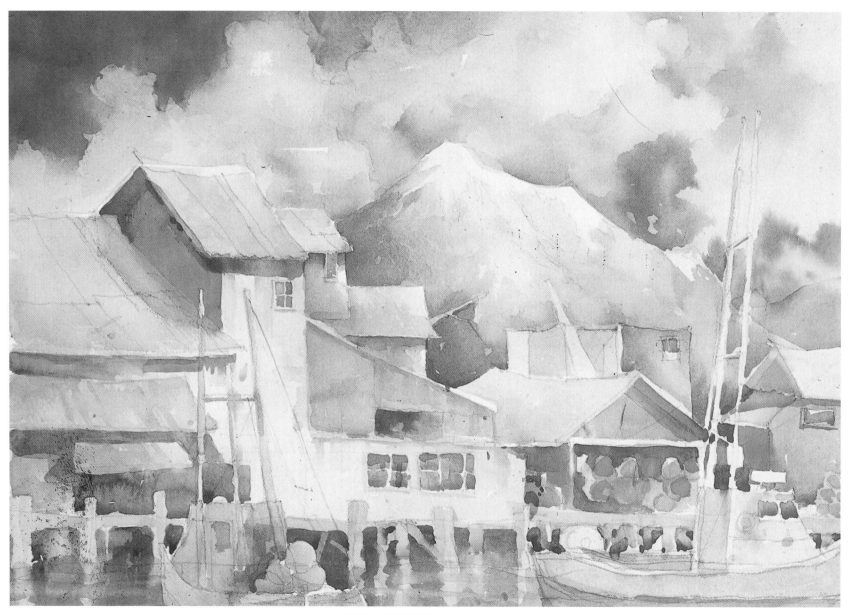

SITKA SEQUENCE (continued).

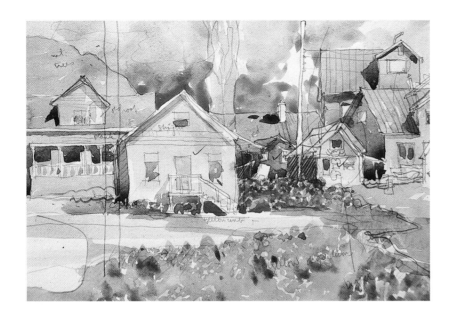

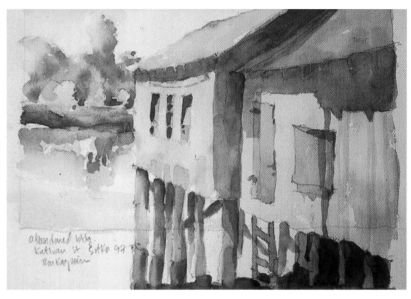

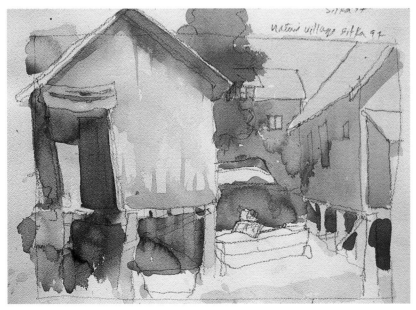

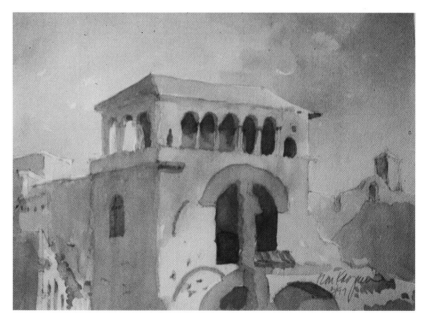

OLD ROME. The field sketch is invaluable for capturing historic and classic cityscapes. In the Rome series, I included the actual field sketch plus the color study completed back at the studio later the same day. If I am unable to experiment with the color and light in the field experience, I take a photograph in addition to doing the field sketch, for later reference. A small sketchbook, pencil, and paint brush with small palette work nicely even while sitting at a restaurant.

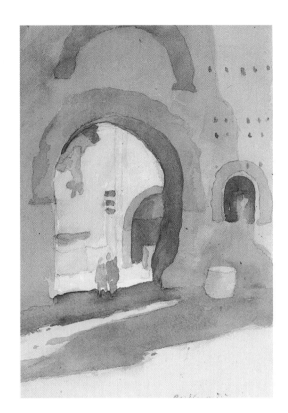

Rome. Field sketches can portray characteristics that often become absorbed and overlooked in field photography. We often see the larger image and photograph it without noticing subtleties in texture, color, and detail. The accompanying sketches of the Campo di Fiori and the Baths of Caracalla portray on-site glimpses of massing, selected detail, and material characteristics.

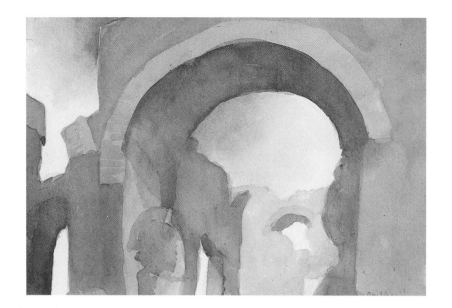

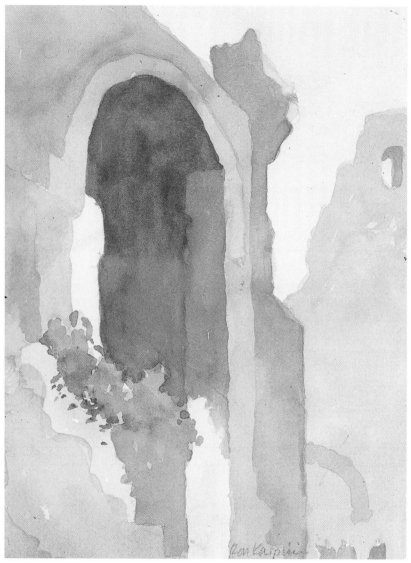

OLD ROME (continued).

The Big Picture: Landscapes and Townscapes Large and Small.
Watercolors, by their colorful and fluid nature, attract attention at client
and/or community meetings. I encourage students to experiment with
composites that tell a contextual story. In the accompanying examples,
two composite *storyboards* portray aspects of western Washington forms:
remote, rural, small town, and urban. They represent the forms of cul-
tures, economies, and histories. Each utilizes a signature identity (Mt.
Ranier) as well as a potential scale ladder.

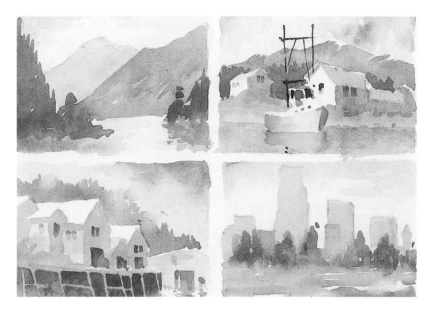

MOUNT RAINIER SEQUENCE. The natural and built forms of western
Washington state are portrayed in a series of small 4″ × 6″ vignettes in
relationship to Mt. Rainier, the mighty ghost. Each sketch represents an
aspect of the forms occurring naturally or through the industry of the
area's people. Logging, fishing, oystering, recreation, and urban living
are represented in direct method sketches.

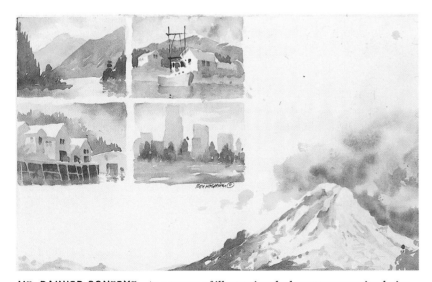

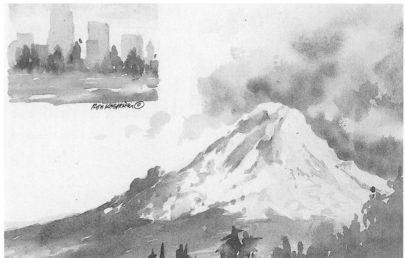

MT. RAINIER CONTEXT. As a means of illustrating the larger community design
characteristics of western Washington, I prepared two composites of urban and
rural forms that capture some of the natural and built diversity of Washington
State. Each composite is highlighted by a different image of Mount Rainier, our
mighty ghost southeast of Seattle. Smaller images (5 × 7) portray the "architecture"
of logging towns, shellfish towns, and mountain lakes that are in effect huge out-
door spaces of contemplation. The composite is an effective way to introduce com-
munities to their surroundings, sometimes forgotten or overlooked through the
morning smog or the noise and intensity of the daily commute. Urban design can
have surprising results and effects on communities when its methods and visuali-
zation skills are used as education and awareness processes of surrounding con-
text, at different levels on the scale ladder.

MT. RANIER COMPOSITE TWO.

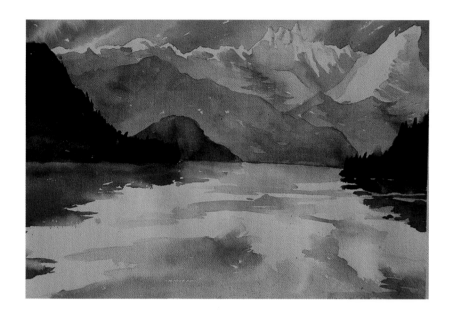

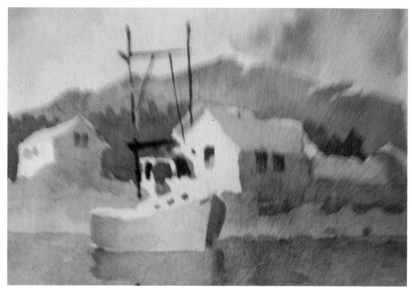

LANDSCAPES. Landscapes are dramatic subjects that put urban life in perspective. Practicing painting skills on nonurban, nonbuilt forms helps develop a freer or looser style, in my opinion, and is highly beneficial. Be it through sketch or painting, the landscape takes us out of the right angle mentality and gets us out of the city!

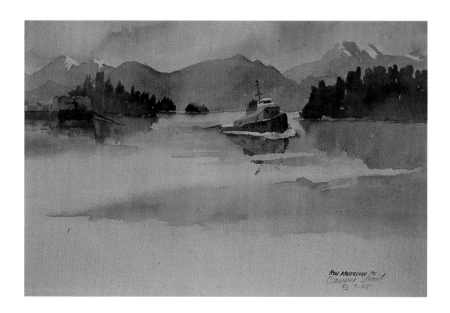

LANDSCAPES. The accompanying landscape scenes vary in subject matter from southeast Alaska/Northern British Columbia to the view from my front porch. They are the larger places within which architecture occurs. Landscapes can be complex with diverse organic forms; these challenge skill development and site awareness through the complexity of curved form and lighting effects. I recommend that students study watercolor using landscapes before engaging in the more rigid or manufactured forms of architectural subjects.

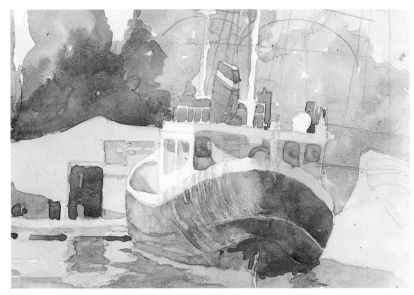

VIEW FROM MY FRONT PORCH.

Town and Cityscapes. The built form of towns and cities has a complexity that can not be captured solely in plan diagrams and photographs. The accompanying sequence includes on-site sketches and painting studies. Their techniques range from loose pencil sketches, with a touch of watercolor added, to larger finished interpretive studies. Students often ask about the amount of interpretation available to them in these context images. In my opinion, there is no correct way to do them. I prefer some semi-abstraction, or a filtering process detail; others may prefer detailed accuracy. There is a mixture of both in the accompanying examples. The process is both recording and storytelling.

TOWN AND CITYSCAPES. These final examples explore a variety of small town and urban scenes, from sketch to finished work. They include South Bend and Seattle, Washington, Pelican and Juneau, Alaska, and Mount Vernon, Washington. They range from the South Bend sketch (5 × 7) to the finished Mount Vernon painting (22 × 30). In the sketch, two layers of wet on dry completed the work in about 15 minutes. The painting took about six hours using graded glazed washes of different colors, yellow to purple and blue-gray to orange-brown complements.

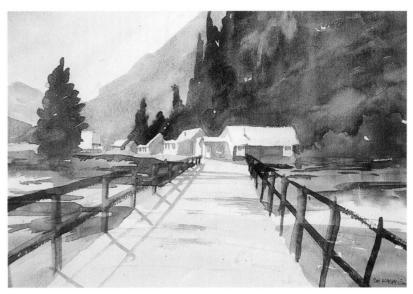

PELICAN, ALASKA (18″ × 24″).

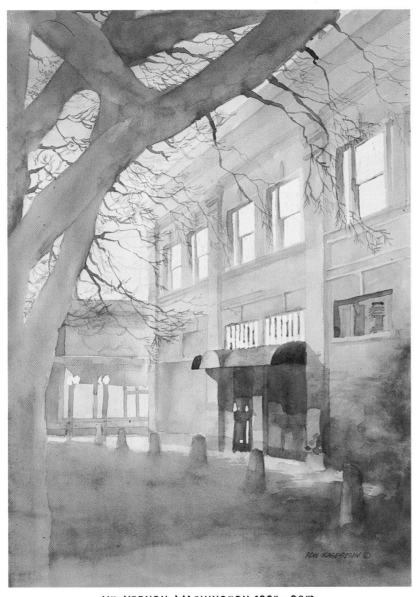

MT. VERNON, WASHINGTON (22″ × 30″).

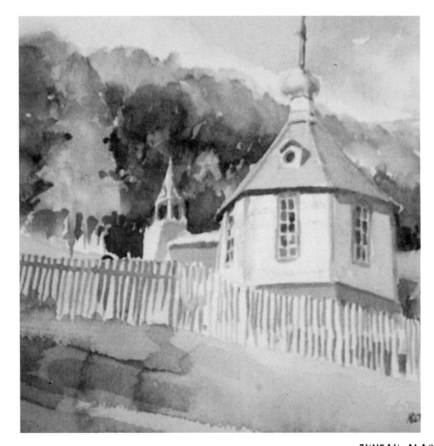

JUNEAU, ALASKA, SEQUENCE.

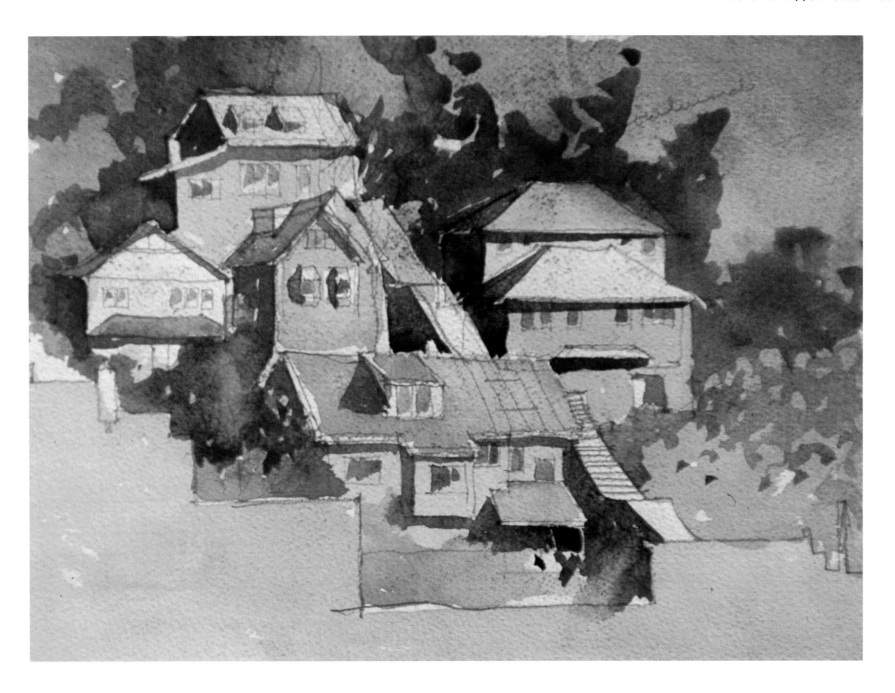

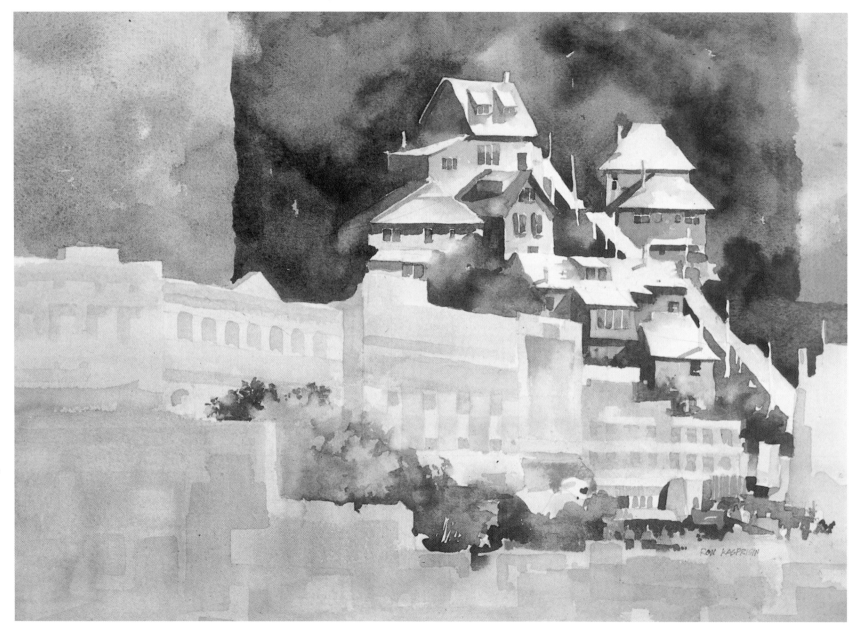

JUNEAU, ALASKA, SEQUENCE (continued).

BIBLIOGRAPHY

Bolton, Richard. 1987. *Painting Weathered Textures in Watercolor.* New York: Watson-Guptill Publications.

Dobie, Jeanne. 1986. *Making Color Sing.* New York: Watson-Guptill Publications.

Kasprisin, Ronald J. 1989. *Watercolor in Architectural Design.* New York: John Wiley & Sons, Inc.

Lawrence, William B. 1994. *Painting Light & Shadow in Watercolor.* Cincinnati: North Light Books.

Materials and Information for Artists. 1988/1989. Vol. 1/Reference Catalog, Issue No. 5. Seattle: Daniel Smith, Inc.

Reid, Charles. 1991. *Pulling Your Paintings Together.* New York: Watson-Guptill Publications.

Schaller, Thomas Wells. 1997. *The Art of Architectural Drawing: Imagination & Technique.* New York: John Wiley & Sons, Inc.

Schaller, Thomas W. 1990. *Architecture in Watercolor.* New York: John Wiley & Sons, Inc.

Webb, Frank. 1990. *Webb on Watercolor.* Cincinnati: North Light Books.

Wilcox, Michael. 1991. *The Wilcox Guide to the Finest Watercolour Paints.* Perth, Australia: Artways.

PEN & INK: LINE, PATTERN, AND VALUE

INTRODUCTION: CHARACTER, WEIGHT, PATTERN, OVERLAYS, AND VALUE

Character

The pen is a direct extension of the hand-mind. It is a tool that transfers and modifies the intentions of mental thoughts into a graphic design image. This third image can be the unique, uncompromised result of mental and tool-crafted explorative thinking. The visual identity or signature of that image is defined by the characteristics of the pen marks, including your physiology, and the types of marks—dots, lines, scribbles, etc. Characteristics are like the distinguishing features on your face that make up your unique visual signature. In pen and ink drawing, basic characteristics of dots, lines, and scribbles are as follows:

Physiology

Large hands, small hands

Calm hands, shaky hands

Short fingers, long fingers

All have a positive contribution to line signature, making it a good reason to avoid mimicking characteristics of others.

Dots

Small, medium, large

Circular

Scratchy

Light, medium, dark

Tight, loose

Lines

Hard-edged

Varied-edge

Wavy

Squiggly

Narrow, medium, wide

Light, medium, dark

Scribbles and Squiggles

Repetitious letters or symbols

Random

Line Weight

Weight is the "lightness or heaviness" of a line. In reality, it is a function of its width, with value a function of width and opacity. A narrow or fine line has the appearance of lightness; a wider or coarser line appears heavier and darker than fine lines. The critical aspect of weight is *value* as expressed in the relationship of two or more lines or dots together, where one or more are different. Other characteristics can be added to weight to produce special effects within one line or dot. It is possible to draw a wide line that is light by using a hollow and wide dash. The narrow-*light* and wide-*heavy* description is a useful convention. Line weights can be:

- fine, medium, coarse

- narrow, medium, wide

- light, medium, heavy

- hollow, semi-hollow, full

- white, grey, black

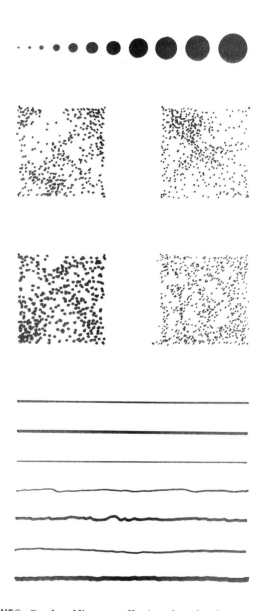

DOTS AND LINES. Freehand lines are effective when they have consistent characteristics—no abrupt or sharp deviations from the straight-line unless intended. Make them free but not sloppy. Don't worry about small variations in line quality.

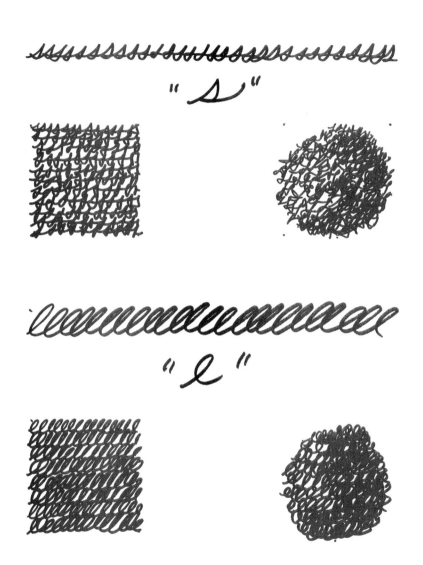

Pattern

Pattern is the compositional relationship of one or more dots, lines, or squiggles placed together, usually in a repetitive assemblage. Pattern is the building block of pen and ink drawing, enabling us to depict materials, values, distances, and shapes. Pattern technique is described in the following sections. For now, remember that pattern is the repetition of similar pen marks, with variations in direction, spacing, character, weight, and complexity. Patterns can be:

- uniform
- compact
- dispersed
- asymmetrical
- directional
- repetitious
- varying
- repetitious with variety

Overlays

Overlays are arrangements or patterns of dots, lines, or squiggles over others. Overlaying or layering represents both a technique and an application strategy. The technique generates differences in value, distance, texture, etc. using layers of similar patterns. As a strategy, it provides a sequential process of working from light to dark in successive layers of ink.

SCRIBBLES. Scribbling is more effective with a consistent line pattern such as a cursive "s" or "e." Scribbling that is heavier in value (more layers of the basic pattern) is generally more effective than with a lighter value.

Value

Value is important to pen and ink as a way of organizing and structuring the shapes in a drawing. It utilizes line weight, dot size and opacity, and layers of ink. Value is the relationship between light and dark shapes. In pen and ink drawing, it can be used as an outline difference with line weights or as shapes.

MATERIALS AND EQUIPMENT

Drawing Pens

For the exercises and techniques discussed in this book, two broad categories of pens are used and recommended: the *technical* pen and the *fiber* pen. The varieties of each are numerous and with specific roles and applications. Knowing when which pen type is more suitable will affect the drawing quality.

Technical Pens. Technical pens are used for fine line detail, both straight-line and freehand. They are not restricted to precise straight-edge work and can be very effective as loose sketching tools, as many of the examples in this chapter indicate. Technical pens are composed of precision metal or ceramic points or tips and refillable cartridges in tubular holders; they also come with pre-filled cartridges. The tips are interchangeable, and are available in the following sizes:

.13 or 5 × 0 ("5 zero or ought")

.18 or 4 × 0

.25 or 3 × 0 ("triple zero")

.30 or 00 ("double zero")

.35 or 0 ("zero")

.45 or 1

TECHNICAL PENS. Technical pens are available from many manufacturers. Some brands have refillable cartridges and others offer replaceable cartridges.

.50 or 2

.70 or 2½

.80 or 3

1.0 or 3½

1.20 or 4

1.40 or 5

2.00 or 6

FIBER PENS. There are many varieties of Fiber pens. Two key points to remember: (1) test for ink opacity and durability—some fade faster than normal; and (2) test for line spread (how much a line spreads out after application).

Manufacturers color code the point casings, but not all color codes are the same between manufacturers.

The points are available in the following materials:

Steel (for paper and vellum)—inexpensive

Tungsten Carbide (for drafting film)—expensive

Diamond or Jewel-tipped (for vellum and drafting film)—very expensive

I use diamond tip technical pens for everything from sketching to final presentation and design drawings, in almost all cases freehand style.

Working fast and loosely, I push the pens and points to their physical limits and find that the technical pen is not limited to straight-edge detail but also for a variety of pressures, patterns, and effects.

Fiber Pens. There are so many fiber or "felt" tip pens on the market that each person must experiment to determine the best for him or herself. Three characteristics help me choose fiber pens:

- opacity of ink
- durability of points
- smoothness of pen movement

The blackness or opacity of the ink is critical to the quality of the image when drawings are reproduced, reduced, or expected to last over time. Some fiber pen inks spread upon application, especially if the paper fiber is at all porous. Others look black or opaque when applied but become diluted and grey after drying. Some inks fade after a short time, making reproduction a problem. Many pens that are advertised as disposable technical pens have tips that fray, flatten, or otherwise distort after brief use to the point where it is difficult to obtain consistency of line quality.

As in painting, economic materials that are cheaply made can hinder your progress unnecessarily. I use a Pentel Sign pen for most of my conceptual and design development drawings because the fiber tips have a quality black ink and the points are fine enough to permit me to use a lot of line patterning which maintains line *crispness* after reduction. Students get a laugh out of the 5 or 6 Pentels that I may have in my pocket at one time, threatening to buy me a pocket protector. The reason for so many is simple: The tips wear down with use and each pen develops a different line weight or fluidity. I will use three or more different Pentels on one drawing, a newer one for fine lines and an older one for wide lines or semi-dry hatch marks. More on this later.

All things considered, quality fiber pens with opaque ink are easy to use, fast and loose in their application, come in many colors, and complement the conceptual and design development process.

Drawing Ink

Waterproof Ink. Waterproof inks resist running or smearing after they are dry. Most are suitable for technical pens, calligraphy, brush, and airbrush applications. Colors include white, black, red, yellow, blue, green, violet, and brown. Pelikan, Mars Staedtler, and Design Higgins are well-known manufacturers. Consult your local supplier for additional manufacturers.

Water-Resistant Acrylic Ink. Inks that are pigmented and reasonably lightfast are produced in a variety of colors. They can be used in dip pens, technical pens, brushes, and airbrush.

Opaqueness and Reproduction. Select inks based on the desired final outcome as well as how they work with pen and paper. In design, many drawings are reproduced in the printed media—enlarged, reduced, and copied on bond paper copiers. Inks that are not opaque can separate and lose their dark value, especially after reproduction.

Paper and Mylar

Transparent Tracing Paper (Conceptual Drawings). Tracing paper is used for conceptual studies and final drawings. Conceptual studies are best done in a layering process, without erasures if possible, thereby requiring more paper and less expensive paper. Erasing takes time and also easily tears the tracing paper. *Flimsy, trace, or bumwad,* depending

on the region of the United States/Canada, is a lightweight transparent paper available in rolls of 12″ to 36″ widths, available in white and yellow. It is best suited for soft pencils and fiber pens. Sharp, hard pencils and technical pens tear the paper.

Trace or flimsy paper is not thick and is not suited for bond or diazo printers with rollers or other internal processing mechanism as the originals can wrinkle or tear. This trace is designed for overlay drawing techniques.

Transparent Tracing Paper (Finished Drawings). Transparent tracing paper suitable for design development and finished drawings is called *vellum*. It is used in both hand-drawn and computer-generated processes. Quality vellum has a 100% cotton or rag fiber, making it heavyweight, durable, and capable of taking multiple erasures, scraping, and repro-duction. The surface takes pencil, fiber and technical pen, colored marker, colored pencil, and pastel very well. It is effective as an original document, suitable for making bond and diazo print, and adding color to the prints.

Mylar. Mylar is a transparent plastic material that is frosted or coated on one or both sides to hold ink, marker, and other media. It is very durable and still used widely where hand-drawn permanent drawing records are desired.

Opaque Paper. Opaque drawing paper is used for sketching and field notes. Smoother surfaces are better for technical pens, whereas more textured surfaces can create effects with fiber pens. Experiment.

METHODS AND TECHNIQUES

The Line

The type of line used is also a matter of preference and desired effect. Designers use both the straight-edge and the freehand line for conceptual work as well as final work, with the exception of construction drawings where freehand is seldom used. I work exclusively with freehand lines, normally over an accurate base drawing, straight-edge or freehand on grid paper underlayment. Other times I work directly on grid tracing paper in freehand, using the grid as my straight edge. In conceptual and design development work, designers who use a straight-edge line often choose pens that enable them to work quickly with minimal chance of smears or ink runs under the straight edge. Fiber pens are effective for this type of use. If you enjoy a more slow and deliberate pace, a technical pen and straight-edge combination produces high-resolution line quality with India inks.

Line *consistency* is a critical characteristic for producing drawings that are clear and nondistracting, whether you are using a straight-edge or freehand technique. In a straight-edge line, *any* wobble, jerk, coffee-twitch, or hesitation will stand out from the straightness and call attention to itself rather than to the line. A straight line is just that, without blemish. In freehand line work, the same rule applies except that you can have more variations in the line characteristic as long as the variations are not exaggerated and disruptive or attention-gathering. I use intentional squiggles and waviness in my freehand line work in a consistent manner to add character to the overall line, not visually generating unnecessary attention to increments of the line.

Let's look at examples of various line types and methods of application.

The Line as Shape and Shape-maker. Shape-making is a basic intent of drawing. The letter "A" is a shape composed of three straight marks or lines developed to represent a certain sound. A circle is a shape that encloses representing space and its mathematical relationships. They are both constructed from the line *shape.* In design, the line is part of an alphabet that enables us to make other shapes from outlines, contours, and patterns.

The Line as Outline. As an *outline,* the line is an edge that defines the limits of shapes. Outline drawings can be with or without value and are used in all aspects of design.

The Line as Contour. Contour lines are figure and feature boundaries, representing the edges of the many shapes that make up a whole. The outline of the windows and doors, their shadows and material and color changes are all small shapes that make up the overall wall plane of a building. They are changes within the interior of the plane, defined by characteristics such as value, texture, voids and solids, and others.

The Shape as Line Pattern. Patterns are fields, screens, or shapes created by the repeated arrangement of lines in a shape. Often it is repetition with variety that defines a pattern. The repetition provides a coherence or parent identity. The variety provides intent and individuality among the pattern elements.

Patterns enable us to indicate texture and value in a shape. In the examples that follow, straight lines and scribbles are layered, sometimes changing directions or densities of lines per square inch to achieve the desired effect. They can be drawn with or without outlines. The more detailed the pattern, the less need for an outline.

Line Techniques

STRAIGHT AND NOT-SO-STRAIGHT. Straight lines drawn freehand are better made when the pen is held loosely and away from the tip, about a third to halfway up the holder. The key is to let the pen do the work. If the pen is clean, and has a point that is not scratchy or damaged, it should glide across the paper or mylar. Grasping the pen tightly puts pressure on the point and drives the pen into the paper, causing more friction and making it difficult to move. I use my small finger to gently anchor my hand to the paper as I glide the pen point along. You can also

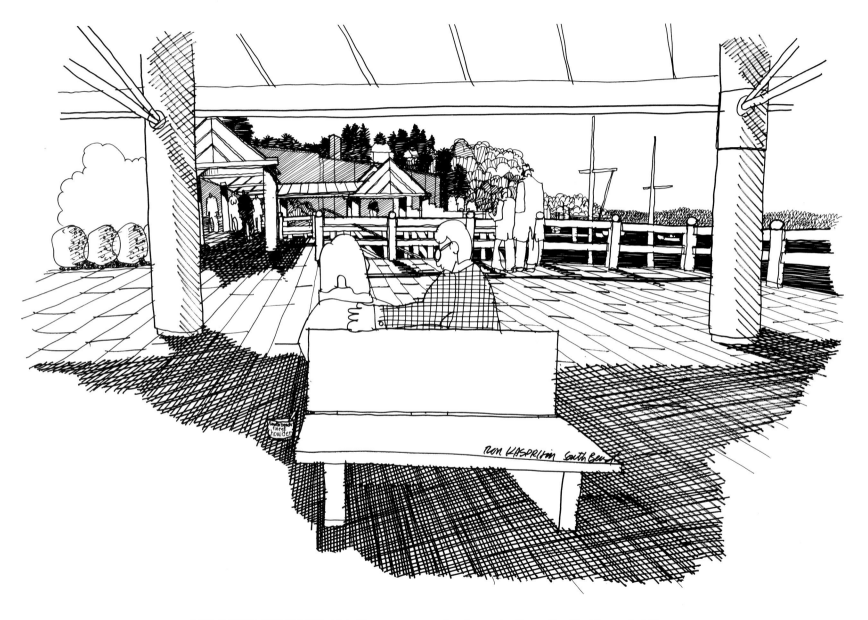

SOUTH BEND VIEWPOINT. This fiber pen concept sketch contains line as line (decking material), line as outline (posts, shrubs), line as contour (trees in distance), and line patterns as shapes (shadows on deck, confiers in distance).

use the meaty part of your palm just below your small finger to accomplish the same. Touch is very important in monitoring line pressure.

DRAW WHAT YOU MEAN. The lines are communication symbols. Always close corners or circles if you intend continuous lines. A break in a line means just that—a pause or a connection with the adjacent shape.

Patterns

Hatching. Hatching is a fundamental patterning technique using consistently spaced straight lines to create a *value screen* such as a shadow, a material, or a depth effect. I have found through experience that keeping the lines closer together, from ⅛ inch to 1/16 inch in width, results in a consistent first value layer. A 45 degree angle is recommended as the best first layer because that angle usually does not conflict with window, door, and other building shapes at right angles to the horizon. When using a straight edge, work away from the last line so as not to smudge. Also, be careful not to create blemishes within any line or at the end of lines with excess blobs of ink. Again, I prefer to do the hatching freehand, usually working through tracing paper over a line guide such as a lined tablet, grid paper turned to the desired angle, or nonreproducible blue pencil drawn to the angle at regular intervals to guide my hand. When doing freehand, I do not fret over lines that get a bit close to the next one because the discrepancy often disappears among the other lines. See the examples that follow.

Layered Hatching or Crosshatching. Layered hatching is a patterning technique used to add value to shapes. The technique is the same as *hatching* but with the directions of each layer oriented differently. Keep these principles in mind:

HATCHING. Hatching is effective when fine lines are used to create a screen or pattern of value. Heavier weight lines can overpower shapes underneath the screen. Make the lines close together rather than far apart; it is the difference between a screen of lines and stripes.

- All layers have the same line spacing (varying the spacing in layer three from layer one, for example, indicates a difference in the basic pattern or information and can confuse the viewer).

- Hatching is more effective if its line weight is equal to or finer than the underlying drawing line weight (the finer the line weight, the better the screen effect because the screen *floats* above the underlying drawing).

- Extend all hatch lines through the underlying shape to be screened (leaving voids right at the edge of the underlying shape creates another unintended shape).

- Four values are generated by the four layers of hatching (vertical, horizontal, and two diagonals); if more are desired, add at 30 degrees, then at 60 degrees.

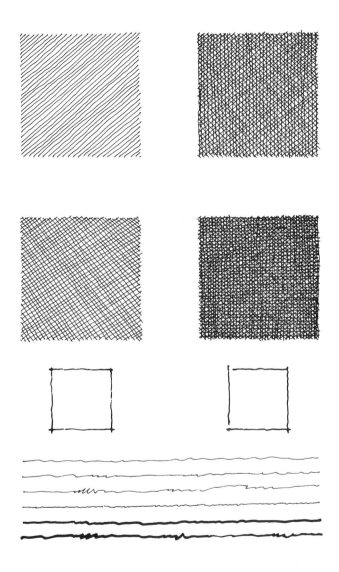

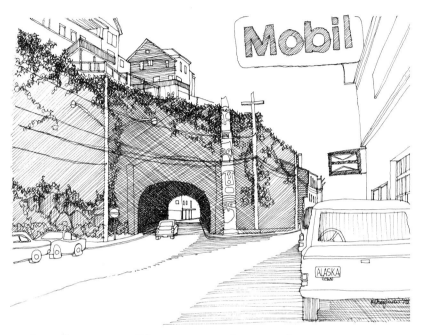

cbd northwest entry

KETCHIKAN TUNNEL. Hatching with a technical pen is used in the rock cliff faces, with more layers added for the interior of the tunnel, creating dark but not opaque values.

CROSSHATCHING. Maintain the same line separation within each layer of hatching for consistent communication. Light weight lines are more affective for screening than those of a heavier weight.

Squiggly Lines. Squiggly lines are achieved by adding a small and consistent jerking motion or jitters to the fingers holding the pen. This is useful when an additional characteristic to the line can be helpful to the overall communication, in other words, making a line stand out from others. I use squiggly lines to make note lines or arrows stand out from a straight(er) line drawing, or to give a sense of texture and materials.

GRID STREET PATTERNS. Dramatize freehand drawing characteristics with squiggly lines used in consistent patterns. Attempting to draw a perfectly straight line with freehand techniques is an oxymoron—celebrate the freehand line by intentionally giving it character.

Scribbling. Scribbling is a *seemingly* loose and unordered technique that produces texture and value. In reality, successful scribbling uses consistent and structured repeated forms. A scribbling technique without repetition and consistency can appear messy and haphazard, whereas an application that uses a basic "s," loop form, or fractal shape quickly applied, retains a consistency in the scribble that holds the larger shape *texture* together. As in most other ink methods, adding succeeding layers to all or part of a shape increases the value, enabling the designer to curve, shadow, and otherwise define the shape with light to dark relationships. See the accompanying examples.

UW COLUMNS. The background trees are composed of scribbles applied in multiple layers until the desired value was achieved. Note the consistency in the overall effect. Scribbling also produces texture, particularly for organic shapes such as trees, shrubs, grasses, etc.

UW TRANSIT. Layers of scribbling add value to the tree shapes. Diagonal hatching lines add layers of value to the street shadows and the lighter tree shapes. Layering is critical to create value shapes. As in *UW Columns,* I used a Pentel Sign pen for all line work.

GRADED VALUE PATTERNS. When layering line patterns for value, keep the spacing between lines consistent for each layer. Too much space between lines in a hatching pattern can create stripes, which in effect become different and competing shapes.

Values with Lines. Value shapes add structure to a drawing by relating light and dark shapes into an integral whole. Color adds temperature, distance, vibrancy, luminosity, etc., but not value. A color photograph without a value relationship is not as strong compositionally as a black and white photograph with value patterns. In ink drawing, value is key to establishing a hierarchy of shapes, focal shapes, centers of interest, and edge emphasis.

Value techniques are worth repeating as a separate element even though they are inherent in all of the technique discussions. The accompanying, images showing two graded bands each have six increments. One band is composed of hatched lines; the second is made from scribbles.

In most cases, a range of five increments is sufficient for value shapes. Up to nine increments further refine the value differences and are more useful in renderings and presentation drawings.

Dots and Dashes. Dots are useful for building and site material effects when composed in patterns and densities. Patterns can be uniform fields or screens; they can indicate direction and movement; depict light and dark values; and portray texture, depth, and curvilinear forms.

Dots are applied uniformly as screens, or in various nonuniform patterns to represent textures, materials, etc. A basic principle of application is to combine *varying density and movement* to create interest and com-

DOTS AND MORE DOTS. The key here is *repetition with variety,* a term I repeat often to students. The dot is essentially the same size but it is varied in density and movement throughout the shape for interest and shape-defining qualities.

position for the viewer. Dots can be applied with forceful downstrokes (harder on your pens) or light taps. If larger blobs of ink result from the tapping, let them dry before erasing or scraping from the surface. It is often possible and fun to work "mistakes" and accidents into a drawing rather than try to eliminate them entirely.

Like dots, *dashes* are symbols as well as line characteristics and are also discussed in *diagramming,* later in this chapter. Dashes are useful in all design applications and are shown here with various pen types. Basic principles include:

- Maintain a consistent dash length to avoid changing the line meaning.

- Make the space between dashes small in length and consistent.

- Make the dash width uniform.

- Apply value principles to dashes (dashes that are darker and/or wider than the background drawing and other dashes indicate a higher order of information; they are also used for boundaries and edges).

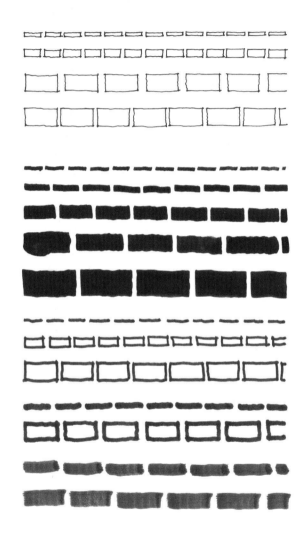

DASHES. Keep the spacing between dashes small to avoid stretching out the line of dashes. The emphasis is on the dash, not on the space between. The desired effect is a broken line.

Spatter. Spatter is a projected or "thrown" effect. Unlike applying dots by touching the pen to the paper, it results from a motion above the paper that splashes the ink. A toothbrush is an excellent spatter tool.

The brush is dipped into ink, then pointed at the target area and flicked with the thumb or finger, propelling the ink to the paper. Some guidelines for using spatter include:

- Mask around the area to be spattered.
- Test the spatter effect and ink density on a scrap piece of paper.
- Hold the brush in the hand with the thumb placed on the front tip of the bristles.
- Pull the thumb back toward you to deflect and release the bristles, propelling the ink forward.
- Apply numerous layers to adjust density (and color, with each layer being a different color), value, and texture.

Value with Dots and Spatters. Achieving value differences with dots is again a layering process. I first apply a pattern that represents the material or shadow effect that I need, followed by one or more additional layers that build a value pattern around the initial intent. In the accompanying images, shadow patterns occur on (1) a wall plane that has an even dispersion of value, using the dots; (2) another wall plane with a graded shadow, that is, a shadow that goes from light to dark, again using dots to resemble the local material texture; (3) a grainy gravel or sandy area where the underlying material is in a semi-random pattern or patterns that represent wind or wave action; and (4) spherical and cylindrical shapes.

Spatters can be used in the same layering process with one additional technique for controlling the direction and locale of the spatter: masking. After applying one or more base layers to represent local material and material characteristics (blemishes, wind or wave actions, etc.), I mask out the areas not to be spattered further and add variable density spatters, in this case with an old toothbrush, to the exposed shapes. This can be done in consecutive applications until a rich and complex pattern occurs.

These are techniques for basic patterns and ink effects. Additional techniques are described in the next section related to elements within design compositions.

SPATTER. Masking the shapes to be spattered is critical for this to work well as there is limited control with an old toothbrush as a tool. You need to outline the shape as well as protect other areas from spatter. As in most line work, value is gen-erated through overlays. In the pyramid plan, a buildup of layers through masking created five values, from white (the paper) to black.

TECHNIQUES FOR BASIC ELEMENTS IN DESIGN COMPOSITION

Elements in design compositions are the basic shapes and patterns that occur regularly in urban design, architectural and landscape drawing. They include:

- *Shadows*
- *Buildings, Building Components, and Materials*
- *Water and Sky Shapes*

 reflections

 depth

 clouds

 rain

- *Landscape Elements: Trees, Shrubs, Other Vegetation, and Hard-Landscape Elements*
- *Edges and Highlights*

Shadows

Shadows separate the vertical shapes from the horizontal (ground) plane through contrast using value changes. Shadows can be opaque (solid black, for example) or dark yet transparent, enabling shapes to be visible within the shadows.

Transparent Shadows. I recommend the following guidelines when making transparent shadows with line work (*Hint: use flimsy tracing paper to rough out your drawing sequence before starting on the final trace or mylar*).

- Determine the entire area to be shadowed.
- Treat all contiguous shapes that are in shadow as one shape for the first shadow layer.
- For the next and succeeding layers, change the direction of the hatching and apply the overlay to all remaining shapes, gradually ending with the darkest contiguous shapes.
- As an example, for transparent shadows, the first layer includes the sidewalk shape within the shadow, whereas the second and succeeding layers omit the sidewalk shape, creating a value difference that reveals, with the lighter value, the sidewalk in the shadow.

In the example that follows, the objective is to keep the line consistency uniform over the entire shadowed area and have the viewer undistracted by breaks or unnecessary edges within the shadow shape.

In *Washington School*, there are three layers of hatching using the same pen. The first covers the entire shadow area (*see Washington Diagram*); the second covers both the grassed and paved areas, leaving the sidewalks with only one hatching; and the third covers only the grassed areas. The three values enable the building shadow to articulate the height of the building while describing walkways and vegetation within the shadow.

(WASHINGTON SCHOOL) TRANSPARENT SHADOWS. Shapes in shadows can be viewed with transparent shadow effects. Sidewalks, trees, and other shapes need not be left in the dark. Diagonal hatching permits shapes in shadows to be viewed by excluding them from additional layers of hatching, or exposing them by limiting the layers of hatching. This diagram illustrates three layers of hatching, each decreasing in the areas that it covers.

In *Omak Façade*, the shadow is in two layers of hatching, drawn with a .30 (00) technical pen. The first layer covers the entire shadow area for line consistency and so as not to have internal breaks in the hatching. The second layer, crossing the first, covers only the window and wall areas, leaving the door and trim more noticeable with a lighter value, and therefore transparent.

When shadowing perspective sketches, try to apply the same principle of *one hatch for all of the shapes in the same shadow area.* In *Multiplex Shadow,* the building wall shapes and the ground plane shadow are all treated as one shadow shape. It may not always be possible to do this with acute angles or odd shapes, but in most cases it works. Avoid hatching individual shapes separately within the larger shadow-shape because each hatch edge will stand out unnecessarily, and hatch lines may not be the same consistent angle.

Additional layers add value to wall planes that are in deeper shadow or to ground conditions that may be darker.

OMAK FAÇADE. Vertical planes such as windows can also be treated with decreasing layers of hatching to expose shapes within the shadow.

MULTIPLEX SHADOW. When shadows fall on two different planes, such as the vertical wall and the ground plane in the example, avoid hatching one shape and then the next separately. This causes unnecessary variations in line work that draws attention away from the overall shadow affect. For the wall and ground planes, one layer is applied to both. Then succeeding layers can be added to highlight various shapes. Overall, the line work is consistent, at the same angles, and in the same directions, unifying multiple shapes.

Opaque Shadows. I often use black or near black shadows with quick axonometric studies, using a fiber tip pen, or in cases where I want the positive object—a building for example—to stand out strongly from the ground plane. When there are a lot of shapes and patterns in a drawing, dark or opaque shadows add important value contrast. The examples shown are drawn with Pentel Sign pens. I use the plural because I use pens that are worn differently: one that is drier can be used for light hatching on a building wall; another that is newer with more ink is great for the dark shadows.

SEAFIRST

HOWARD

RIVERSIDE

BUS WAITING AREA

SEMI-ENCLOSED
PEDESTRIAN
WAITING AREA

PARKADE PLAZA

AUTO ACCESS TO GARAGE

BUS WAITING AREA

EXAMPLE THREE:
TURNBACK TRANSFER FAC
ON HOWARD

SPOKANE. When vertical dimensions are substantial, such as in high-rise buildings or mountainous landscapes, the one-point birds-eye perspective view can be dramatic and fun. This is a Pentel Sign pen drawing in freehand on vellum. Shadows are essentially opaque to dramatize the building shapes. Speed, clarity of value, and basic detail combine to make this a powerful graphic.

OPAQUE SHADOWS. I use opaque or solid shadows when I want to increase the value contrast between the building or landscape shape and the ground plane. Solid black or very dense scribble techniques are effective.

BRICK. I am less interested in perfectly illustrating or rendering brick as I am in semi-abstractly implying brick in design development sketches. A small amount of detail communicates the brick materials in these examples, enough to reinforce the more distant horizontal lines without vertical joints that also represent brick materials.

Buildings, Building Components, and Materials

This book deals more with drawing in the act of design and design communication than rendering and final presentation. The following discussion on materials applies to design process drawings and does not cover all of the more detailed rendering techniques.

Brick. How much detail to communicate is a function of distance between the observer and the material. Brick material is best accomplished by line work representing coursework and brick dimensions, usually the course height. I very seldom put in the vertical coursework unless the view is close and the detail is necessary to the description. When the vertical courses are desired, a partial application at one of the corners saves time and busy-ness in the drawing. The rest of the vertical lines are faded out and omitted. See the accompanying examples and captions.

Stone. Characteristics of stone that can be drawn with line work include irregular outline shapes, and/or varying directions in the surface textures suitable for hatching that go in different directions, as in *Stone Wall 1*. Dots and spatters are very effective in adding texture and surface variation to stone shapes. They also keep their symbolism when shadows using hatching are layered over them, as in *Stone Wall 2*.

STONE. Lines representing coursing with large scale stone shapes, supplemented with dots, provide an excellent quick stone effect.

Concrete. Concrete has textured surfaces that can be represented by dots, spatters, and shadow line effects. Dots can be either uniformly spread across the plane or clustered to illustrate varying surface textures. Spattering is similar but requires masking with paper, tape, or masking fluid. Ribbed concrete can be illustrated with dots and hatching in the shadow areas. The dots are more realistic for the granular material of concrete. I stylize the stone work. If more realism is desired, refer to photographs and field observations for detail.

CONCRETE. Dot patterns combined with larger shapes uninterrupted with line work (except the occasional expansion joint) are effective indicators of concrete. Diagonal hatching can add value for shadows without being confused for joints.

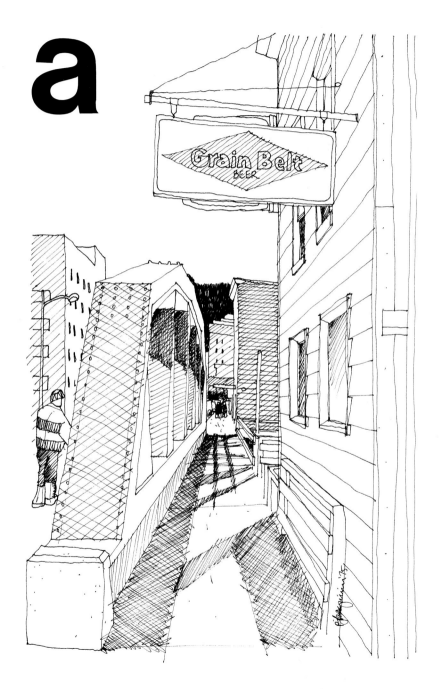

Wood. Its dimensions and grain characterize wood. As in brick, horizontal lines with spacing that approximates the siding width, vertical lines, and shingle courses can represent wood siding.

Roofing. Composition roofing and shake roofs are defined by their dimensions and coursing. Since the coursing can be extensive, often it is better to omit the detail and treat roofs as light or dark planes (shaded with hatching). Metal roofing materials often have larger coursing dimensions and are easier to depict without making the drawing busy.

WOOD AND ROOFING MATERIALS. Wood is usually a linear line pattern with varying heights. Edge details often help represent wood, as the lines meet window trim, etc. Distant wood walls often have larger spacing in between vertical lines, helping to distinguish them from brick materials. Wood can also be easily represented with lines that are directional, such as vertical siding or smaller shingle shapes. Roofing is also distinguished by the outline of material units: seams for metal roofing, scallop or looping shapes for shingles and tiles.

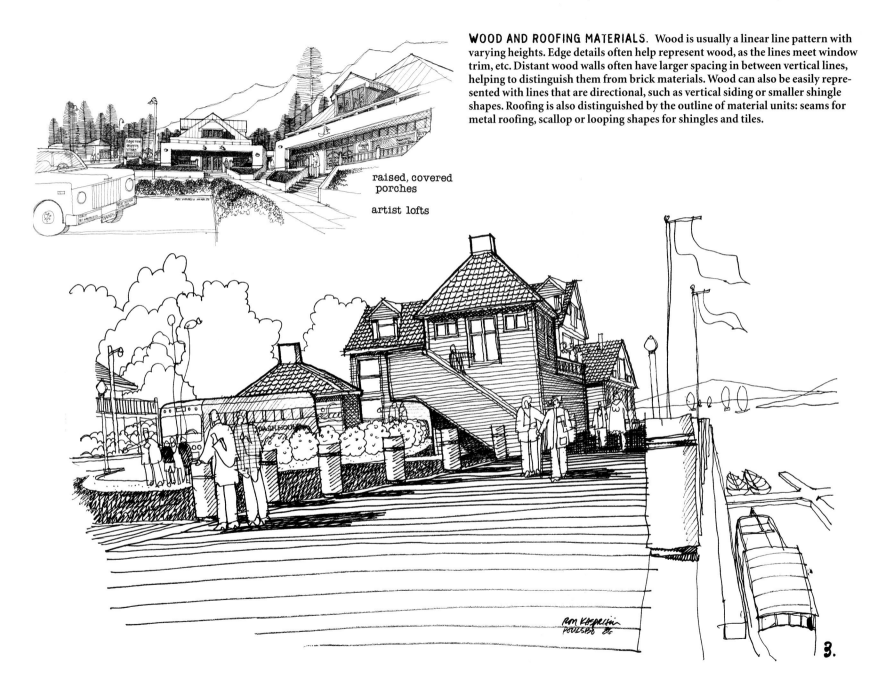

raised, covered porches

artist lofts

3.

WATER. Water shapes are often unifying compositional elements in a design sketch or plan. Techniques range from opaque (black) to light line patterns containing reflections and shadows. Black or opaque shapes provide the most contrast with white or light shapes. Transparent water effects can be used to represent depths within the water, using same-direction line density variations (skipping every other line for a lighter shape). In perspective, where a light value is desired, lines expressing movement of water or the distortion of reflections on the water surface can quickly and effectively represent water and its surface conditions. How? Draw the outlines of reflected shadow! In perspectives with more distant water shapes, horizontal lines closer together or graded from close to closer represent the movement of rippling of the water surface without unnecessary detail.

Water and Sky Shapes

Water and Sky. Water and sky elements are supporting shapes in most drawings, often understated. If they are not added as competing or disruptive effects, they can add realism and excitement to design drawings.

Water in Plan. Drawing water in plan with pen and ink can be done as line work or as an opaque solid or wash. When using lines, the entire surface area can be lined, or they can be limited to the embankment-edge shadow and/or other shadows on the water. Again, speed is important when doing design studies, so decide what is most effective for the time allowed. A part of the decision is value. The water shape provides an opportunity to develop light to dark relationships between major shapes. The water can be a unifying shape for the entire drawing—dark when all other shapes are lighter or light when most other shapes are darker.

Vertical lines are less confusing when used for water surfaces because grasses and other vegetation are often drawn with close horizontal lines. Avoid stripes. Place lines close to or even overlapping one another. With vertical lines, reflections and shadows are easy to add as additional overlain lines in the same direction. Value can be adjusted darker with additional layers.

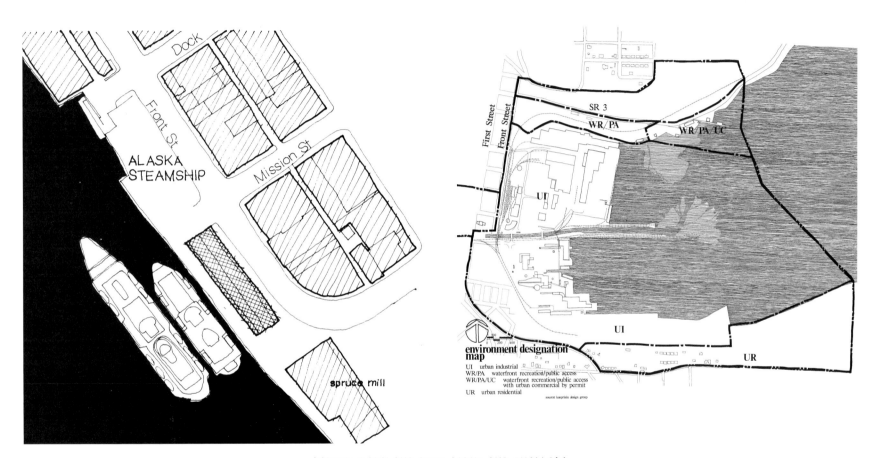

WATER: DARK AND DEEP, LIGHT AND SHALLOW.

Water in Perspective. Drawing water in perspective can be done with vertical or horizontal lines and lines that align with the vanishing points. I prefer fine or lightweight lines for water because they do not over-power the other shapes. Fine lines, .30 technical pen for example, are capable of taking numerous overlays for shadows and reflections.

REFLECTIONS. Without spending excessive amounts of time, use simple overlay techniques to represent reflections by placing one layer of lines over the previous layer(s). In some cases, vertical lines over horizontal, or lines parallel to the first layer, help define reflected images. A positive reflection is one where the object being reflected is drawn in a darker value (more lines) and a negative reflection is drawn with less lines than the background water shapes.

Reflections. Reflections in water mirror the sky and surrounding objects. With pen and ink, reflections can be drawn with line work, both vertical and horizontal, and opaque washes.

Key principles for reflections are:

- The height of a reflected object is the same as that object.
- Angles are reflected in reverse.
- The value of the water surface can be slightly darker than the object and sky being reflected, representing value changed by the depth of the water.
- The edges of reflected objects in the water are improved by inter-locking reflections with adjacent reflections, a characteristic of water movement from wind and wave action.

Clouds. Sky shapes are best left open unless the weather or cloud formations are critical to the graphic communication. In the Pacific Northwest, it rains a lot and clouds are a natural part of the skyscape. Florida's afternoon storm clouds are contextual shapes that connect sky and water the way mountains do in Washington, Oregon, and British Columbia. I use clouds for the following reasons: to depict weather patterns useful in the communication, to add shapes that help unify the composition, and to hide or mask out other background shapes that are redundant or a lot of unnecessary work (mountains, cityscape, etc.).

Rain. Rain can be both drawn with lines and dots and implied with negative space. Fine line weights can indicate rain and its direction. Large rain squalls can be blank negative shapes when integrated with line work and dots.

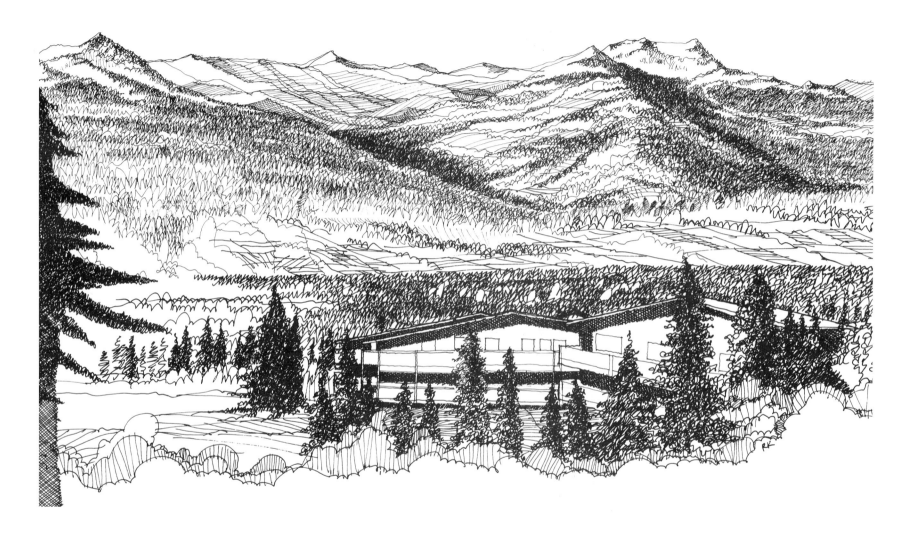

Landscape Elements: Trees, Shrubs, Other Vegetation, and Hard-Landscape Elements

Trees. I use trees in design drawings as massing devices and as broad tree types rather than as specific tree species. I am usually concerned with concepts and their communication to clients and community members for architecture and urban design subjects. Obviously, projects where the landscape architecture needs to be specified according to species will have more detail. The emphasis in this book, however, is not on final presentation imagery.

TREE MASSING. As massing devices, trees are used to indicate compositional elements, vegetative massing, tree type by outline, tree size, and tree details as value techniques.

TREE SHAPES AND TEXTURES. I use looping line work for distant tree shapes because the loops reflect the vertical and repetitious yet variable size of many trees together. I add value in clusters, adding additional variety to a repetitive technique. Add value in layers. Don't try to achieve the desired effect in one application. Other techniques for distant tree masses include vertical lines overlain with diagonal slashing lines. Close-up trees require more detail definition without drawing in every leaf or bough. Line shapes that are rounded, looping, irregular, and/or squiggly represent organic tree shapes much more effectively than circular lollipop shapes. Remember to introduce value patterns among the tree shapes, using light and dark contrasts to attract the viewer. In some cases, a simple diagonal hatching can add a layer of value to a lightly articulated tree mass without drawing in another detailed layer of foliage shapes.

Hard-Landscape Elements. The accompanying examples, and others throughout this chapter, illustrate paving, street furniture, textures, and other hard features in the landscape. This is accomplished by outlining shape characteristics of specific materials or building units, and/or by defining shape with texture and values.

HARD-LANDSCAPE ELEMENTS. Outlines of identifiable hard-scape elements are often sufficient to represent fences, sculpture, street furniture, signs, and others. Keeping shapes simple and adding value with shadows can communicate concepts and enough detail without extensive rendering. People, cars, and trees are often the most troublesome shapes to students. They are the shapes that sour a good illustration because they are overly fantasied or cartoon-ish, or overly detailed. I try to keep them simple and a bit semi-abstract unless the content of the graphic calls for more detailed representation. Develop your own style. Remember that if a shape is a supporting actor, you shouldn't let it dominate the show.

HOSTMARK LANDING

APPLICATIONS

Drawing techniques are only as good as their effectiveness in graphically communicating design ideas. Sketching design concepts, diagramming space program information and organizational relationships, and preparing *quick* design alternatives greatly benefit client and public meetings.

Each person has favorite methods and techniques. Developing a personal style from the many approaches already in use is advised for familiarity, confidence, and as a personal signature. The following are examples of a style that I have developed over many years under tight budgets and time constraints, but always with a love of drawing. When time permits, I use technical pens because of their sharp, crisp lines, working them quickly and loosely. For an even faster pace, my other tool of choice is the Pentel Sign pen. Experiment for yourself as there are many quality pens on the market. In any event, the examples that follow are meant to be executed quickly with strong values. I hope they encourage you to pursue your own techniques.

Context: Field Sketching and Site Inventory

Drawing in the field in any medium captures a freshness and energy superior to sketching from slides or prints. Since light and other field conditions can change, quick drawing techniques are helpful. Students are often intimidated by the act of drawing out-of-doors because of the sheer number and complexity of shapes. Two basic guidelines help me in the field:

- Filter out unnecessary detail.
- Establish a boundary or frame for the sketch.

FIELD SKETCHING. Sketches in the field are important information gathering tools because they require the designer to assess in detail what he or she is observing. From composition to the values and colors of a scene, the act of drawing it as a recording device in effect loads the human brain with imprints and images. Too often with field photography, the designer selects a composition, takes the picture, and moves on, missing valuable detail and characteristics. I hope you have had the opportunity of observing the difference in quality between a sketch made in the field and one made in a studio from a slide or photograph. In my opinion, there is no comparison. The following examples represent sketches made on site, including the first one, which was sketched in a small museum in Canmore, Alberta from an historic photograph. A Pentel Sign pen again is used to quickly rough in shapes and add value. I believe contour drawing is the most effective technique for field sketching, selecting a composition and drawing only what I see.

Here are summaries of sketching techniques that are useful for pen and ink in the field.

Contour Drawing. Contours are outlines or edges of shapes. The basic principles of modified contour sketching are: draw within a frame or window that encloses your composition; aggregate shapes, avoid unnecessary detail; use the frame as a reference grid; draw only what you see, not what you think you have memorized.

DRAW WITHIN A FRAME OR WINDOW. Make a view finder from card- or illustration board with a 3 inch by 5 inch or larger proportion cut-out, similar to a window in a frame. Along the edge of the window itself, mark the centers and quarters of each side for reference; dark enough so you can see the marks at arm's length. Some people actually make a grid across a plastic window for additional reference. Make a similar window, larger but in the same proportions, on your sketchpad. Transfer the center and quadrant marks so that you have a common reference from view finder to sketchpad. You can hold up the view finder to determine the view to be sketched. Move your hand to and away from you for a larger or smaller view. Make your decision. See where certain shapes within the view meet the edge of the view window. Select a point along the window where an edge of a shape intersects the edge. Now you are ready to sketch.

hip roof

single pitch slot roof.

continuous covered walk

Built up

parking 34 m in width (9m)
① on grd
② on 1st — width issue #23-28 (feet)
③ Railway — "happy bus" Banff (Trade)

AGGREGATE SHAPES. Many artists limit a sketch or drawing to a maximum of twelve (12) shapes. Let's take the hint and do the same. It helps filter out confusing detail that can be added later. Look at the view and group shapes together. For example, a hillside can be one shape, the outline of all of the trees, rather than each tree drawn separately. Or, multiple buildings can be grouped together for the initial sketch, with the hillside, sky, and water all additional sketches. Detail can be added as a second or third task; or in the office from field photographs.

USE THE FRAME AS A REFERENCE GRID. Don't hesitate to use the view finder to reaffirm your view and composition. Obviously, try to hold your position and point of view.

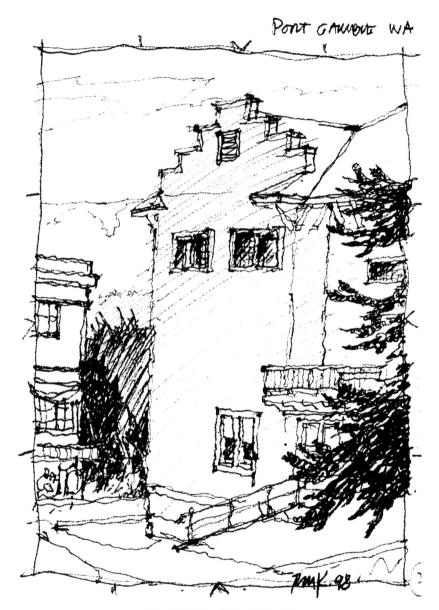

PORT GAMBLE, WASHINGTON.

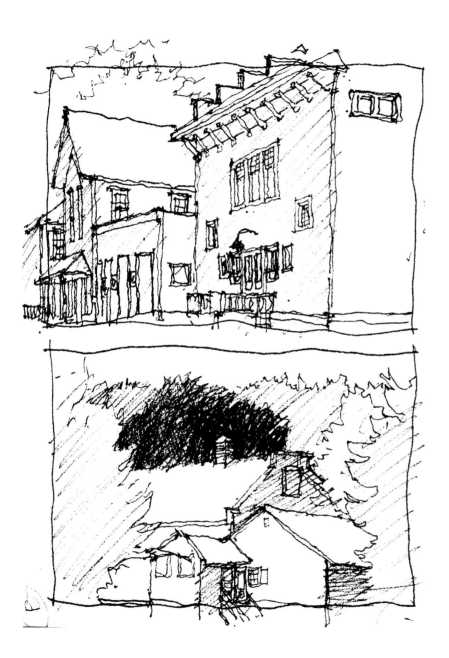

DRAW ONLY WHAT YOU SEE. After the view is selected *and studied* within the frame, put the frame away and begin drawing what you see, using aggregate shapes. Modified contour drawing requires the person sketching to *really* look at the angles and curves of the objects in the view, piece by piece, increment by increment. Draw overall outlines first; then follow edges from the outlines into the interior shapes. Look for edges and value changes as lines to draw.

Another version of contour drawing consists of doing a small thumbnail sketch with very little detail, 3 inches by 5 inches for example. On a larger sketchpad, draw the frame and edge marks and blow-up the sketch using the marks as a guide (look at where lines meet the frame-edge on the thumbnail sketch and replicate on the larger sketch). In the field, I often do numerous small sketches and then enlarge them in the office using the frame-edge-marks.

Dot to Dot Sketching. Dot to dot sketching is another version of contour drawing where a dot is placed at each change in direction of the object's line (outline, value change, etc.). As in contour drawing, *the pen remains on the paper at all times.* As a change in direction is reached, anticipate the length and end point of the next increment; and, draw a line along that length and place a dot at its end. Repeat for the next directional change. Some artists suggest that this procedure eliminate curved lines altogether and rely on straight lines only. The more directional changes, the more "curved" the aggregate straight lines and their dots become. A quick overlay can then produce a finished sketch with curves and straight lines.

Program, Concept, and Design Concept Development Drawings

Diagrams. Graphic diagramming is a semi-abstract visualization of information in organizations, structures, and contexts; relationships of parts; and, design ideas in various states. The pen and ink are ideally suited for diagrams because of the choice of line, weight, and patterns. The basic rules of shape, value, and relationship apply. A diagram that has a lot of graphic information but is weak on composition or crowded and overstated is not a good communication. When diagramming, consider these suggestions:

- Rough out all preferred information on a base plan, axonometric, etc.
- Decide what priorities and hierarchies are present in the information
- Assign graphic values to that hierarchy and select symbols and patterns to represent information and relationships
- Prepare a draft diagram to test the amount and expression of information
- Do it again if necessary. Drawing with fast techniques means more alternatives and graphic tests.

PLAN DIAGRAM. Plans are quantitative and measurable. Their added value as conceptual diagrams occurs when the material is semi-abstracted to convey conditions and relationships without additional detail. There are many variations of plan diagrams; use your imagination but maintain a reasonable scale and reference and orientation images to reduce exaggeration.

site and adjacent states

LOCATION DIAGRAMS. Diagrams are often forgotten in the design and planning process. In many ways, they represent a logic or flow diagram of needs and spatial organization and structure. This is not a rendering issue but one of communicating complex ideas simply. Struggling to make a diagram work is important to making a design work. Basic location diagrams are effective for public meetings, presentations, and project reference and orientation. A fine point technical pen was used for all line work in the Washington State map diagram, except for the darker and wider Graphos nib line for state and provincial boundaries. Simple hatching and value contrast techniques highlight the diagrams: the boundaries are important in the upper diagram and the distances, not the boundaries, in the lower diagram, communicated through value.

mileage distances

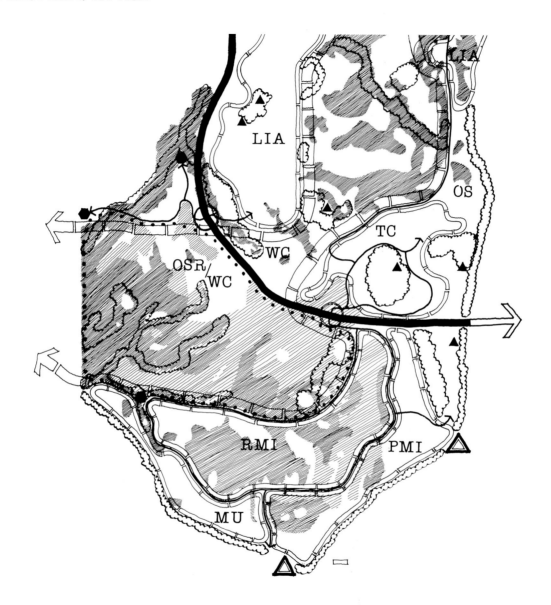

POINT MACKENZIE. Hatching, squiggles, and value contrasts all combine to communicate land use policy recommendations for an outlying Anchorage area port development. Strong, clear value patterns were made with technical pens on mylar. Darker lines were made with a Graphos nib pen.

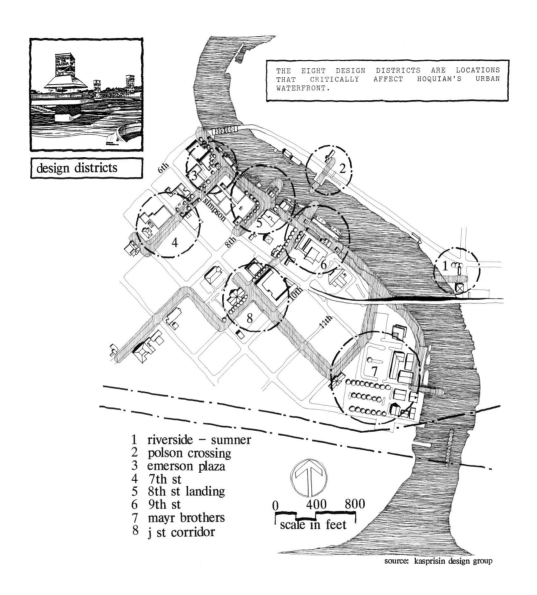

design districts

THE EIGHT DESIGN DISTRICTS ARE LOCATIONS THAT CRITICALLY AFFECT HOQUIAM'S URBAN WATERFRONT.

1 riverside – sumner
2 polson crossing
3 emerson plaza
4 7th st
5 8th st landing
6 9th st
7 mayr brothers
8 j st corridor

0 400 800
scale in feet

source: kasprisin design group

HOQUIAM WATERFRONT. This implementation strategy diagram has detail representing key buildings and streets with an overlay indicating priority design districts. The circles focus attention on the districts and were drawn with a Graphos nib pen (or heavier technical pen point). Light hatching on key streets emphasizes the connections between districts.

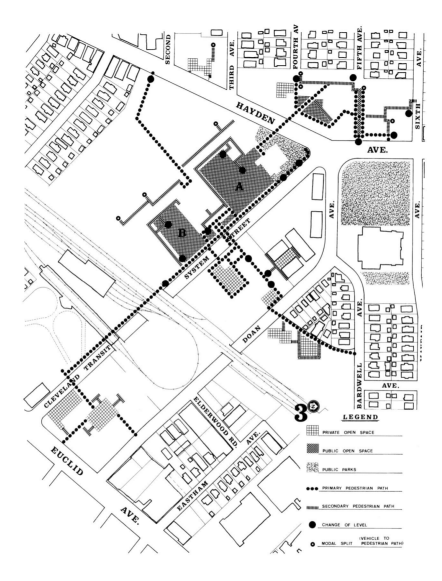

LEGEND

- ▦ PRIVATE OPEN SPACE
- ▨ PUBLIC OPEN SPACE
- ▒ PUBLIC PARKS
- ●●● PRIMARY PEDESTRIAN PATH
- ||||| SECONDARY PEDESTRIAN PATH
- ● CHANGE OF LEVEL
- ○ MODAL SPLIT (VEHICLE TO PEDESTRIAN PATH)

EAST CLEVELAND. This diagram is composed of press-on sticky-back patterns. Mylar is an excellent base as it does not tear or cut. Plan the diagram's shapes, values, and patterns before cutting and burnishing the press-on material. This method is less used but provides a good example of clip-art application with computer graphics. The basic principles of value hierarchy and contrast apply to communicate spatial organization and structure.

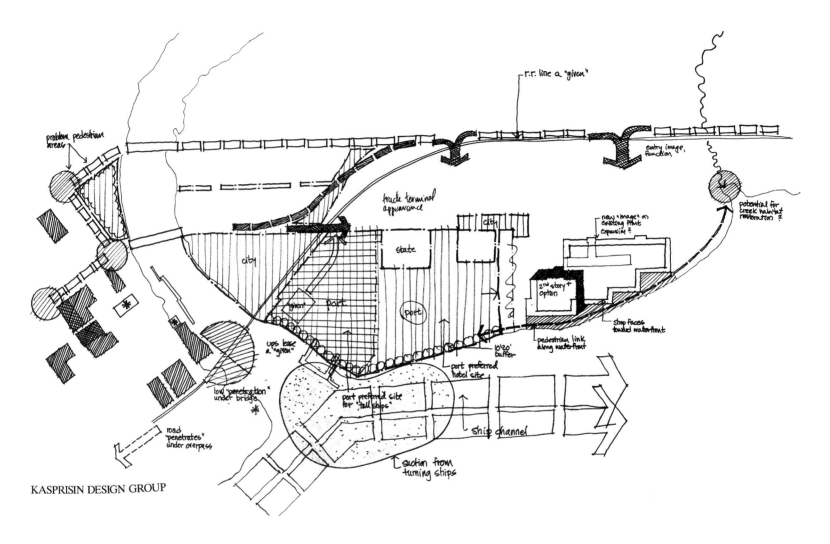

r.r. line a "given"

entry image, function

problem pedestrian areas

truck terminal appearance

city

new "image" as existing Plant expansion ?

state

city

2nd story + option

potential for creek habitat restoration ?

city

shop faces toward waterfront

port

port

pedestrian link along waterfront

"given"

ups lease a "given"

10'-20' buffer

port preferred hotel site

low "penetration" under bridge

port preferred site for "tall ships"

ship channel

road "penetrates" under overpass

suction from turning ships

KASPRISIN DESIGN GROUP

ABERDEEN. Diagrams assist in spatially organizing uses and movement patterns prior to setting geometry to a site. This Pentel Sign pen concept diagram was useful for the design team and as a presentation tool at public meetings. I draw many of these on gridded vellum, using the grid as a guide to freehand in patterns and symbols.

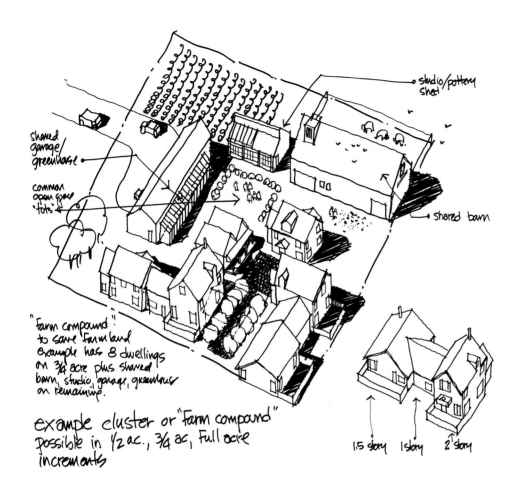

studio/pottery shed

shared garage greenhouse

common open space "tots"

shared barn

"farm compound"
to save farmland
example has 8 dwellings
on 3/4 acre plus shared
barn, studio, garage, greenhouse
on remaining.

example cluster or "farm compound"
possible in 1/2 ac., 3/4 ac., full acre
increments

1.5 story 1 story 2 story

attached "meandering" farm house
- 2 dwelling units
- mixed tenant/owner types (senior/family/empty nester)

"guest house" 60 ft. diameter
- 430 sf to 530 sf dwelling (example only)
- 1 story w/ loft

"relative's house" 80 ft. diameter
- 1500 sf dwelling (example only)
- 1.5 story

"main house" 110 ft. diameter
- 2320 sf dwelling (example only)
- 2 story + 1 story

AXONOMETRIC DIAGRAMS. Axonometrics are measurable-to-scale drawings in most cases. They function as a plan diagram with the added benefit of a third dimension. In this series, rural farmstead housing models are explored in three dimensions. The resulting concept and design development drawings are also useful in meetings and public participation events, easily viewed by the lay public.

This was done with Pentel Sign pen on gridded vellum in freehand. In many cases, I make templates of key housing types and trace them onto the final vellum when the design is finalized. Opaque shadows contrast the building shapes from the ground plane, making them easier to view.

AXONOMETRIC DIAGRAM. Axonometric diagrams combine the measurable plan with a measurable vertical dimension—creating a three-dimensional graphic that is both qualitative and quantitative. I use them extensively and I encourage the student to explore their design applications as a visual thinking tool.

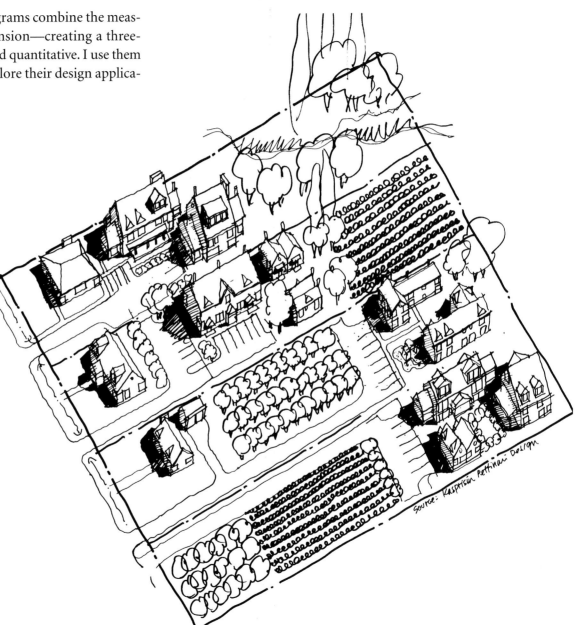

Source: Kasprisin Pettinari Design

AXONOMETRIC DIAGRAMS (continued). Comox, British Columbia.

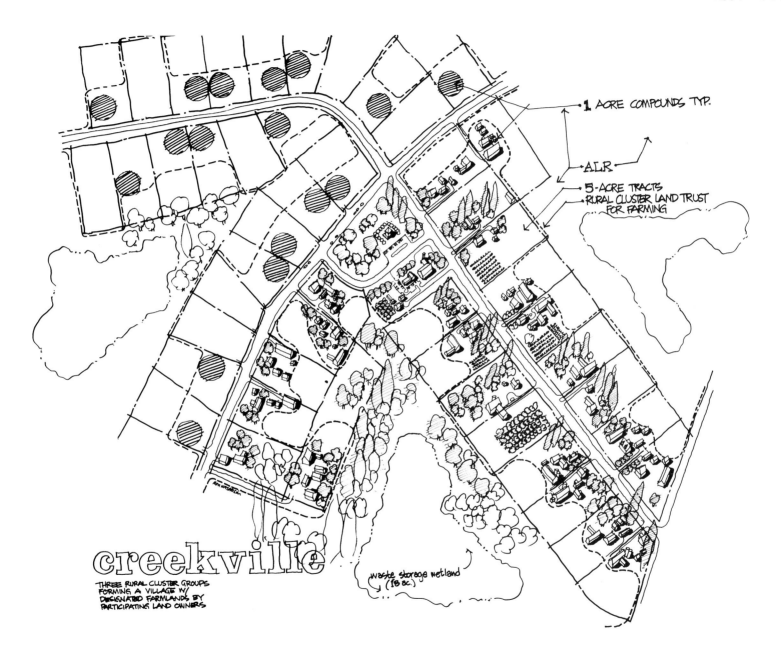

1 ACRE COMPOUNDS TYP.

ALR

5-ACRE TRACTS
RURAL CLUSTER LAND TRUST
FOR FARMING

creekville

THREE RURAL CLUSTER GROUPS
FORMING A VILLAGE W/
DESIGNATED FARMLANDS BY
PARTICIPATING LAND OWNERS

waste storage wetland
(18 ac.)

PERSPECTIVE DIAGRAM. Perspectives are selected three-dimensional views that provide a sense of realism to design concepts. They are dependent upon the point of view of the observer. When used with plans, elevations, and sections, they add a multi-dimensional relationship to planes, axes, and other geometrics. Some perspectives, such as the one-point birds-eye, can be both qualitative and quantitative (the ground plane is a plan—to scale and measurable).

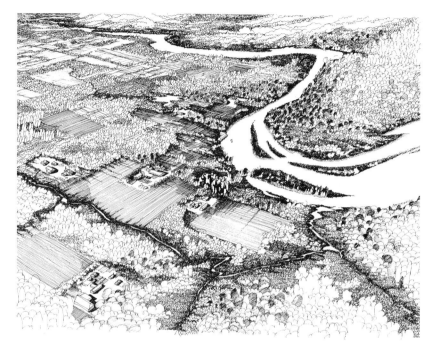

KASPRISIN

WILSONVILLE. This aerial oblique perspective series was drawn with a fine point technical pen on vellum. Looping lines, hatching lines, scribbles, and numerous overlays to build value contributed to the final effects. The river shape was left white to increase the contrast between land and water. Darker value patterns help emphasize building masses, the river, and undeveloped areas. Dark values along the river edge help dramatize the river corridor. This edge is composed of layers of scribbles, built up to the desired darker value.

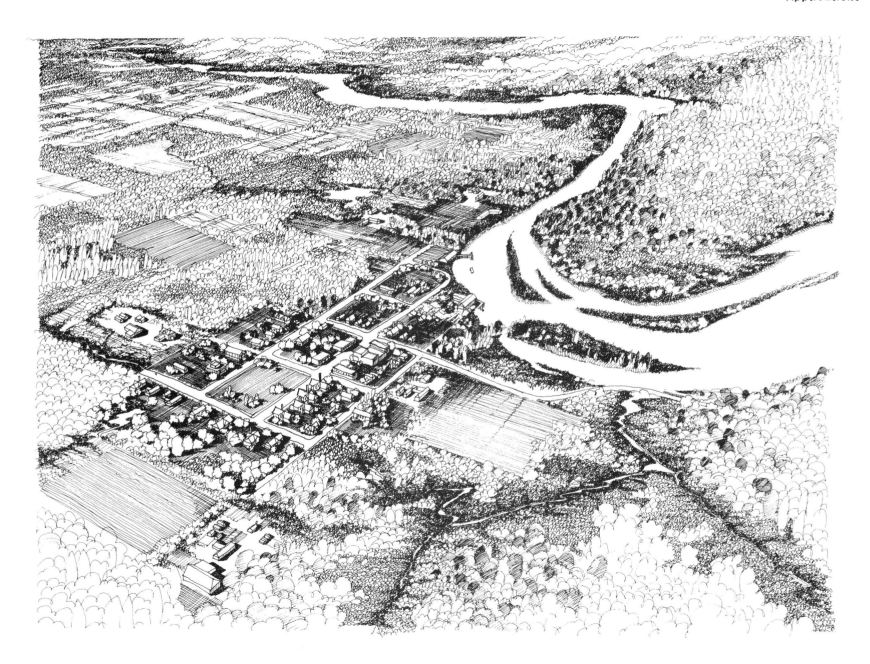

WILSONVILLE (continued).

Context and Scale. Concept and design development drawings are effective when they are *in a context* and *to scale*, no matter how sketchy. The examples shown are from various urban design projects that involve the testing of community development regulations with design scenarios and the communicating of development policy and regulation to citizens. Techniques are described in the accompanying captions.

The following examples represent pen and ink drawings ranging from metropolitan and regional scales to town and cityscape scales. Many examples describe a larger context for urban design proposals or community education exercises related to design and development issues. These examples can be accomplished with an economy of time—working fast, yet loose, with consistency in line work and an attention to composition and value. The intent of the drawings is to express ideas quickly and effectively, with a crafted characteristic unmatched by digital means.

SUSTAINABLE
RACINE

Bird's-Eye View
Urban Environment & Lake Front

SUSTAINABLE RACINE HINTERLAND. A U.S. Geological Survey (USGS) map was photographed with slide film at an oblique angle, approximating 30 degrees; the slide was projected onto tracing paper at the desired size (24″ × 30″) and traced (major streets and landforms only). The final ink drawing was completed using scribbling and layered value techniques.

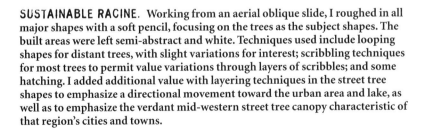

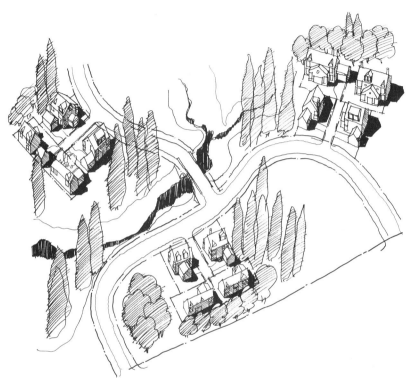

SUSTAINABLE RACINE. Working from an aerial oblique slide, I roughed in all major shapes with a soft pencil, focusing on the trees as the subject shapes. The built areas were left semi-abstract and white. Techniques used include looping shapes for distant trees, with slight variations for interest; scribbling techniques for most trees to permit value variations through layers of scribbles; and some hatching. I added additional value with layering techniques in the street tree shapes to emphasize a directional movement toward the urban area and lake, as well as to emphasize the verdant mid-western street tree canopy characteristic of that region's cities and towns.

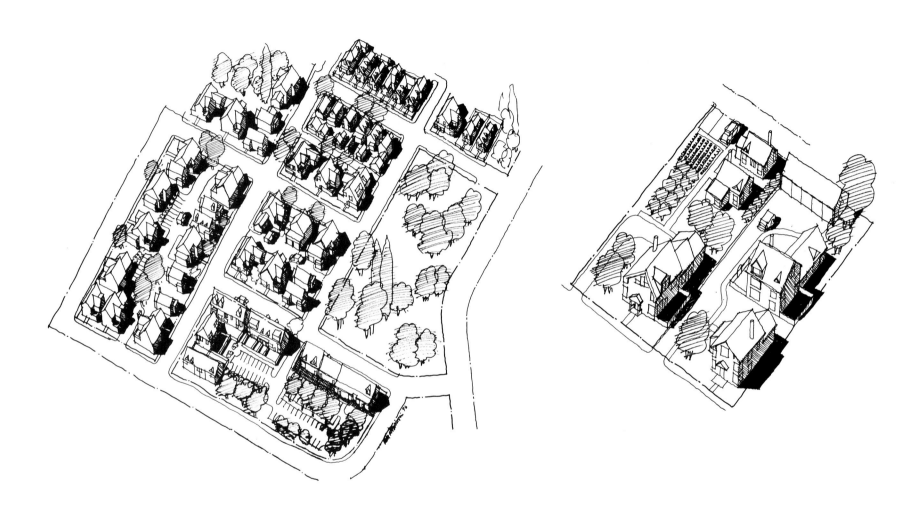

COMOX-STRATHCONA SERIES. This series of Pentel Sign pen drawings is a part of a design guideline package for the Comox-Strathcona Regional District on Vancouver Island, British Columbia. It summarizes a fast yet effective drawing style and technique for two- and three-dimensional images. All drawings were done on 17″ × 22″ gridded vellum, freehand, suitable for reproduction and public presentations. Color is always an added option to bond prints of the original drawings.

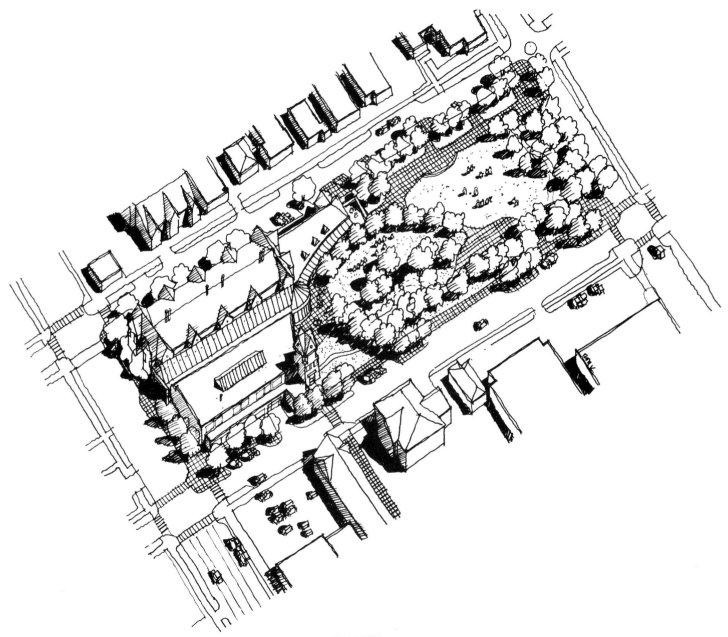

BALLARD.

UW CHARRETTE.

Site Concept Axonometric Sketch

CITY OF BREMERTON DOWNTOWN/WATERFRONT REVITALIZATION PROJECT

north

0 20 40 80 feet

Tonkin Hoyne Architects Kasprisin Pettinari Design

Site Concept Axonometric Sketch

CITY OF BREMERTON DOWNTOWN/WATERFRONT REVITALIZATION PROJECT

north

Tonkin Hoyne Architects Kasprisin Pettinari Design

Second Street Hill Climb

1 Gateway
2 Gateway Information/Cafe Building
3 OverWater Park
4 Office building with retail arcade
5 Residential over retail arcade
6 Short term parking
7 Local access street
8 Hill Climb with shops and housing
9 Restrooms/Public Services
10 Community meeting room (up) with
 open market/multipurpose space
 (down)
11 Residential over retail
12 Market area with booths
13 Residential
Source: Tonkin Hoyne/Kasprisin Pettinari Design

BREMERTON WATERFRONT. Once I mass in an axonometric, drawing additional options is fast and half the effort of the first. I begin with a sketch outline plan on gridded vellum with little detail. I raise the verticals and draw in the initial three-dimensional massing. Then I add necessary detail before transferring the design to final vellum, in this case with a Pentel Sign pen. Four alternative axonometrics were completed in a short time once the initial basic plan and massing were completed, making modifications to the plan for each alternative.

spuce in

CONVENTION CENTER.

WASHINGTON SCHOOL SITE.

PORT GAMBLE.

WILSONVILLE MARINA.

WILSONVILLE DEPOT.

SOUTH CAMPUS.

BALLARD STATION.

THE GHOST.

UW CLASSROOMS. Hatching at different densities provides enough value difference without adding additional layers. Window openings are kept transparent with cross-hatching. Just the outline of a tree is enough to create the edge of the image. Pentel Sign pen was the drawing tool.

BIBLIOGRAPHY

Cullen, Gordon. 1961. *Townscape.* New York: John Wiley & Sons, Inc.

Gosling, David. 1996. *Gordon Cullen: Visions of Urban Design.* London: Academy Editions.

Guptill, Arthur L. 1976. *Rendering in Pen and Ink,* edited by Susan E. Meyer. New York: Watson-Guptill Publications.

Kasprisin, Ronald J., and James Pettinari. 1995. *Visual Thinking for Architects and Designers.* New York: John Wiley & Sons, Inc.

Laseau, Paul. 1980. *Graphic Thinking for Architects and Designers.* New York: John Wiley & Sons, Inc.

3

PASTEL AND COLORED MARKER

INTRODUCTION

Colored pastel and colored marker are fast-applying visual thinking and presentation tools. Their drawing characteristics provide effective spatial analysis and conceptual techniques for the design process because of their "broad-brush" technique capability. They both also lend themselves to detailed finished techniques. They are markedly different in technique and product.

Pastels are best applied in layers, like watercolors, and can be applied in larger washes in pencil or stick form to cover large areas, followed by finer details. Pastels can be blended smoothly or applied with line or texture characteristics. Markers are intense inks suspended in solvents, applied through a fibrous tip. The shape of the tip directs their application: narrow and pointed, wide and flat, narrow and flat, and so on. The tips leave a characteristic marking, either as straight and slightly overlapped lines or as swirling marks. They can be mixed within limits. I find each medium to be appropriate for selective tasks in the design process: pastels for filling out studies and for community and/or client meetings, and markers for diagrams and concept organizations as well as presentation drawings. Pastels can be applied over marker but not the reverse.

Source: James Pettinari.

PASTEL

Materials and Equipment

Pastels are a combination of gum tragacanth, pigment, and precipitated chalk, gypsum, or clay. They consist of pigments mixed with the gum to form a paste, which is molded into sticks and hardened. The word *pastel* comes from the Italian *pastello,* essentially meaning paste.

Types of Pastels

SOFT PASTEL. Soft pastels are square or cylindrical sticks, 2 to 6 inches in length. They are water soluble, soft in texture, and easy to apply with smearing or blending techniques. Their softness comes from a larger proportion of pigment to binder than hard and pencil pastels. Soft pastels break easily, which is not a problem in application or purchase as you most likely will break them anyway. Their application is a broader stroke technique as opposed to a line technique of pastel pencils. Soft pastels have a variety of levels, from student grade to professional quality. Most professional pastels are made of natural materials; student and economy grades can be a combination or all synthetic materials. Many artists use soft pastels for the bulk of their work; whereas designers may find the hard and pencil pastels better for more detailed work. As we discuss, a combination of both is highly effective in design drawing.

HARD PASTEL. Hard pastels are chalk sticks similar to soft pastels. They have more gum binder, making them harder than soft pastels, and are mixed with a black pigment instead of chalk. Hard pastels are useful for drawing outlines, detail, sketching, and hatching. They can be sharpened with a razor blade and to a limited degree with small hand sharpeners. Hard pastels are used in the preliminary stages of pastel paintings and for detailed highlights. They also work well on bond prints with pen and ink drawings. Hard pastel can be erased from bond prints with soft erasers. To erase from textured papers, a soft rag or bristle brush gently applied can be effective.

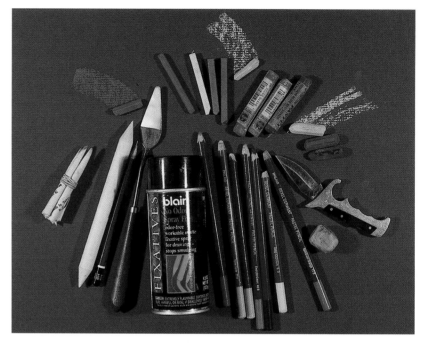

PASTEL MATERIALS.

PASTEL PENCIL. Pastel pencils are hard pastels formed into thin rods or strands and encased in a wooden holder, similar to a graphite or charcoal pencil. Holders are also available for the rods similar to a mechanical pencil that is used to hold a drafting lead. Like hard pastels, they are effective for sketching, hatching, and detail work. They can also be rubbed onto medium size shapes and smeared with success. Pastel pencils can be sharpened with razor blades, sand paper, knives, or hand-held pencil sharpeners. Avoid putting pastel pencils into electric erasers as you will be the scourge of the office. They break off and jam the sharpeners.

OIL PASTEL. Oil pastels are formed by taking the same raw pigments used in soft pastels and heating them in an oil-soluble wax binder, form-

ing a hard-soft "buttery" paste, then molded into sticks or crayons. They are water-resistant, unlike soft and hard pastels. Oil pastels do not have chalk as a binder and are therefore free of dust, which is good news for computer buffs who draw and type in the same space. They need no fixative during the process and are effective for large shapes and areas. They do not erase easily and are more difficult to smear, although they can be worked to a point. Oil pastels are effective on paper that has been through a copier, as they do not coat over with toner as easily as hard pastels.

Papers

Almost any paper (from bond print paper to fine art paper) or illustration board can be used with pastels. A determining factor in which to use is the texture effect desired. Papers with more texture, micro ridges, and valleys receive the pastel on the upper ridges, creating a textured effect. Watercolor paper is an excellent support for pastels with the added advantage that it does not have to be stretched. These papers come in hot pressed (smooth), cold pressed (textured), and rough (very textured), as discussed in Chapter 1.

Pastel papers come in many colors, sizes, edge conditions, and textures. They are usually machine-made, with rag content from 100% to less than 65%. Common paper weights are 64 lb and 80 lb.

Mediums

GUM TURPENTINE. Gum turpentine is an oil-soluble paint medium for both oil and chalk pastels. Like oil painting, the turpentine places the pastel in a soft wash state.

ACRYLIC MEDIUM. Acrylic medium is used to place chalk pastels in a paint-like solution or wash for broad applications.

WINGEL. Wingel is an alkyd painting medium used with oil pastels either to make hard finishes or to speed up the drying process, and with chalk pastels to make transparent glazes.

ZEC. An oil-based paint medium used to add more body to oil pastels and speed up drying.

Fixatives

Pastel fixative is varnish in a diluted solution. It is sprayed onto the pastel layers to fix the underlayment and to provide a base for additional pastel. Workable fixative is used over pastel that has built up in order for additional layers to be added. It has a matte finish. Final fixative is used as a last coat to adhere the pastel particles permanently to the paper. Acrylic fixative is stronger than workable and final fixative. It can have a shiny or glossy finish (depending on the amount used) and makes it more difficult to remove color. Read the instructions on the spray cans carefully. Always spray in well-ventilated areas, preferably outdoors.

Tools

BLENDING STUMPS AND TORTILLONS (OR TORCHONS). Blending stumps and tortillons/torchons are composed of paper rolled into a thin cylinder or stick blotting tool. Tortillons are longer than blending stumps are used as blending and wash or spreading tools. Your fingers are excellent blending tools but the stumps are narrow; they are useful for smaller areas and finer detail.

PALETTE KNIVES. Palette knives are flat metal tools, like trowels. Use them to scrape away or apply color. They are also used to press the loose pastel into the paper or board, and for mixing and spreading solvents and mediums.

FOAM ROLLERS. Foam rollers are used in mixed media applications to spread acrylic mediums over chalk pastels. They pick up less dust or loose pastel. When used with oil-based mediums with oil pastel or sticks, they are excellent for smoothing out rough textures.

RAZOR BLADES AND X-ACTO KNIVES. These are used for scraping colors after their applications and for scraping colors from sticks (to create dust) for application.

HOLDERS. Pastel holders are used for both soft and oil pastels, and are particularly useful for smaller, broken pieces. Hard pastel "leads" are easier to sharpen in holders.

ERASERS. Kneaded, soap, or pink pearl erasers all work well on pastels for removal and touch-up. Pastel can sometimes coat the harder erasers, making it harder to pick up pastel. Wipe or scrub the eraser on a clean piece of paper to remove the built-up coating before proceeding. A preferred method is to press the eraser to the pastel surface rather than rubbing or smearing.

SPREADING MATERIALS. Tissue paper, paper toweling, soft rags, and chamois cloth are all used to spread and smear pastel. Experiment with various types to determine which works better for you.

BRUSHES. Watercolor brushes such as mop or wash types are useful for blending pastel colors. Bristol brushes are useful for removing pastel particles in areas that have not been oversaturated or heavily coated. The brushes can loosen particles that can then be lifted off with an eraser.

Color

Unlike watercolors, mixing secondary and colored grays from basic primaries is not standard practice in pastels because they are opaque—pigments suspended in chalk. Consequently, pastel colors are available in a range of up to eight value grades per color, making the selection very large. Picking pastel colors can be manageable if done according to the needs of the application: lighting, atmosphere, local color of materials, intense vs. earthy, cool vs. warm, etc. Pastel artists suggest buying at least three shades of value per color, i.e., light, middle, and dark (Roddon 1987).

Color Palette. The color palette in pastels is extensive. Since all pastels are opaque, brilliance rather than transparency differentiate the palettes. Colors can be mixed with hatching and overlays from the primaries, but most pastel colors are pre-mixed.

Color Complements. Color complements or opposites work the same in pastel as they do in watercolor. They are opposite on the color wheel but complementary when placed next to one another.

Color Grays. Colored grays can be mixed as well as used as pre-mixes. They are essentially the tertiary colors, a mixture of the three primaries. See Chapter 1 for a more complete discussion of color.

Principles

- Pastels are worked in multiple layers.
- Layering adds more colored chalk to the paper, gradually filling in the paper fibers.
- Oversaturating the paper with pastel pigments results in muddy or dull gray color.
- Pastel is applied in numerous ways:

 with broad strokes and fine lines with the side or tip and/or edge of the stick, respectively

 by dusting (i.e., scraping pastel particles from the stick onto the paper) then spreading with knives, razor blades, or papers

 spread as a paint when mixed with paint solvents

 as hatching or cross-hatching (parallel lines)

- Fixative can be used after each layer of pastel to create a base for additional layers
- Pastel can be worked in numerous ways:

 removed with erasers, razor blades, and knives

 smeared and spread with cloth, fingers, tortillons or stumps, and paper

 (if fixative is being used) scumbling uses pastels in multiple layers to create texture, with fixative applied between each layer

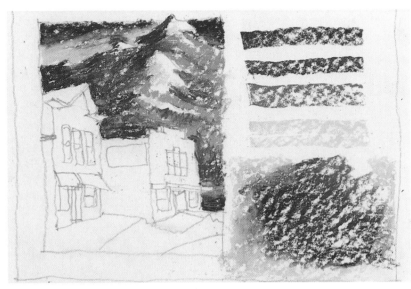

BROAD OR FLAT STROKES. Break a soft pastel into a 1-inch length and move its length across the paper. The paper texture is inherent in the stroke characteristic. I also used the edge of the sectional round to apply chalk to detailed edges or boundaries. Broad strokes can be overlapped to mix additional colors.

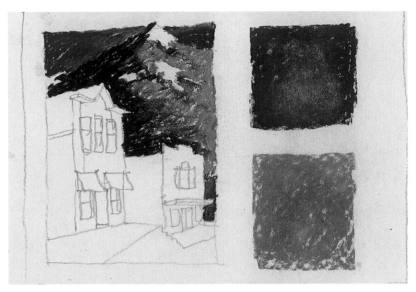

DUSTING. A soft application using the edge and broad strokes laid the foundation for the mountains in this Haines Main Street sketch. Yellow and orange chalk flakes were scraped or dusted off of the sticks onto the foundation to add highlights. These images have been fixed, which darkens and spreads the chalk dust. A red pastel pencil was used for the sketch outline.

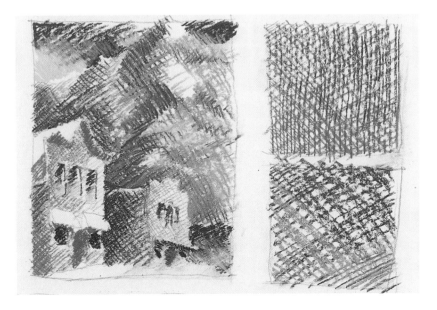

HATCHING. In this fast sketch, hatches and crosshatches of various colors establish color, complements, and value. A combination of hard pastel sticks and soft pastels were used as overlays.

At the point that you would use fixative, you can instead apply a layer of flimsy tracing paper or cellophane over the painting; cover that with a large flat weight like a wood board, and apply pressure. This adheres the particles to the surface of the support or paper without darkening or making the pastel into a slight paste (impasto) by using fixative. Many artists contend that the pastel without fixative eventually fixes itself by absorbing natural moisture over time (Roddon 1987).

Not using fixative maintains the original colors of the pastels. Fixative darkens color. For designers, the fixative is a convenient way to add layers without oversaturating. Considering the need for detail in many architecture and landscape architecture subjects, and the need to take sketches and studies to client and public meetings, using layers of fixative is effective. A nice alternative, if the paper support is fairly light, is to fix the paper from the back by holding up the paper and spraying the backside. The fixative soaks through enough to fix the pastel without making it a paste (Roddon 1987).

Approaches and Process

Pastel applications are done in layers. Pastel colors are opaque, not transparent or translucent unless very thinly applied. Consequently, light colors can be added over darker colors and blended, unlike watercolor. Working from dark colors to light colors is an effective approach because it enables you to establish a value limit or range early in the work. The principles of color temperature and value that apply for watercolor also apply for pastel color.

Line Work. Line work uses the line in the same manner as pen and ink: as outlines and/or texture and value patterns with lines. Overlaying hatching, cross-hatching, or scribbling creates color.

An outline can be drawn with a pastel pencil, colored pencil, or hard pastel "lead" in a holder, and then color may be added to shapes with hard or soft pastel sticks. A pen and ink or pencil outline can be the base drawing with pastel line work filling in the shapes. Last, shapes can be created with line hatching and scribbling without line work—in this case, the edges are established by the line patterns within the shapes.

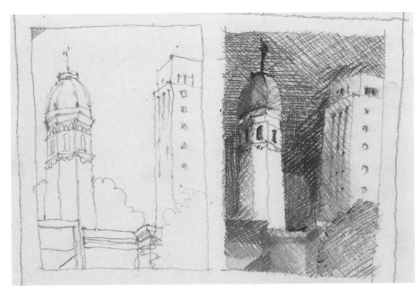

TOWER HATCHING STUDY. The rough hatching "thinking" process helped to explore color issues. Hatching is fast and versatile for early layers.

Process

- Hatching strokes with hard or pencil pastels are used to shape, add value, and fill out in color.

- Avoid blending, smoothing, or smearing colors at the early stages; maintain the line characteristics.

- Overlay multiple colors to create additional colors, with hatching or scribbling.

- After all shapes have initial layers of color, temperature, and value, fix the layer with workable fixative spray. Allow to dry.

- Soft pastels are used to add color refinements and additional texture.

- Use hard or pencil pastels to add detail and outline highlights.

- Add final fixative.

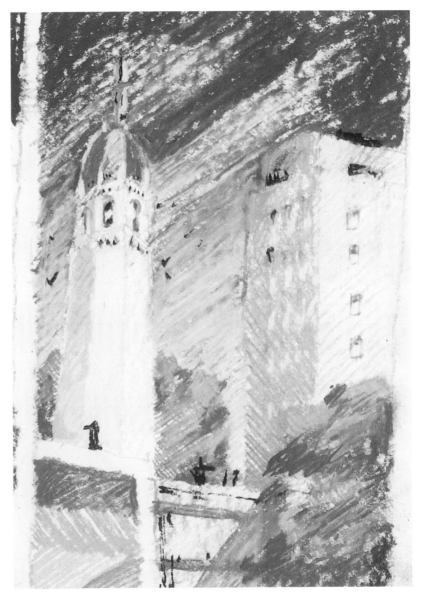

TOWER STUDY. Flat and stick-edge applications were overlain on an initial hatching layer, to explore light and color. The white was applied last, light over dark.

Blocking-in or Massing. Using the wider side of a stick, block-in or stroke broad swatches of color for the drawing shapes, paying little attention to outlines or edges. This is also referred to as side strokes, where the pastel stick is laid on its side and skimmed over the paper. Build up colors from the inside out. Broad strokes can create texture as well as color. Work in layers so as not to oversaturate the paper or board. Add the light highlights near the end of the work.

Process

- Block in large areas or shapes of the composition first with the broad or wide side of a soft pastel stick.
- Use light pressure as you build up layers; this prevents premature saturation of the paper fibers.
- Add basic color patterns in broad strokes.
- Fix with workable fixative. Allow to dry.
- Over the underpainting, add lighter colors to shape and model the forms and lighting effects.
- Blend colors where desired.
- As the painting becomes saturated with pastels, use larger, softer sticks for highlights.
- Blend colors with a sponge or soft paper material and, if necessary, flatten pastel dust with a palette knife.
- Graphite pencils, pastel pencils, and erasers can be used to add final outlines, edge highlights, or local color.
- Fix with final fixative.

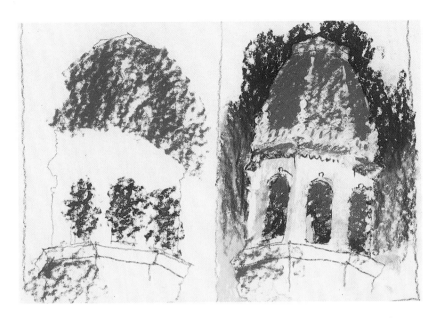

OUTSIDE THE LINES. Light and dark cover dark, so a fast application of red on the roof form spilled over the shape outline. Blue and white applications covered the underlying red and blue respectively. If the applications are saturated, use workable fixative to set the base so it can be overlain with more pastels.

BLENDING. The sky is isolated here to show how three blues are blended by soft, flat applications, creating graded sky washes both in value and in color. Reds, oranges, and browns do the same on the building façade. The paper is from an inexpensive watercolor work tablet that has considerable texture. A smooth blend obviously results from smoother paper.

TOWER BLOCKING-IN. Fast illustration with massing or blocking strokes works well for initial or less detailed images. A blow-up of the tower and adjacent building are the composition. Flat, broad strokes were applied to a rough watercolor paper, accounting for the white splotches. Stick-edge applications provided solid color where desired.

Line and Massing. This method uses both the line and massing tech-
niques to create a translucent and rich effect. Because hatching is used
extensively, the color is woven or interlocked. The mission is to build a
mood with loose and fast lighting effects. Gradually build the image
with layers of hatching without blending until the very end; then adding
scumbling and limited blending. The line and massing approach produces
a nice study quality beyond the sketch but not finalized like a heavily
blended rendering.

Process

- Begin with hard or pencil pastel colors, using hatching and cross-
 hatching strokes.

- Build up the hatching layers until a mood or lighting scheme is
 achieved, with a color temperature dominance that is cool or warm.

- Create positive shapes with negative hatched shapes or positive
 shapes with hatching strokes, seeking to maintain a hatching pat-
 tern throughout.

- After the color, temperature, and overall value patterns are estab-
 lished with the harder pastels, spray with workable fixative.

- Scumble soft pastels over the first layer for color and texture high-
 lights.

- Reinforce dark values, where needed.

- Fix with final fixative.

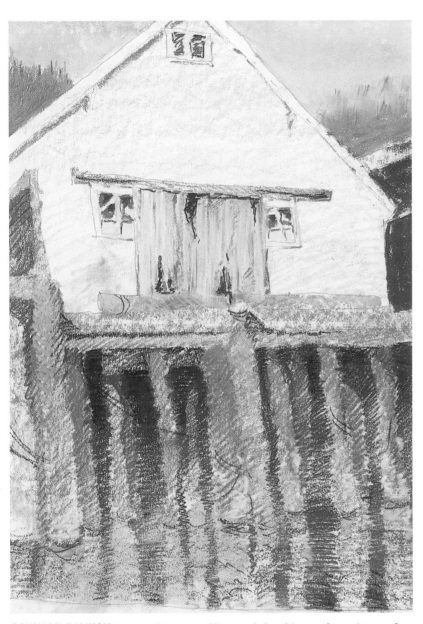

CANNERY REMNANT. A combination of line work, hatching, and massing resulted in a strong yet semi-transparent value scheme. Yellows and purples complement one another.

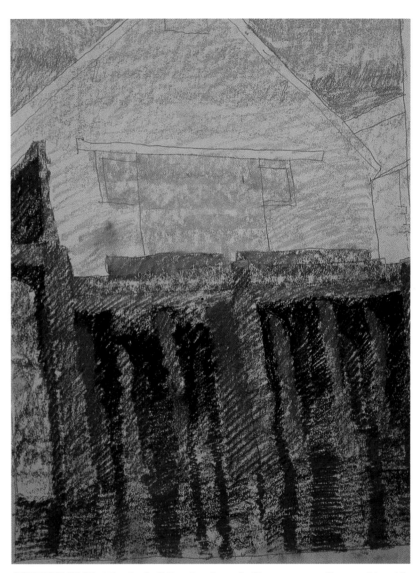

CANNERY BASE. The sky, building façade, and piling area were all massed in with flat broad strokes of underlying color. In the piling area, I merged brown with purple broad strokes as a base for later hatching.

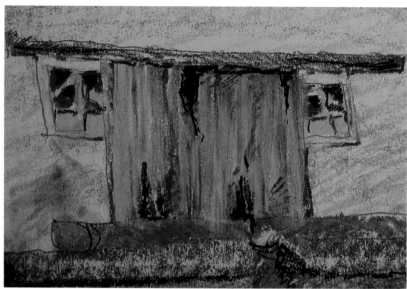

CANNERY DOOR. The door is old and deteriorated, a telling story to the harsh wet weather of this magnificent working building. I layered vertical streaks of oranges, blues, grays, and lastly white as a blending tool. Black was added to the painting to push the darks deep under the pilings and into the building through cracks in the door and windows.

CANNERY PILINGS. Hatching was then used to begin distinguishing piling shapes under the wharf, with loose strokes. I continued this technique, alternating between orange grays (browns), purples, and some orange until the paper became somewhat saturated. I then used workable fixative to set the chalk.

Application Techniques

Blending. Blended color is smooth and flat or solid in appearance and is characterized by a lack of or minimal texture. As in watercolor, blended colors are mixed together. Entire shapes or just their edges can be blended, thoroughly mixing one color into another. Mixing or gradually blending the edges attains merged edges or transition areas. Blended colors are smeared or smoothed directly into a clean coloration. Colors can be mixed with the finger (be careful of body oils and friction), soft papers, stumps or tortillons; or mashed or pressed down with a palette knife or razor blade. Use rags and soft papers for larger areas and the finer pointed tools for details and smaller areas.

COLOR MIXING 2. Grade one color from dark to light by easing up on the application pressure, going from darker (more pressure on chalk) to lighter (less pressure), followed by a smoothing process. Create grays by overlapping three primaries, smoothed or not.

Blending can be used to mix two colors into a third, three colors into a colored gray, or blend two colors at an edge, producing a blended transition. Blend colors before there is a heavy buildup of pastel, usually in the early layers.

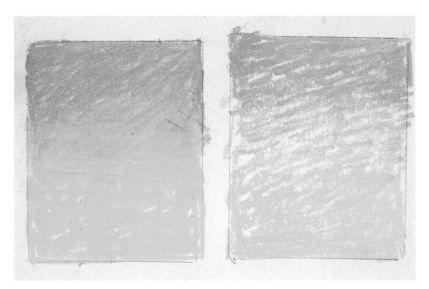

COLOR MIXING 1. Mix colors by (left) simple overlap and (right) smoothing out the overlap with a stump, paper, finger, etc.

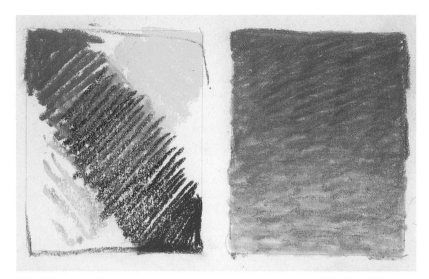

EDGE OR TRANSITION SHAPE BLENDING. Mix two colors by swirling or scribbling one over another. With your finger or stump, blend or smooth bits along the edge to create a *lost and found* or hard and soft edge condition. The light falling on tree boughs can be depicted by blending three shades of green with overlapping, and hard and soft edges.

SKY BLENDING 1. Blending for sky conditions can produce multiple color and value gradations for any condition. Colors are loosely applied, overlapping one another at their edges. A paper, cloth, or finger as a smoothing tool is used to blend the edges and achieve a smooth transition from color to color or value to value.

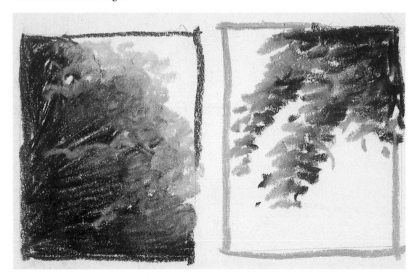

MERGING. Mix multiple colors together at their edges, creating varietal background effects. Useful for large areas of foliage, wall surfaces, clouds, and sky conditions.

SKY BLENDING 2. Soft billowy clouds can be easily blended. The light blue was applied over the dark blue and smoothed to a soft edge.

Quick and Dirty Blending

In design work, I use a quick and dirty technique for adding color to studies and intermediate presentation drawings for public and/or client meetings.

- On a bond print of a conceptual or design development drawing, usually in ink, scribble or hatch colors into the shapes with a pastel pencil or hard pastel stick.

- Add all of the colors for local color, color temperature (close and distant shapes), and color complements.

- Using a stump or tortillon, blend the colors into the shapes (this goes quickly and works well even for small, detailed shapes).

- Go back and add small detail colors.

- Apply workable fixative, let dry.

- Add final dark values (note: dark values can be added in the early layers as lighter pastels can be applied on top of darker colors that have not been fixed, to a limited degree).

- Add final fixative.

Adding Strength and Brilliance

- Use matte or smooth watercolor paper.
- During the first layering process, lightly add pastel with a hard stick or pencil.
- Brush pastel around to blend without leaving any heavy buildup of pastel.
- Mash or press down the pastel with a palette knife to smooth colors without over-saturating paper.
- Fix the drawing.
- Add more brilliant colors in a scumbling or hatching method with less blending. This adds some texture and brilliant color over the softer blended base.
- Apply final fixative.

RAINIER VISTA. A wash effect is created by pastel pencil hatching, which is then smoothed or blended with a tissue or soft rag.

RAINIER VISTA PARTIAL.

Broken Color. Broken color is used less often in design studies. It offers a strong and dramatic aspect to urban subjects, in many cases more semi-abstract in nature. This is due to a lack of blending, with more texture and color variation in each shape. Broken color is textured, interwoven with other colors rather than blended smooth.

Broken Color Characteristics

• Very rough paper, watercolor paper included

• Use of soft pastels, lightly applied

• Fixing layers in preparation for additional soft layers

• Little or no blending (except at very end to clarify edges or key details)

Application Techniques

• Use a textured or very rough watercolor paper or fine art paper.

• Apply color with hard or soft pastels in a hatching and/or scumbling technique, with light pressure.

• Use a large, soft pastel to add highlight color, again with a light skimming application.

• Apply workable fixative.

• Add additional highlights and texture where desired without blending colors.

Harmonious Color. Color harmony occurs when the basic primary colors are distributed throughout the drawing. This does not mean that each shape is a colored gray, but that there is a distribution of the dominant color(s) in most shapes. For example, a cool painting may have a blue in all of the shapes, with others being combinations of secondary and tertiary colors using that blue as a base. Some techniques for achieving harmony are:

OLD HOUSE. Textured watercolor paper makes the pastel skim the surface, leaving a white and "broken" field of color.

• Apply a coat of the same color to all shapes (except white) in varying values to add a color harmony to the drawing. Overlay that basic color with additional color(s) and leave some shapes just the original color.

• Using hatching and feathering techniques, add the basic color to all shapes overlain with additional color hatching.

• After the initial colors are applied near saturation to the entire drawing, fix the work; scumble additional colors over the base colors.

PRESSURE. Try applying different pressures from light to heavy until the chalk breaks.

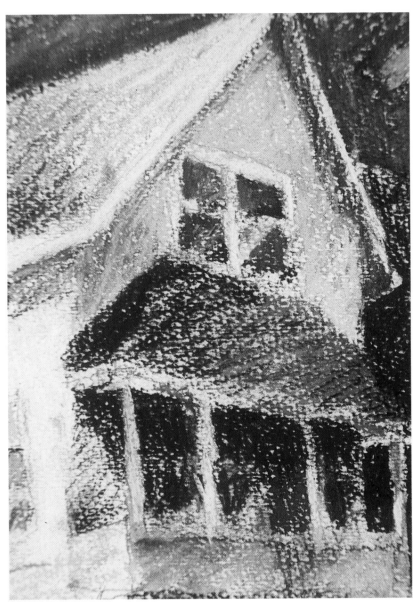

OLD HOUSE PARTIAL. Hatching overlays of different colors help "blend" from one color to another. Try various pressures.

Pressure. The pressure placed on the tip or side of the pastel affects the texture and consistency of the application. Gradually adding or subtracting pressure near an edge produces a nice value change. One stroke can have numerous values simply by adjusting the pressure applied to the stick.

SCUMBLING. A soft orange pastel is stroked along its side over a blue blended layer that has workable fixative. In this example, lighter covers darker colors.

SCUMBLING ON WHITE. Scumbling can work on smooth or rough textured paper (white or colored). Layers of scumbling can also be applied to increase textured effects.

MORE SCUMBLING. A soft red pastel is stroked along its side over a lighter background that has workable fixative.

Scumbling. Scumbling is a method of creating texture and color variation by lightly skimming or dragging a soft pastel over another color on a rough or textured surface.

Application Techniques

- Use a rough textured paper, including watercolor paper.
- Be careful not to oversaturate the paper by pressing the color into the paper depressions; be light handed.
- Scumble one color (possibly two) over the previous wash before fixing.
- Add highlights in the same manner, also using light-pressured hatching and scribbling.

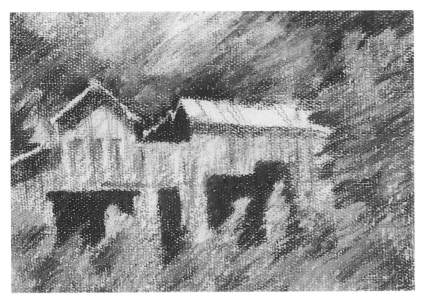

FEATHERING. Diagonal hatching produces color and texture effects without blending. Textured paper adds to the lighter atmosphere by exposing more white paper.

- Work light to dark or dark to light (unlike watercolor).
- Adding fixative can darken colors, which can be an asset.

Texture on Smooth Paper. Texture can be applied to smooth paper by placing a rough textured surface under the bond paper and rubbing the pastel over the surface. The texture from the underlayment is picked up on the top layer.

Feathering or Hatching. Feathering is a hatching technique that consists of parallel lines (usually diagonal) that are added to another color. It is a way of adding some transparency to an opaque medium. It works well on blended applications where additional brilliance or highlights are needed without erasing. Use soft, hard, or pencil pastels.

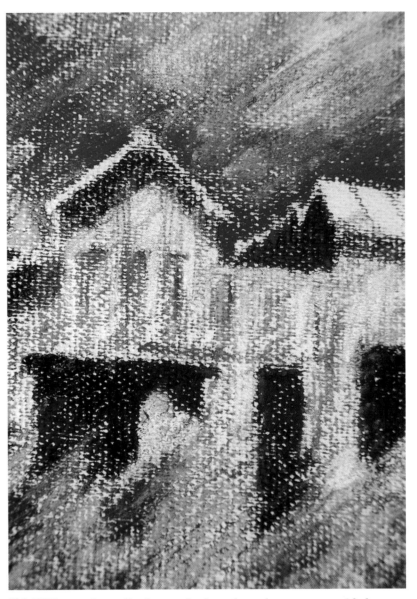

UW SHED. Heavier applications on the sky and tree shapes contrast with the whiter effect of the building (more white paper showing through).

Dusting. Dusting consists of shaving pastel particles from a stick onto a painting. This allows the designer to add a spattering or dusting of dispersed color particles over an area without leaving hatching or other application marks. The particles are pressed into the painting with a palette knife. Different colors can be dusted or sprinkled onto a given area to mix colors without blending, and the effect is different from adding broken color with scumbling. It is not unlike stippling with a pen or spreading watercolor with a toothbrush (spattering). As colors are pressed into the paper, they will spread out a bit. Experiment on a practice paper to determine how much pressure and what density of dusting are needed. This technique also helps make some applications "transparent," enabling one color to show through another.

Pointillism. A point is a dot. Pointillism is the process of using pure color dots to build up areas or shapes of color created by the aggregate of two or more colored dots clustered together. Hard and pencil pastels work best for this technique.

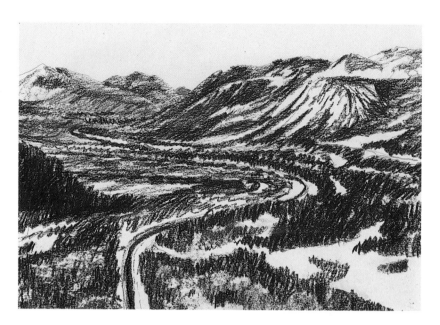

Techniques for Basic Elements in Design Compositions

Elements in design compositions are the basic shapes and patterns that occur regularly in urban design, architectural and landscape drawing. These elements apply to scale, context, concept and design development drawings. They include:

- Shadows
- Rural
- City and Townscapes
- Buildings, Building Components and Materials
- Water and Sky Shapes

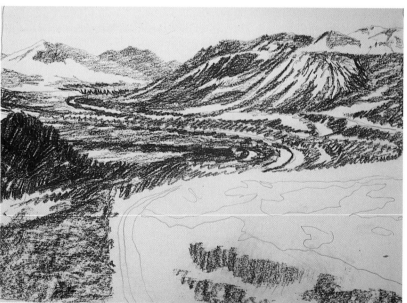

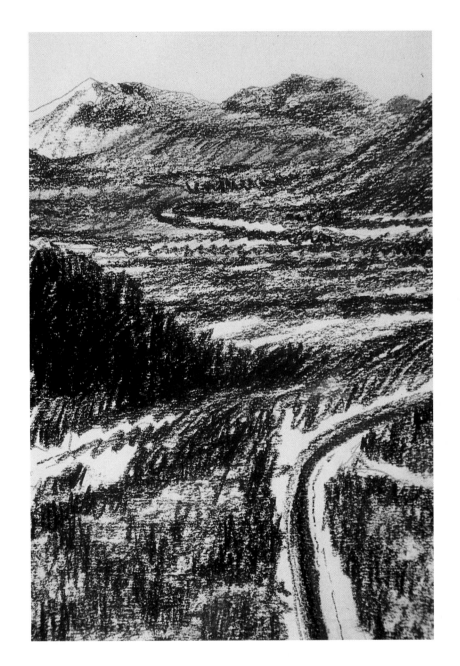

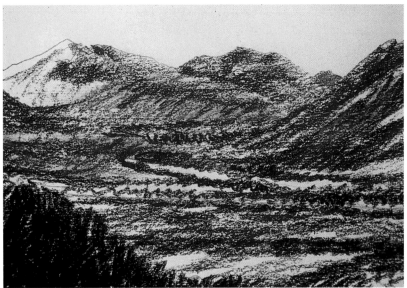

ALASKA HIGHWAY SEQUENCE. This 15-minute 20″ × 30″ soft pastel sketch was done in three stages: a fast, one-color application using continuous diagonal strokes; a second layer of same color overlay to create darker values where desired; and a third layer of a different color (blue) to add a touch of distance (cooler in the distance).

- Landscape Elements: Trees, Shrubs other Vegetation, and Hard-landscape Elements
- Edges and Highlights

The accompanying examples demonstrate the use of pastels in design study and composition.

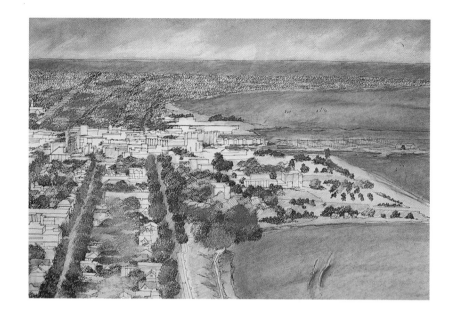

SUSTAINABLE RACINE. Pen and ink sketches were printed on bond paper and washed with pastel sticks, rubbed smooth, and scumbled over in key areas (water).

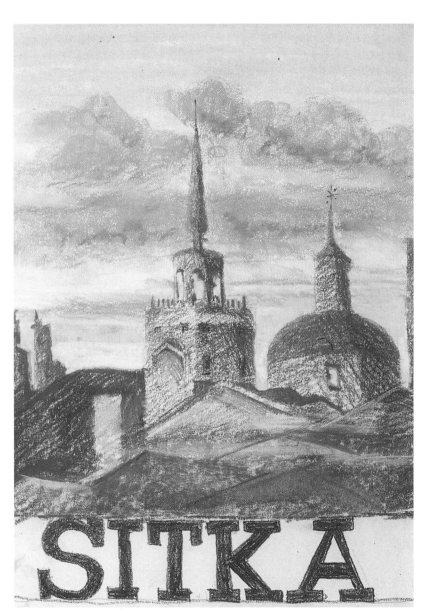

SITKA TOWNSCAPE. The sky color was first blended, followed by the cloud formations. The horizon yellow was added after the buildings were initially massed. The buildings were applied with a combination of feathering and broken strokes, darkening the values after a layer of fixative. Some detail was added last with a hard pastel pencil.

SITKA TOWNSCAPE PARTIAL.

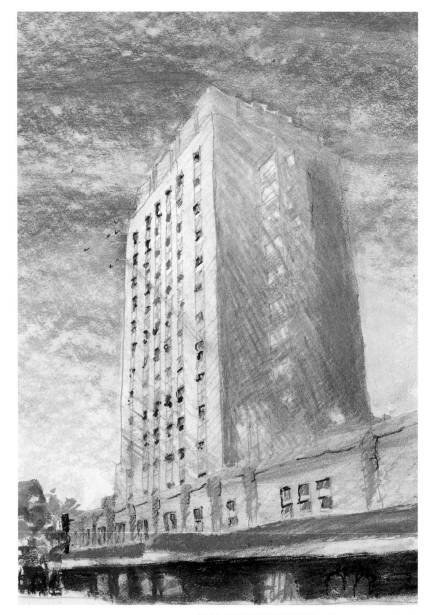

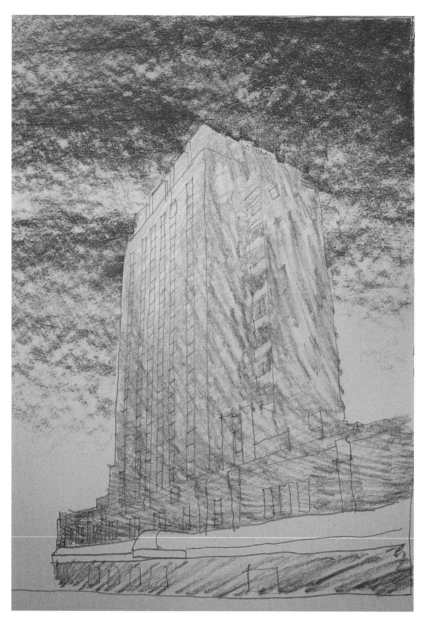

BELLINGHAM CLASSIC. Three coats of broken and scumbled applications of soft pastels produced this simple complement of blues and oranges. Detail was added last to windows, canopies, and shadows.

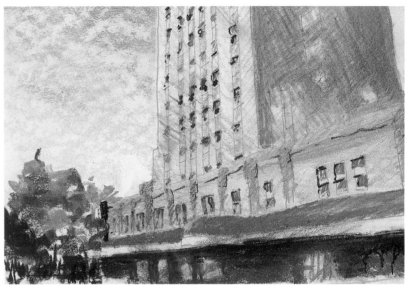

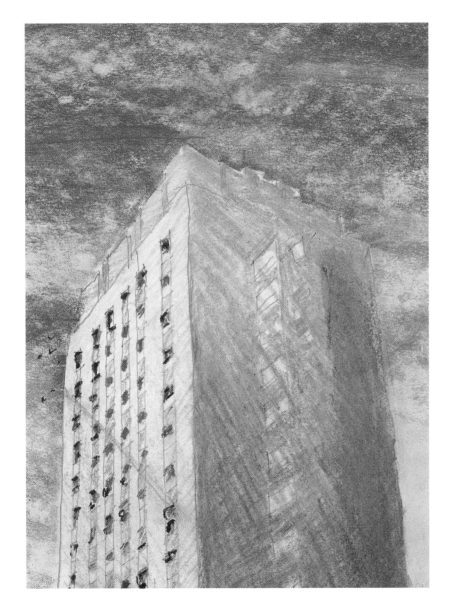

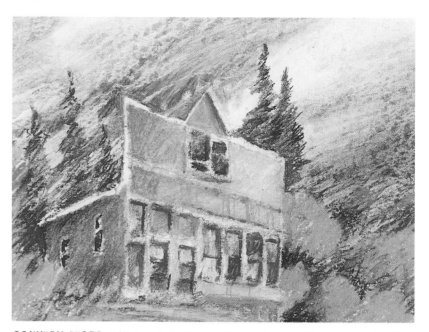

COUNTRY STORE. This is a study drawing for a watercolor. The colors are bright to explore a contrast between the building and the forest. It is a combination of blended and feathered strokes.

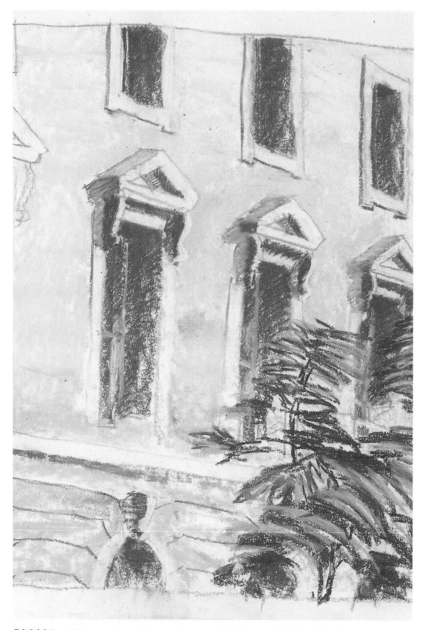

FAÇADE. Yellow and purple complements brighten a building façade.

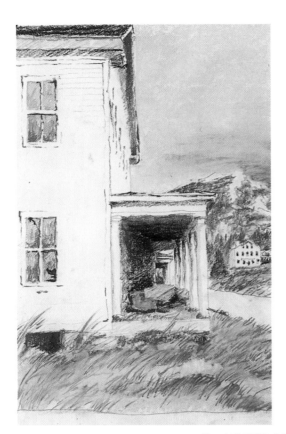 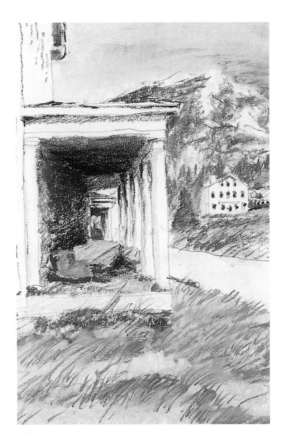 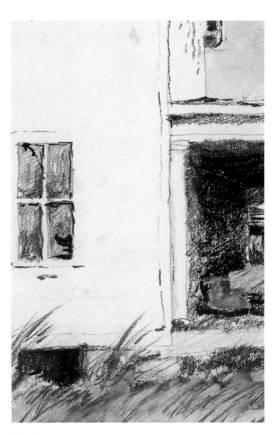

FT. SEWARD BARRACKS. Fall grasses provide a base for this partial elevation of the former barracks building in Haines, Alaska. Yellow and purple complements are strengthened by large white shapes and dark interior shadows.

COLORED MARKER

Colored marker is presented in this book in combination with pen and ink or pencil, for study sketches and diagrams. Markers have been a mainstay of graphic visualization in design and planning for decades, revolutionizing graphic presentations. They have been greatly improved regarding the toxicity of the solvents that carry the pigment. Common solvents include xylol, alcohol, and water. As in many art material uses, the designer needs to exercise care when using markers due to the solvents. Ventilate work areas and do not ingest materials. Some designers actually wear latex gloves when using colored markers so as not to absorb solvents through their skin. Check the manufacturers' literature for cautions and ingredients.

The color principles discussed in the watercolor chapter on temperature and complements generally apply to colored marker. Colored marker is consistently more intense or brilliant, making drawings either "hot" or garish. Pastel and colored pencils are effective in muting or reducing these effects.

Materials and Equipment

Color Availability. Numerous manufacturers provide approximately 50 colors. Chartpak, Berol, Eberhard Faber, Magic Marker, Panatone, and Prismacolor are among the more commonly used. They come in larger nibs with wide and narrow (rectangular section) nibs, and fine, medium, and heavier pointed nibs (round section). Water-based ink markers are also available. The best approach is to buy one or two of each type by manufacturer and try them on paper and mylar. See which you find more comfortable to work with. I find that some brands do not last as long as others (drying up), and suggest that you vary manufacturers over time to determine which have more staying power.

COLORED MARKERS. Markers come in many varieties including refillable holders. Try different brands to judge their staying power, absorption, and spread or bleeding, and how fast or slow they dry out.

Sample Palette. Doyle (1993) suggests the following palettes:

Naturals

Slate Green

Dark Olive

Light Ivy

Light Olive

Olive

Pale Olive

Sand

Beige

Burnt Umber

Redwood

Brick Red

Kraft Brown

General Palette

Salmon

Chrome Orange

Dark Yellow

Chrome Green

Forest Green

Aqua

Crystal Blue

Space Blue

Purple Sage

Pink

Colors used by Doyle are AD markers; equivalents can be found with other brands.

Paper

PRINT PAPER. Markers work well on most paper used in reproduction process. These include the diazo process papers: black, blue, and brown line; sepia; sepia mylar; mylar reproductions; and bond copy paper. I personally never use blue line diazo paper for color work. The blue is very difficult to make compatible with most color dominance and harmonies. Black and brown line diazo prints work well, preferably with an intentional background "fuzz." Sepia paper works up to a point: the emulsion may coat the tips of markers.

For diagrams and other concept drawings where a transparent sheet is desired, I ask for black sepia paper to be run through the print machine, usually with a title placed on the sheet. The printers think I am a little daffy sometimes, but I use them as transparent (to trace through) sepia sheets for colored marker diagrams. Bond paper is thinner and lighter weight than the diazo papers, so use care in selecting markers. Some brands can bleed more than others on bond paper. Doyle recommends using alcohol-based markers on photocopy reproductions.

Tracing paper (flimsy, vellum) takes marker well on both sides. Applying color on the reverse side mutes the brightness of markers due to the paper fiber.

COLOR MIXING WITH OVERLAYS. Layer a yellow and red to get an orange. Markers are versatile and can be mixed to some degree.

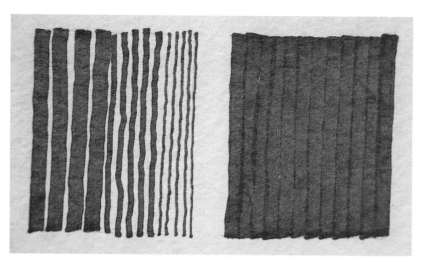

LINES. Characteristics of the marker tips—try all combinations.

MARKER MERGING. Markers can be merged together with soft edges or transitions when applied to most tracing paper, flimsy or vellum, and mylar. The smoother the surface, the easier it is to merge.

Marker Techniques

Copying Marker Drawings. Use marker on original drawings sparingly if at all. Copy the original line drawing onto bond, diazo, sepia paper, or mylar. When photocopying marker drawings, use a dot screen to break up the color mass.

Mixing Colored Markers.

Markers can be mixed by:

- Overlaying one color over another dry color, i.e., red over yellow to make orange. The solvent can disturb the underlying color, making it fluid again depending on the paper type.

- Swirling one color into another on smoother surfaces (flimsy tracing paper, mylar, vellum).

Building-Up Values. Layering one color over itself (dry) builds value.

- Darker colors can cover lighter colors for value increases and highlights.

- Color can be applied to both sides of the paper, particularly with tracing paper, flimsy or vellum. The color on the back side is muted by the paper fiber, producing a lighter version of the same color on the front side.

Line Techniques. For wide lines, use the side of the larger marker nib, keeping the edge consistently down on the paper. It is difficult to go over marker, as blossoms or smudge marks can occur.

- For consistent patterning, use vertical or horizontal lines in a clean and deliberate (vs. sloppy) motion. I tell students to "cut the grass," reminding them of their summer chores when each row of grass cutting slightly overlapped the previously cut row to ensure the absence of "sprouts" or in this case white voids. Take your time when filling in fields or areas of color (plan diagrams, land use maps, etc.). In most cases, you will still be faster than a GIS (Graphic Information System) technician.

- For freehand lines, use an underlayment to trace from or draw basic shapes with a nonreproducing or light lead pencil to trace over. Use a deliberate slight squiggle when doing freehand. This negates any notice of imperfections when a straight line has a blemish.

- For straight lines, use a triangle, old T-square, or other smooth edge. Lines made with a straight edge can sometimes leave a streak or buildup of color on one side of the line from the way pressure is applied against the straight edge. Since I use markers for sketches and diagrams, I seldom use straight-edge lines, preferring instead the straight freehand lines discussed above and demonstrated in this chapter.

Graded Effects. Grading color is changing the value (and sometimes color, too) from light to dark or dark to light. With colored markers:

- Apply the second and succeeding values immediately onto the last of the previous and still wet application, effecting a merge of the two wet colors.

- Using the same color, add succeeding layers over the previous one (leaving a portion of the original or previous layer exposed).

- Use alternating stripes in the transition zones:

- apply the first color in contiguous bands

- at the transition area, leave every other band blank for two or three rows

- add the second value and/or color into the blanks in the transition area

- finish by applying the second color in contiguous bands

- repeat as desired

VALUE. Layer the same color over itself and value is increased. Four value ranges are shown here.

COLOR TRANSITION. On absorbent or less smooth-surface paper, marker can be blended or transitioned into another color using a stepped approach. Alternate the two colors within the transition area.

SHADOWS. Shadow shapes are darker in value with local color retained in the darkness. One method of shadow-making is to overlay the same ground color over the first, increasing its value (as many times as necessary). Another is to add a warm or cool neutral (noncolored) gray as an overlay to darken. This retains some local color. A third way is to add the complement of the ground color as the overlay: red on green grass, purple on yellow sand, or blue on an orange-brown wall. Adding a complement creates a colored gray which has the local color as one of its components.

Shadows. Apply shadows in three ways:

- Either before or after the local color, apply a cool or warm gray underlay or overlay.

- Apply a layer(s) of the same color marker over the previous application.

- Apply a color complement over the previous application, being careful not to generate mud. Purple over yellow, blue over orange, and green over red can work if the colors are less brilliant and lighter in value.

With few exceptions, make shadows transparent in study drawings and diagrams, whatever the medium. Vital information can be lost on the ground plane (sidewalks, landscape treatments, entry drives, etc.). Transparent shadows reflect the texture and value of the surface materials.

Using Colored Markers with Other Media

Pen and Ink. In professional urban design projects, I prefer to work with marker as a mixed medium. Most projects require studies and conceptual drawings for client and public meetings rather than final illustrations or renderings for financial packages and other marketing roles. Consequently, the pen (technical and fiber tips) and ink take precedence in that the value can be applied directly and strongly before any color.

THE BLACK AND WHITE BASE DRAWING. Ink drawings provide sharp and clear *shape* edges for colored marker and pencil. Two options are available: an outline drawing with no value or texture (as texture can create value), and a drawing with a clear hierarchy of value, from light to dark. In this manner, one color applied over a base with value produces lights and darks of the same color. Less color use can be easier for the viewer given the high intensity of the marker ink. Limited complements like orange and blue ranges can be used over the ink drawing for dramatic effects (Schaller 1990).

VALUE AND TEXTURE. For those designers accustomed to drawing with pen and ink, the colored marker becomes an effective wash medium. Value is added to the drawing in pen and ink with hatching, scribbles, stippling and so on, creating the value patterns. The drawing can be reproduced as it is, used as a black and white document, or printed and used with color. Texture becomes a means of adding value with pen and ink, whether to building materials or landscape elements. In this manner, the color becomes a fast highlight treatment rather than a major color rendering.

Pastel and Colored Pencil Over Marker. Pastel and colored pencils are both opaque materials and will cover any light or dark colored marker application. With marker, they are best used as highlights, adding texture, masonry coursing, and lighting effects. Refer to the section on pastels for application techniques, particularly the use of fixative.

Applications

The early stages of design require the development of many ideas visualized in a short period of time. Colored marker aids greatly in expressing local color; highlighting patterns and massing; and coalescing loose studies into effective visualizations for public workshops, charrettes, and meetings. Most of the examples that follow were done as working visualizations, most a part of a visioning or community design process where speed and quantity of quality images was an important objective. Other drawings are more deliberate conceptual or design development images.

Reference and Orientation Drawings: Context. Context, that assemblage of *places* large and small that we all dwell within, provides the designer and the community with reference, orientation, and structure. It can explain and humble the *why* of our settlement patterns. It can shock us into wondering why we did what we did. It is always a great place to begin when helping the public understand their relationship to the land.

The technical and/or fiber pen drawings shown were used in various public design awareness projects. Colored marker added local color, atmosphere, and highlights to the underlying pen and ink work.

MESABE IRON RANGE. These are pen on mylar drawings by James Pettinari with color marker overlay.

TOLEDO SITE DIAGRAMS. Colored marker on exposed sepia diazo print paper showing location and site characteristics. The sepia paper is transparent, making it easier to trace images (James Pettinari).

The Diagram. Colored markers are effective in developing diagrams related to site and building programming issues, as well as recording and analyzing data. Their color permits a coding system for organization of uses and functions, as well as an easy to understand public visualization tool. Diagrams are semi-abstract visualizations that can portray quantitative and qualitative information in a spatial framework (plan, axonometric, section, etc.).

Spatially referenced diagrams are similar to the conventional bubble diagrams, composed of blobs and arrows indicating organizations of uses and their relationships. The difference is they are drawn on or over a measurable frame such as a plan or axonometric, usually to a conventional scale. This frame adds reference, orientation, and structure to the concept organization.

CONSTRUCTING THE DIAGRAM. Prepare a draft diagram on flimsy using pen or pencil, or lay out the diagram on the final paper using a nonreproducible blue or color pencil. For consistency of shape, I use circle templates and straight-edge or grid paper aids to get the diagram accurate.

Using the colored markers, color coded by function, draw over the rough draft, either tracing through from the flimsy or drawing directly on the final sheet. Value, the light to dark relationship, is important in the diagram to indicate major vs. minor shapes, historic or other significant structures, key edges or view corridors, or major circulation routes or paths. Color plus value is the key to a striking diagram. For conventions and examples in symbols, refer to Lynch (1960), Kasprisin and Pettinari (1995), Cullen (1995), and Laseau (1997).

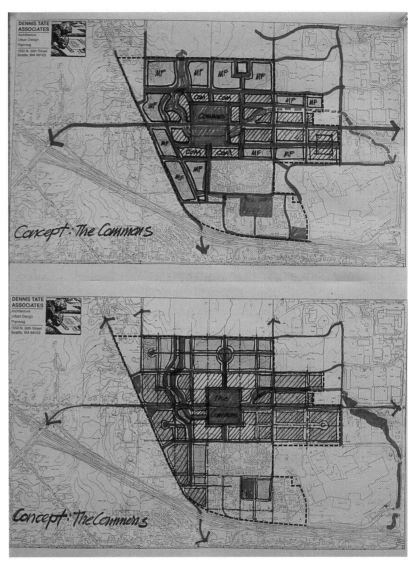

WEST BAKERVIEW. Street layout options colored with marker on bond print of site area with background information. Fast, effective diagrams suitable for public meetings (Dennis Tate).

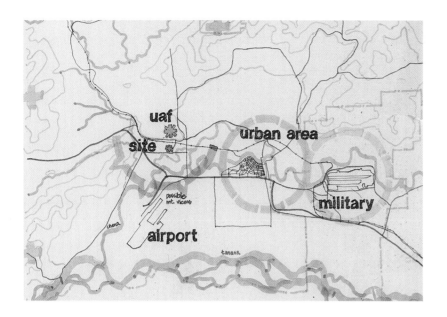

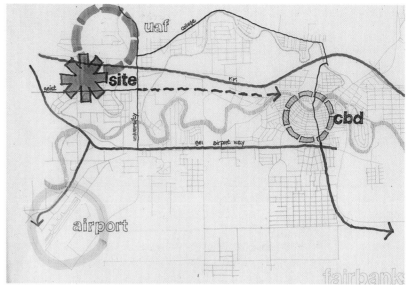

CONCEPT DEVELOPMENT. Preliminary ideas can be quickly summarized in plan, site section, elevation, axonometrics and sketches for client and public meeting reviews. The colored marker is used as a wash, covering over shapes first drawn in pen and ink or marker added to a pencil or pen drawing and highlighted with colored pencil or pastel.

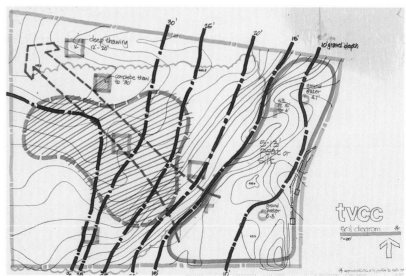

TVCC. Community College master plan analysis diagrams drawn on exposed sepia print paper. The final diagram is traced directly onto the sepia from a rough draft. Templates were used for circles and arrows. Other symbols were traced from templates or guides placed under the sepia paper.

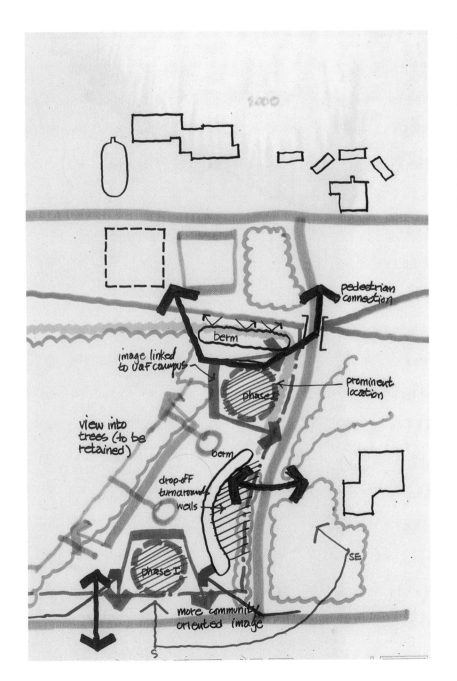

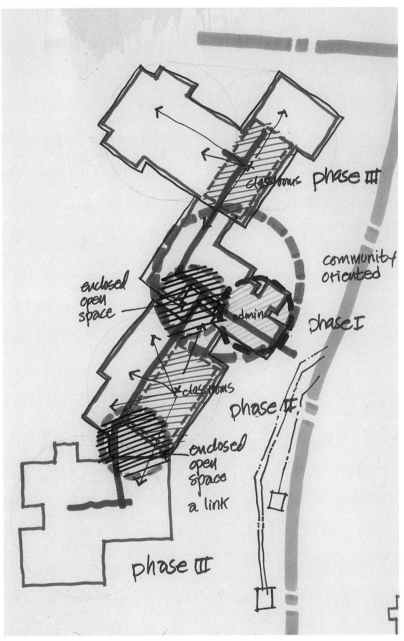

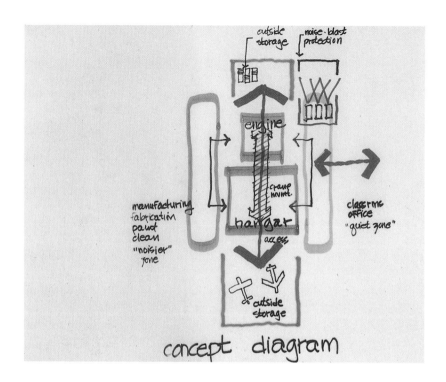

concept diagram

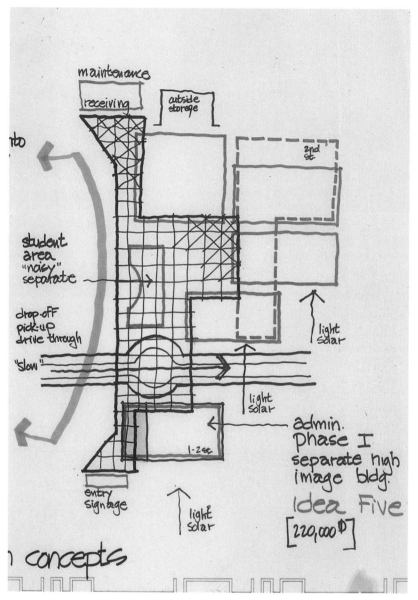

TVCC (continued).

scheme d₁
urban design
concepts

to dorm parking

IV

major enclosed pedestrian spine

enclosed - non-heated open space

service vehicles

open and covered outdoor storage

IV

entry

heated transit stop

upper level

II

daylighting scoops

III

upper level

service v. emergency shuttle from noe

pedestrian route west h.s.

wells

entry

existing trees to remain

parking

earth berms assist in utilizing material, adds drama to small structure and entry impact

"commons"

"commons" could w/ translucent year round use

tvac image.

skating & summer activity

clock tower

entry

entry

visitor, staff parking and access

pedestrian access from

earth berms phase I

south and southeast solar exposure

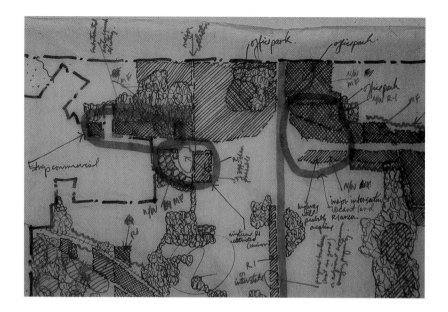

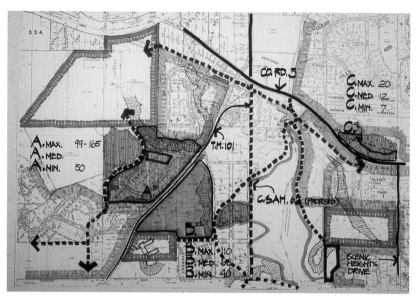

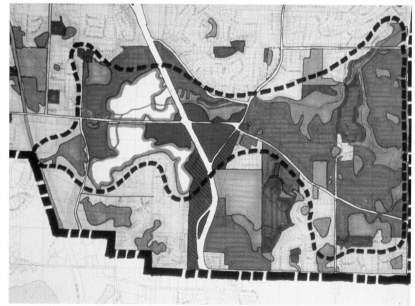

MINNETONKA ANALYSIS. Quantitative analytical drawings, for land use, buildable areas, etc. are effectively done with colored marker on black-line prints. Avoid using blue-line prints as the blue color can clash with applied marker colors (Bill Beyers, upper right).

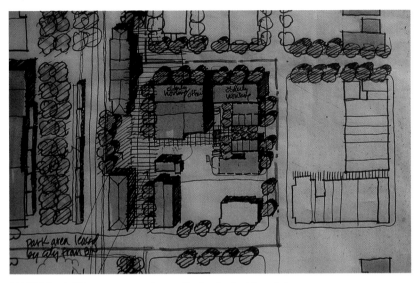

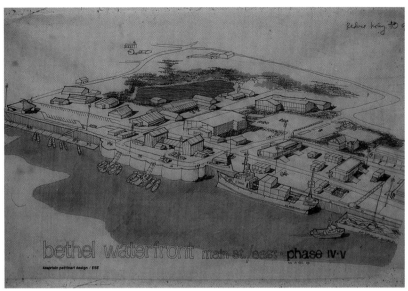

YAKIMA PLAN. Marker can be applied to both sides of the transparent paper: on the front side for higher intensity color effects and on the reverse for a more muted background effect (green).

BETHEL, ALASKA STUDY 2.

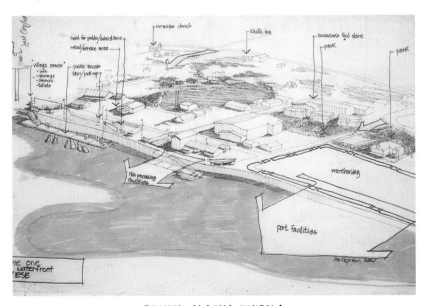

BETHEL, ALASKA STUDY 1.

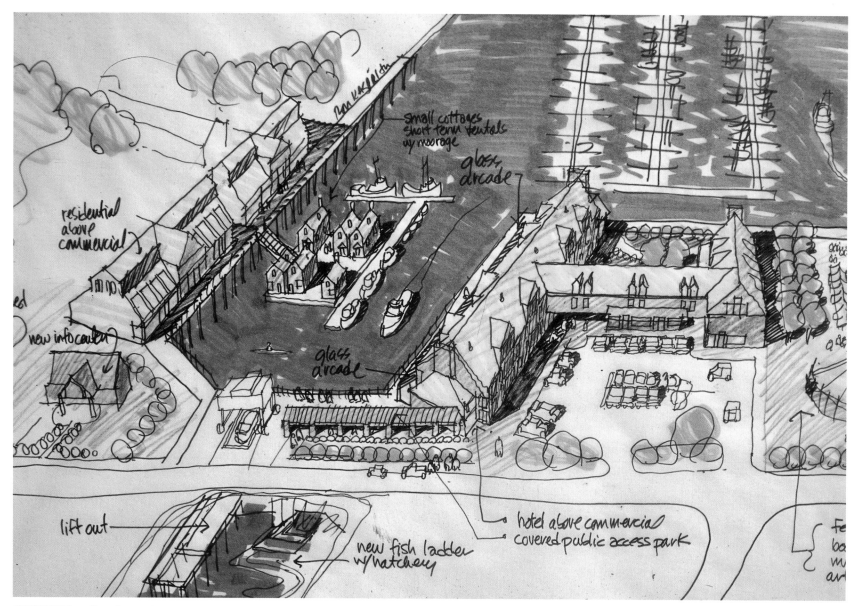

Labels within the sketch:
- small cottages short term rentals w/ moorage
- glass arcade
- residential above commercial
- new info center
- glass arcade
- lift out
- new fish ladder w/ hatchery
- hotel above commercial
- covered public access park

CONCEPTS. Yellow flimsy sketches, done as a part of community workshops and charrette intensives, consist of Pentel Sign pen drawings with colored marker loosely applied as a wash either on the front (Ocean Shores marina) or on the back (Bethel waterfront). The loose and sketchy nature of the drawings is usually well received during workshops, representing ideas rather than rigid and final plans.

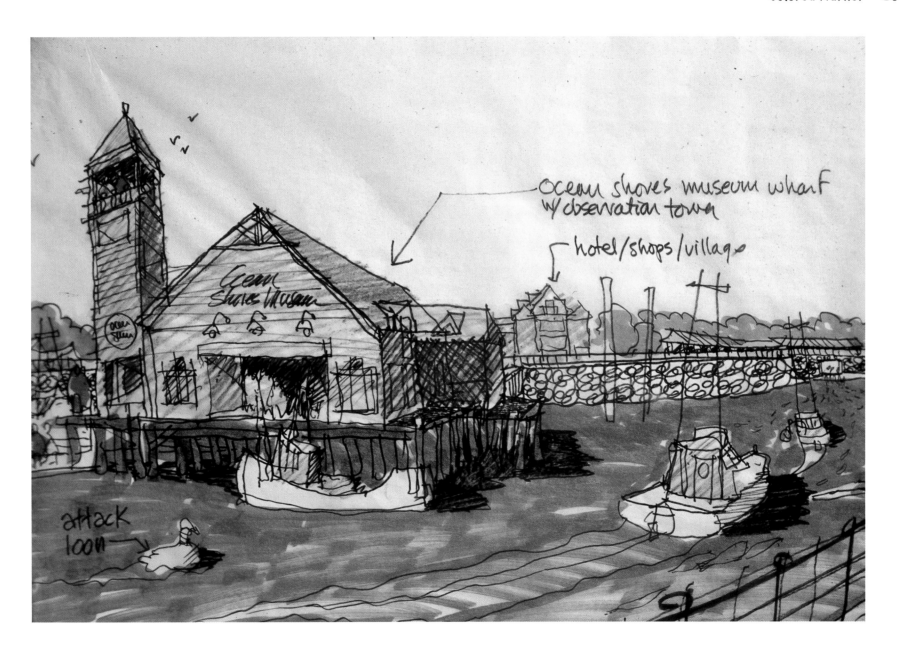

ocean shores museum wharf
w/ observation tower

hotel/shops/village

attack
loon

HERMOSA BEACH. These concept drawings were drawn with a Pentel Sign pen on vellum with colored marker on front and back. They were a part of an AIA R/UDAT where time and speed were of the essence. They are perspective diagrams that denote broad concepts with massing, movement, and a hint of detail augmented by a hint of color.

DESIGN DEVELOPMENT. Design development requires a detailed description of design intent. Illustrating added detail to both urban design and building design projects is fast and effective with colored markers on pen and ink. Multiple options can be colored quickly. There is a wide range of technique options available at this stage, depending on the type of meeting and client expectations or the public's familiarity with architectural conventions. The examples shown illustrate a variety of marker techniques.

CASINO SERIES. Pen and ink on mylar with colored marker. This series illustrates daytime and nighttime exterior as well as interior effects (James Pettinari).

CASINO SERIES (continued).

CASINO SERIES (continued).

SAND POINT WORKSHOP. As a means of expressing program data and concepts to lay people during critical workshops, aerial oblique diagrams were used in this sequence to dramatize building use, adaptive re-use, and new construction in one image. One aerial oblique perspective in pen and ink was reproduced numerous times on sepia print paper. The color coding was added in marker on both sides of the paper, depending on the intensity or muted effect desired.

EXPANSION OF CC
TO NE ALONG
I-5 E OF
PARAMOUNT.

CONVENTION CENTER SERIES 1 AND 2.

BIBLIOGRAPHY

Creevy, Bill. 1991. *The Pastel Book.* New York: Watson-Guptill Publications.

Cullen, Gordon. 1961. *Townscape.* New York: John Wiley & Sons, Inc.

Doyle, Michael E. 1993. *Color Drawing.* New York: John Wiley & Sons, Inc.

Kasprisin, Ronald J. and James Pettinari. 1995. *Visual Thinking for Architects and Designers.* New York: John Wiley & Sons, Inc.

Laseau, Paul. 1997. *Graphic Thinking for Architects and Designers.* New York: John Wiley & Son, Inc.

Lin, Mike W. 1993. *Drawing and Designing with Confidence.* New York: John Wiley & Sons, Inc.

Lynch, Kevin. 1960. *The Image of the City.* Boston: MIT Press.

Roddon, Guy. 1987. *Pastel Painting Techniques.* Cincinnati: North Light Books.

ABOUT THE AUTHOR

Ron Kasprisin is an architect and community planner; an associate professor in urban design and planning at the College of Architecture and Planning, University of Washington; and has been a practicing urban designer in Oregon, Washington, British Columbia, and Alaska for thirty years. Ron develops and facilitates public involvement events for community design projects and instructs continuing education media workshops throughout the Pacific Northwest, Alaska, and British Columbia. He is coauthor, along with Professor James Pettinari, of *Visual Thinking for Architects and Designers* (John Wiley & Sons, Inc., 1995) and the author of *Watercolor in Architectural Design* (John Wiley & Sons, Inc., 1989). He lives in Seattle, Washington, in a houseboat on Portage Bay.

INDEX